# Norwich
## THE BIOGRAPHY

# Norwich
## THE BIOGRAPHY

CHRISTOPHER REEVE

AMBERLEY

*Dedicated to Jo Parker,*
*in recollection of many happy times spent together in*
*the city.*

Unless otherwise stated, illustrations are copyright of the author or
Martin Evans.

This edition first published 2014

Amberley Publishing
The Hill, Stroud
Gloucestershire, GL5 4EP

www.amberley-books.com

Copyright © Christopher Reeve 2011, 2014

The right of Christopher Reeve to be identified as the Author
of this work has been asserted in accordance with the
Copyrights, Designs and Patents Act 1988.

British Library Cataloguing in Publication Data.
A catalogue record for this book is available from the British Library.

ISBN 978 1 4456 3460 9 (paperback)
ISBN 978 1 4456 0935 5 (ebook)

Typeset in 10pt on 12pt Sabon.
Typesetting and Origination by Amberley Publishing.
Printed in the UK.

# CONTENTS

# Preface

This book is a biography of a city and its people. It provides a summary account of its history from early times to the present day, but the main focus is on the experiences of people who have lived and worked in Norwich, or come as visitors during the past thousand years.

Any history of Norwich has to include the familiar names of the great and the good, the movers and shakers, who helped to shape the great city it became and the fine city it remains today. Many of these well-known characters appear here, but the book also focuses on more ordinary inhabitants, the poor and the not-so-poor, whose lives were dominated for better or worse by the attitudes of their lofty superiors. The sort of people whose lives are only occasionally mentioned in old legal documents, wills, graveyard memorials, or the annals of the hospitals, prisons and workhouses, providing us with a flickering moment of insight as if a match had been struck in a dark room, then the flame splutters and fizzles out, and all is hidden in darkness once more.

For some characters, the light burns more strongly – like a candle rather than a match. But whether the information that survives is detailed or flimsy, it offers an intriguing insight into the personalities of all sorts of humble and forgotten people – Moll Gay, Goody Sparks, or old Jeremiah Winterbottom – and how their lives were affected at particular moments during the city's long and often turbulent history.

The characters include chimney-sweeps and lamp-lighters, bishops and prostitutes, murdered children and convicted criminals, kings and queens, artists and writers, mayors and actresses, romantic Royalists and repulsive Roundheads, and a chorus of market stall-holders with such odd titles as 'fripperers', 'skirmischurs', and 'punder-makers'.

The 'mob' is also a significant character, playing a pervasive role in the history of the city on many occasions. It usually comprised a number of genuine activists fighting for causes in which they believed, but was egged on by dozens, sometimes hundreds or thousands, of idle apprentices, unemployed youths and ragged urchins, who fought valiantly for worthy causes such as Kett's Rebellion, but these events too often degenerated into extreme and vindictive violence against the Jews or minority religious groups.

The book is divided into a chronological sequence of centuries, offering a historical context for the personalities and the events in which they were involved. It is not a detailed history of the city, as there are other books which can provide that sort of information. Those which have proved particularly useful for my research, as well as delightful to read, will be found in the notes and bibliography.

Much of the biographical material has been derived from manuscripts, diaries, letters and other documents in the Norfolk Record Office. I am grateful for the helpful assistance and advice I was given, and the permission to quote from all the material requested. The Record Office, adjacent to County Hall (which has been unflatteringly described as like a 'giant public convenience'), has a pleasant and tranquil search-room to work in, with large windows overlooking a field of wild flowers. I recommend it to other local historians and look forward to spending many more absorbed and happy hours of research there.

Christopher Reeve
1 September 2011

# Introduction
## Norwich Before 1066

When you enter the centre of Norwich today, your senses are immediately aroused by the big shops and offices, the roar of traffic, the hustle and bustle of pedestrians, a multitude of sights, sounds and smells. If you climb up the steps to the summit of the Castle Mound, you can see the city spread out around you, in the foreground the broad thoroughfare of Castle Meadow, lined with shops, and beyond a dense panorama of buildings of all shapes and centuries, with the medieval churches of St Peter Mancroft, St Andrew's and St Giles's, and the clock tower of the City Hall soaring dramatically above their humbler neighbours below. And, on the horizon, you can just get a glimpse of the trees and fields and wide open spaces of rural Norfolk beyond.

But as well as this abstract collage of jumbled shapes, patterns, and materials, what you are most aware of, consciously or unconsciously, is the immense sky arching above you, the light and shade, the colours and atmosphere it creates, so that the appearance of the city is always changing, even from this single perspective from the Castle Mound.

So it's the great East Anglian sky which exerts the most profound effect on our experience of the ancient city. For in Norwich, maybe because of its hilly contours, maybe because of its wide streets and open spaces, maybe because unlike other cities it is not dominated by high-rise buildings, the sky seems grander and more pervasive. The heaving metropolis changes its atmosphere and colour with every flicker of sun or cloud, night

and day, the pale stone of the old churches turning to golden sand in the rain, or silver by the light of the moon, the pavements altering from matt grey to gleaming black as the rain washes over them. And the new buildings – the Castle Mall, Chapelfield, the Cathedral Refectory, and, grander than all these, the magnificent Forum – are all designed to let the sky penetrate in a way which never happened with local buildings in past centuries.

The behaviour of the people is also altered by the moods of the sky – treading cautiously on snow-covered pavements, rushing to get into shops and out of the rain, or enjoying a pint of beer in the sun in the courtyard of The Bell. The summer sky encourages people to linger in the streets and become more familiar with the city's appearance and atmosphere, exploring the shops in Goat Lane, enjoying street theatre from the steps of the Forum, or strolling about the market stalls in cotton shirts or flowered summer frocks, choosing here a punnet of strawberries for tea, or there a pair of saucy summer shorts to take home for cousin Nigel.

Gazing down from the Castle Mound, or wandering around the peaceful Cathedral Close, we may sometimes pause to marvel at how this familiar but ever-changing sky has been a feature of the city since way back when. But it takes a huge leap of imagination to visualise the ancient past, when although the sun shone, and the rain fell, just as it does today, the familiar buildings and streets around us didn't exist at all. The time when this bustling modern region was just crude groups of scattered encampments along the banks of the river. When the small number of settlers lived in rough wooden huts, spearing fish, hunting wild beasts for meat, grinding between two stones corn from their scanty patches of crops. Their lives were often short and painful. They suffered from disease, warfare and poor diet, and they lived in constant fear of enemy attack for at any moment bands of invading tribes might whoop down from the hills to attack, burn, and pillage.

Worst of all, perhaps, was the fear of the great unknown, and how to appease the implacable gods. For them, as for us, the overarching sky made their days happy or miserable. The thin spring sunshine and green shoots awakened hope. The long summer evenings provided ease. The winter was a time to dread,

as the wolves on the snow-clad slopes howled for blood, and the ice-bound rivers threatened a long, slow death from starvation.

From prehistoric times, these small tribal settlements developed on the gravel terraces in the valleys of the rivers Yare and Wensum in east Norfolk. The area was densely forested, and the two rivers and their tributaries provided access routes from the coast to the interior. Norwich developed as a major centre of habitation from these early scattered encampments, which were conveniently placed above winter flood levels, but close to water supplies, and near the lowest fording point, where the Wensum offered an easy crossing from the north to the south side. West Norfolk, which had lighter soils, easier to cultivate, was initially the more densely populated part of the area, but improved tools in the Neolithic, Bronze, and Iron Age periods gradually enabled the early farmers to hack back the forests and cultivate areas for crops in the more productive soils of the eastern region.

The town of Venta Icenorum, now Caistor-by-Norwich, became the major settlement during the Roman occupation of Britain, AD 43–410. The Romans also built roads crossing the area which subsequently became central Norwich. Ber Street, running north and south of this development, is thought to have been one of the Roman routes. When the Romans returned to Italy to protect their own homeland, Saxon tribes settled in East Anglia, and relics of their occupation from the sixth century have been found near St Benedict's Gate, in the area they named 'Westwic', indicating a hamlet, or subsidiary settlement. The name also occurs in twelfth-century documents, and the 'wic' termination indicates that it originated before AD 850. The name 'Coslania' suggests a similar origin, and the present-day Coslany, on the north side of the River Wensum, seems to have been occupied by fifth- or sixth-century Saxons, burial grounds having been found on higher ground, in what is now Eade Road.

Saxon occupation has also been traced in the Cathedral Close area, adjacent to the old Holmstrete–Westwick Way Roman road. This area of settlement is close to Bishop Bridge, which formed the important river crossing in the Roman period.

The position of 'Northwic' at the centre of this fast-developing area caused it to grow in importance, as subsistence farming gradually changed through the Saxon period to the production of surplus

produce that could be traded for other goods. It was well placed for river trade via the Yare and Wensum, and the roads constructed by the Romans must also have contributed to its developing prosperity. It became an important inland port for trade across the Channel with Europe, and contacts with the Rhineland areas were ongoing from at least the seventh century, the Norwich area's broad river route via the Wensum making it accessible for the larger types of sailing ships.

The name 'Northwic' first appears on coins of the Saxon King Aethelstan I of England minted between 925 and 940. As noted above the 'wic' suggests that this hamlet, too, originated before 850. Its actual location remains controversial, but, as it grew in importance, its name was eventually adopted for the entire group of settlements around it. The Aethelstan coinage suggests that by 925 these settlements were governed by a single administration, and by 1004 Norwich was described in the Anglo-Saxon Chronicle as a borough, that is, a fortified town with municipal administration.

Historians suggest that it 'is impossible to give any coherent picture of late Saxon Norwich until the eve of the Norman Conquest'.[1] The Domesday survey of 1086 compares the situation just before the Conquest with how things had developed following Norman rule. It indicates that Norwich had its own administration separate from the rest of the region by 1065. The inhabitants of the borough were not self-governing but paid rents and taxes to a royal official, the King receiving £20 per annum, and the Earl of East Anglia £10. The total population was about 5,500, and the community was divided into three lordships for judicial purposes, the tax-paying burgesses forming rather more than a quarter of the residents. The largest group of inhabitants was responsible to Edward the Confessor, while smaller percentages were responsible to King Harold, a former Earl of East Anglia, and Stigand, Archbishop of Canterbury, who had formerly held the see of East Anglia.

Evidence suggests that the borough at this time was smaller than the city later contained within the medieval walls. It was probably protected by earthworks, ditches and banks surrounded by wooden palisade fences. The prosperity of the community is indicated by the number of churches listed in the Domesday survey, at least twenty-five, although estimates vary, as it is not possible to identify all of them.

# 1

# 1066–1200

## 'Assailed with indiscriminate revenge'

This chapter focuses on the lives of three people who achieved prominence in the city, for very different reasons, during the formative years of the Norman Conquest. A young bride, besieged in the Castle by the King's forces. The charismatic founder of the city's great Cathedral. A young boy tortured and killed, for which a racial minority was blamed and victimised. These stories throw light on the tensions and problems, but also the remarkable innovations, which affected the Saxon community as they slowly came to terms with the new governing class.

The Norman invasion under William the Conqueror in 1066 was a massive shock for the Saxon community. In Norwich they had gradually been developing their own ways of governing, building, living and trading within the developing burgh. Now they were under the domination of a fierce and autocratic race, whose ways were alien to them and whose language they could not understand. There may have been small and sporadic attempts at fighting and resistance but these were swiftly and savagely suppressed. So after a while, scarred and subdued, the Saxon people settled down to endure the new regime as best they could, gradually accommodating to being a conquered race and doing what they were told.

One of the first things they had to get used to was forced labour. They were conscripted to assist with ambitious building programmes, which the Normans were very skilled in undertaking. King William was keen to see a castle or fortress established in

every sizeable town, both as a protection for the new governors, and as status symbols to demonstrate their superiority to the conquered race. It also created a degree of community cohesion. The Saxons, once they had grown less disgruntled, could see how their manpower could help to make their place prestigious, prosperous and safe – even if it was forced labour. And generally, as long as they had shelter, warmth and food they remained reasonably contented. From the Norman point of view there was the benefit that if their subjects were kept busy with building works and other activities, there would be no time to organise rebellions. So it was quite a cunning plan, making people do what you wanted them to, in the belief they would thank you and be grateful in the end.

The Castle and the Cathedral were the two significant buildings to be commenced during the eleventh century. And Norwich is unthinkable without them. They dominate the city scene today just as they did when they were first built over 900 years ago. They have a less overwhelming impact today than they did originally when they towered above a more compact centre consisting mainly of small residences and stalls, for during the centuries, larger building developments have encroached around them. Nevertheless, wherever you walk in the city you are likely to see one or the other popping into your line of vision, rearing up like solemn giants above the rooftops. To stand in front of them is to gawp in wonder at their grandeur and massive solidity. The Normans created structures that not only inspired awe and fear among their conquered subjects but, despite all our advanced modern technology, continue to amaze us today.

The most recent great building in the city, the Forum in the market centre, commands an impressive view of both the Castle dominating the skyline and the Cathedral spire soaring into the blue beyond. They were intended to dominate, because the Cathedral was built to the glory of God and to point humans in the direction of heaven, while the Castle was the headquarters of the governor, and a stern reminder that the Normans were now in charge.

The building of the Castle preceded that of the Cathedral, because Norwich did not become the seat of a bishopric until

1094, and also because William the Conqueror declared it an imperative. The residential areas in the Saxon period must have been protected by earth mounds, ditches and wooden fences, but Gyrth Godwinsson, a brother of King Harold, and Earl of East Anglia, had an official residence in what is now Tombland, which was strongly built for defence, perhaps of rubble and flint, or maybe timber like most other buildings of the period. The Castle, commenced shortly after the Conquest, was probably a timber structure with defensive embankments, thrown up as quickly as possible for defence purposes.

The building of the mound on which the Castle was sited commenced in about 1067, and it became the largest castle motte in the country. It was positioned not in Tombland, where Gyrth Godwinsson's palace stood, but on a more strategic site where it overlooked the main roads running east–west and north–south through the centre. It also created the focus from which the Norman borough developed, later including the development of a new market trading area.

The timber fortress seems to have served the invaders well enough while they were establishing their authority among the conquered populace. In 1075, it was sufficiently strong to withstand a siege after the Norman governor, Ralph de Guader, had hatched a plot that caused the King's wrath to descend upon him and his fellow conspirators.

Ralf had been appointed Earl of East Anglia by the King, in 1071, shortly after the Conquest. He was also constable of Norwich and occupied the newly built Castle. The Domesday Book states that it was Ralf who created the 'French Borough' thought to be in the Mancroft area. It featured a large rectangular market area, and two main streets, known as Upper and Lower Newport, leading west from the centre. In 1086, there were forty-one French burgesses in the new settlement, and eighty-three other inhabitants. At the time of the Conquest, although Norwich formed a single borough for administration, it still contained three distinct areas relating to the original settlements, but the new 'French Borough' by the mid-twelfth century became the focus around which a more unified community developed.

Earl Ralph held the most prestigious role in the region, with the blessing of the monarch. His position placed him in charge of the prosperous developing areas of Norwich and the East Anglian countryside. But he was ambitious, and eager for even more power and wealth. King William was often obliged to return to his homeland in Normandy to deal with property and disputes, and it was during one of these absences that Ralph took the opportunity to gamble for high stakes.

He had formed a family alliance with Roger Fitzwilliam, Earl of Hereford, by marrying Roger's sister Emma. The wedding took place at Exning, near Newmarket, in 1075. Among the many wealthy and prominent guests was Waltheof, Earl of Northumberland. Fired by drink, meat, music and merriment, the three men found each other good company, and discovered they had much in common, not least an ambition to increase their power if fortune should favour them.

Between them they owned the greater part of the north, east, and west areas of the country. They now hit upon the idea of extending these by jointly raising an army to seize the King's lands as well (while he remained absent and powerless in Normandy), realising that if they acted swiftly, it would take some time for William to get back to England and rally an army against them.

It seems that Roger Fitzwilliam was the first to set the plan moving, by returning to Hereford to organise forces, and to prepare for battle. Meanwhile, Ralph dallied at Exning to prolong the pleasures of his honeymoon with Emma for a while longer. Waltheof, who, it seems, may only have been pretending to support the plan to trick his new acquaintances into treason, immediately made contact with Lanfranc the Archbishop of Canterbury and a loyal supporter of the King.

In a short time, Lanfranc and Waltheof mustered a small army. Roger and his supporters were taken by surprise in Hereford, seized and taken prisoner. Earl Ralph was fortunate in not having raised an army quite so soon; but now Ralph was identified as a traitor, Waltheof organised a party of henchmen to intercept him and his wife and retainers as they were returning home in unsuspecting gaiety from Exning. They managed to escape and

get back to Norwich. But Ralph now had a ransom on his head and urgently needed to raise his own fighting force to prepare for retaliation by the King's own army seeking revenge. He therefore made arrangements to depart for Denmark, where he planned to raise a force of Scandinavian warriors, leaving Emma behind in his Norwich fortress to await their return.

It seems an odd decision. He must have realised that he would be absent for some time as the victim of tides and winds in those far-off days of slow sea-travel. During his absence his enemies would be sure to attack his property and seize what they could – maybe including Emma. Perhaps he felt he had sufficient supporters in the city to defend his fortress. Perhaps he thought he had no other alternative. Perhaps he was a coward who just wished to escape safely abroad until the hue and cry had died down. Or maybe he just wasn't very bright.

Whatever his motives, the result was that his new young bride became a prisoner in the Castle, awaiting the almost inevitable attack from those loyal to the King. There was little she could do, other than supervise the work of the servants – those, that is, who had not already escaped back to their own homes – or work at her embroideries, the main pastime of ladies of noble birth at the time. Each day she would sit gazing fearfully out of the narrow slit windows in the walls, watching to see what happened outside, and whether there was any sign of the approach of the King's men, or her own husband with his supporters.

The city Emma gazed down upon was very different from the view from the Castle Mound today. The region was largely undeveloped, with areas unoccupied by properties of any kind. The winding curve of the river was visible, fields where corn and crops grew, meadows where beasts grazed, and beyond were dense forests where wolves howled fearfully as winter drew on. The shape of the landscape was more apparent, with its contours of hills, before it was cloaked in buildings: for Norwich is one of the hilliest cities in England.

But the area was developing fast under Norman rule, so Emma could amuse her time by watching the many and varied activities. Sailing vessels of all shapes and sizes, ranging from ships delivering stone for new buildings to small fishing boats,

travelled slowly along the rippling current. On the landing stages she could see little pin men loading and unloading, and goods being piled in wagons or handcarts to be wheeled off to where they were needed. The city at this time imported pottery from the East Midlands; millstones, swords, pottery, wine and wine vessels from the Rhineland; luxury goods from Scandinavia and Russia; walrus ivory from Scandinavia; and fine woollen cloths from Flanders – all unloaded at the Norwich quays. Much of it was destined for the market area in the new 'French Borough' that Emma's husband had been supervising in the new city centre, quite close to her line of vision.

It was developing around what is now the site of St Peter Mancroft church. Another church stood there when Ralph arrived in the city. Emma could see the large rectangular trading area, with its stalls laid out in rows, and packhorses with wagons, and men with wheelbarrows and handcarts trundling their fish, meat and corn around, and many customers from the city and the countryside around, flocking to buy. And she could see the two main roads leading from it into the open countryside, now Bethel Street and St Giles.

Apart from this busy trading area, by the late eleventh century the city had a growing and diverse community, a network of streets and roads had been constructed, and the view before her was also dotted with a large number of churches – between twenty-five and forty for a population of about 5,000–10,000 inhabitants.

At this time the main area of occupation still lay south of the river, and the area that is now Tombland comprised the Saxon trading area – still busily in use among the 'locals' – and was dominated by the former Saxon earl's palace, as well as a major church, St Michael's.

The Castle had been sited to survey the main thoroughfares running through the district, so Emma could see the constant passage of foot travellers, traders, horses, and wagons. But although there was much sign of new prosperity, there was also evidence of the devastation caused by the Norman invasion. Many of the leading Saxon burgesses had fled, leaving houses empty and property untended. Some of the primitive hovels in which

the poor lived, constructed of wood or wattle and daub, were now vacant, so there were many empty plots with remains of scorched earth and burnt-out buildings. She could also see bits of the industrial areas, two water mills by the river for the grinding of grain, pottery kilns, iron smiths smelting ores dug from the river gravels to make weapons and tools. All these businesses, and all the households, had their own hearths and fires causing numerous spumes of smoke to ascend in the air, blowing north or south, up or down as the wind changed direction, grew strong or light, or fell still.

So Emma watched and waited. The long nights were the worst, when darkness fell and she was alone in her chilly bedchamber, trying to sleep but too anxious about both the fate of Ralph and what would happen when the long-dreaded attack occurred. Is that a heavy hand, rattling the latch? No. Silence. A rat maybe, scrabbling in the eaves. But the mornings were as bad, when she woke and remembered afresh what a terrible predicament she was in. There were rumours that she and those with her would not gain support from the local people.

Some of the Normans swore loyalty to Ralph, their leader, but others felt that loyalty was due to the King, and feared what revenge his forces would take once they arrived to storm the Castle. And the native Saxons, although they were getting accustomed to the new order of things, after ten years of foreign rule, were still aggrieved by what had happened, remembering the slaughter of relatives and neighbours, the destruction of homes, the forced labour, and the insult of having to waste time working on Ralph's ridiculed 'French Borough'. No, she could hope for no support from the Saxons. And who could blame them?

Sometimes, as she lay awake in the long dark watches of the night, Emma felt like a princess waiting for her handsome hero to arrive and rescue her. Each night she knelt and prayed to the Virgin Mary and saints embroidered on the silk hangings of the chapel shrine, that this would be the favoured outcome. But this was not a fairy tale, and there was to be no happy ending.

Only a few weeks previously she had been so happy, all faces smiling upon her as the Earl's bonny bride, and the joy of feasting, music and dancing and the first night of passionate lovemaking

beneath the embroidered counterpane – when his beard tickled her and they both laughed and renewed their lovemaking with even greater intensity. And then she wept bitter tears. For now, all was changed, utterly. A terrible fate seemed to be creeping up on both of them. And all due to her husband's foolish conspiracy.

Long before Ralph was able to rally a force of Scandinavian mercenaries, the King's supporters arrived, on horseback, dragging the weapons of war on wagons or sleds behind them, then preparing for an attack. They encamped some distance away, because the Castle had a wide defence work of fences, mounds and ditches, and if they approached too close at this juncture they would be an easy target for Ralph's men, lined up with their bows and arrows, giant catapults and slings at the ready.

For three months his small number of soldiers and servants managed to protect the Castle from invasion. At last, worn down by hunger and thirst as supplies diminished, they were obliged to surrender.

Emma, as a woman and a relative of the King, was saved from immediate punishment. She was given forty days to escape from the country. If seized after that time, she would be sentenced for treason and perhaps the death penalty. She took a ship to Brittany, where she was reunited with Ralph. All his lands and possessions in East Anglia were seized by the Crown. It seems that they remained in Brittany for twenty years, and eventually, as Ralph became bored and ready for new adventures, both of them departed for Jerusalem, where Ralph joined the First Crusade.

Emma did not wish to be parted from her husband again, and, having endured all the terrors of the Norwich siege, felt that little could daunt her spirits now. In any case they owed it to the Lord God to help protect His Holy Land in thankful piety for Ralph's escape from a grisly death. He died somewhere in the Holy Land. Of Emma's demise, nothing is known.

It had been an extraordinary time for her in 1075, married, besieged and exiled all in a matter of a few months. But the real victims of Ralph's vainglorious and reckless action were the people of Norwich. On the King's eventual return from Normandy, Norwich 'was assailed with indiscriminate revenge', as the writer of the Anglo-Saxon Chronicle reported. The city

was ransacked, many innocent people were killed, and all their possessions were confiscated. Even more, the local people had cause to hate and resent their new masters. The Domesday survey of 1086 reveals that in what had been a prosperous borough, the number of burgesses wealthy enough to pay tax had been halved, several had fled to Beccles and other towns in the region, and the majority were financially ruined. There were abandoned properties throughout the borough.

Even Earl Waltheof suffered the King's revenge for his part in Ralph's plot. He was beheaded, in 1076, on St Giles' Hill near Winchester. Roger Fitzwilliam was heavily fined and had all his lands confiscated.

Although only a timber fortress in 1075, the Castle was clearly strong enough, and strongly manned enough, to withstand the three-month siege. The new earl and governor appointed by the King to succeed Ralph was Roger Bigod.

The building of a stone keep, the Castle we know today, commenced in about 1094, and was completed by 1121. It was during this period, as the community settled down again after the King's savage revenge, that the other great Norman edifice, the Cathedral, was built.

The massive bulk of the stone-built Castle perched atop its mighty mound continues to dominate the centre of the city today. Although it stands a little distance apart from the busy market area, it looms directly above the Castle Mall, and Castle Meadow, which curves around the mound, is also a busy shopping area and a main thoroughfare for buses.

To walk from this area to Tombland, and to the Cathedral Close, is to experience a profound change in the atmosphere of the vibrant, humming city. For as you proceed in that direction along London Street, or from Castle Meadow into Bank Plain or Upper King Street, you are turning away from the main commercial centre, the crowds of shoppers and the roar of traffic, into a more gentle, tree-lined environment dominated by two impressive medieval gateways, with a partial view of the Cathedral spire looming into the sky. It is an area that seems to be ruminating on its past rather than noisily engaging in the hurly-burly of business and entertainment, as the city centre does.

This is Tombland. When you arrive, you feel as if you, too, have travelled back in time to a more olde worlde environment, like a scene from a Trollope novel. Where the mind has more freedom to absorb the atmosphere, fewer crowds to navigate around, and fewer shops to beguile and distract. It's a mixture of features, dominated by restaurants – for this is the city's upmarket dining area, with Zizzi's, Café Uno, Tatler's and several others – but also a few business offices, an estate agents, a pub, and the Tombland Bookshop, which always has a tray of cheap volumes outside to browse through, and has just the right character for the Trollopesque setting. There are quaint old public lavatories into which you descend from cobbled pavements, and for the newcomer, the inviting mystery of what might lie beyond the ancient stone gateways.

A bit further along, facing towards the Cathedral's west front, the giant figures of Samson and Hercules continue to guard the front porch of the building that has been an entertainment centre for maybe a hundred years. Half-clad pagan figures facing the Cathedral gates? Tut, tut! The building once had a heated swimming pool, displayed antiques, and was a popular dance-hall when music rhythms changed from the waltz to the tango, the jive and the twist. Many older residents will remember Saturday nights there as the best times of their lives.

This is in fact the more historic core of the city. Tombland was the original market area of the Saxon community, but the whole site was cleared in 1096 to provide space for the Cathedral, and create a wide open area around it. Its historic associations, chequered and at times violent, seem to linger in the atmosphere, but peacefully now, like an old man dreaming. Also, perhaps because you have wandered into it from more crowded thoroughfares, it assumes an air of wistful melancholy, as if, despite its adventurous past, it is now forgotten. This is also the case if you wander further along Wensum Street and into Magdalen Street, where you may feel that you had somehow strayed away from the great city of Norwich into a much less prosperous place.

But this is one of the things that makes Norwich so fascinating. You only have to wander a short distance from the centre into the

narrow side streets, and like Alice disappearing down the rabbit hole, you soon find yourself inhabiting very different aspects of 'Wonderland'.

Hidden behind a row of smart restaurants is the Cathedral Close. It can be entered by the quirkily decorated Ethelbert Gate (matched only by the equally flamboyant Guildhall in the Market area) or by the west front through the more sober Erpingham Gate. The Ethelbert Gate, *c.* 1316, is the sort of structure that, if it appeared in the Close today, would provoke 'Outraged of Costessey' to fire off a letter to the *Eastern Daily Press*, and the avant-garde would describe it as 'brave'. But what can seem like a grotesque carbuncle when new can mellow into something more endearing and quaintly eccentric as the years move on. Even so, in the sedate atmosphere of Tombland, the Ethelbert Gate looks as startling as a punk rocker at a cathedral synod. It was built by the people to placate the Prior after a town and gown battle. Were they deliberately cocking a snook? Difficult to tell now, because its bizarre starry headdress was restored in the nineteenth century.

The Erpingham Gate is a very different affair and could offend nobody. Compare Erpingham with Ethelbert, and it's like the difference between a Crome painting and a Jackson Pollock. Among its sculptured features is an image of the man whose name it bears, Sir Thomas Erpingham, kneeling in a niche. Some say he is kneeling in penance and was obliged to build the gate by Bishop Despencer as a punishment for advocating leniency to the Lollards, whom the warrior bishop sought to savagely suppress. But this colourful story is now scoffed at. The gateway, affirm the historians, was built by Erpingham to celebrate the famous victory at the Battle of Agincourt, 1415, in which he fought, and for his own safe return to his house on Palace Plain just around the corner. And his kneeling stone figure was probably made for the chantry chapel in the Cathedral, where he lies buried, and was therefore not designed for the gateway. Whoever designed the gate obviously had no wish to outshine the Ethelbert style, which remains one of the most splendid attractions of the Close. And of Norwich.

The Erpingham Gate leads towards the west front of the Cathedral and from this aspect the building looks rather narrow

and unimpressive, not much larger than a traditional parish church. But it features two fine broad-winged angels above the door, and on either side, in the alcoves, Mother Julian, the fourteenth-century mystic clutching her book, *Revelations of Divine Love*, and on the opposite side, St Benedict with a shaven head, holding one finger to his lips. This indicates the vow of silence pertaining to the Benedictine priory once attached to the Cathedral church. But it looks as if he's playing a game of hide and seek with Mother Julian, and murmuring 'Hush' to us not to reveal his hiding place.

To view the magnificent Cathedral in all its splendour you have to walk through the Close to the east end, where you can see the massive length of the nave in relation to the spire soaring into the heavens like a glowing altar candle. On a clear day when the sun is shining and the sky is blue, this is one of the most breathtaking sights the great city has to offer.

The Cathedral is a fascinating building, but just as fascinating is the man responsible for building it. Herbert de Losinga was born at some point between 1050 and 1060 in Normandy and was educated at the local monastery of Fecamp. It is thought that his father, Robert de Losinga, may have travelled to England with William the Conqueror. Herbert had already become acquainted with the King and his son and heir, William Rufus. They recognised the young man's abilities, and he was chosen as their royal chaplain. When he, too, settled in England he was appointed the Abbot of Ramsey in the Fen district.

In 1091, he was offered further promotion when the bishopric of Thetford in Norfolk fell vacant. A large fee of about £1,000 was due to the King in return. Herbert paid it, because he was keen to secure so prestigious and lucrative a position. However, such payment constituted the ecclesiastical sin of simony – that is, buying or selling a religious post or privilege – so in order to clear his conscience and his character, Herbert travelled to Rome to seek forgiveness from the Pope. During their meeting, he was also bold enough to ask if the bishopric could be transferred to the more prosperous and rapidly expanding city of Norwich. The Pope, obviously as impressed with Herbert as the King had been, agreed.

It was perhaps as part of his penance that soon after being installed as Bishop, Herbert made plans to build both a cathedral and a Benedictine priory to accommodate sixty monks. The building work probably commenced in about 1094, and the foundation stone was laid in 1096, at the base of the Lady Chapel at the east end of the building. Herbert, with his winning ways, was given gifts of money and land from wealthy local people. The site of Tombland, as already mentioned, had been the Saxon trading centre. It was on a main road network, and conveniently placed near the river for the easier conveyance of building materials. A canal dug from the present Pull's Ferry to the Lower Close also speeded things up. Apart from Caen stone from Normandy, Barnack stone from Northants was shipped in, and Roman bricks were used from the Roman settlement at Caistor-by-Norwich.

Bishop Herbert liked to get his own way, regardless of opposition, or what upsets he might cause. The development of the site involved demolition of the houses of the Saxon inhabitants, causing grief and anger. He had negotiated the acquisition of the site from Roger Bigod, the new governor of Norwich who had succeeded Ralph, so the local people had little redress. As they saw it, it was simply the appalling Normans trampling them into the muck again. A sort of Baldrick and Blackadder relationship, as lovers of that great TV comedy series will appreciate.

The buildings destroyed to create the new area named Tombland also include the palace of the Saxon earl Gyrth Godwinsson – no doubt of revered memory to the Saxon community – and the church of St Michael. It's thought that the church of Holy Trinity, owned by the Norwich burgesses in 1066, may also have been demolished and lies buried beneath the north transept of the Cathedral. The homes of the poor near the river were also swept away. These buildings were just obstacles in the way of progress to the Normans, but to local inhabitants they were not just their homes and important communal buildings, but part of their identity and heritage. In fact, exactly what the new lords wished to exterminate. The Saxons must learn to become Normans in a new, united city.

Bishop Herbert also organised the building of St Leonard's Benedictine priory on Mousehold Heath as the residence of

Prior Ingulf and his monks until the Cathedral priory was completed. In 1101 the new building was sufficiently developed to be dedicated to the Holy Trinity. It is thought that the choir, presbytery and part of the nave were completed by the time Bishop Herbert died in 1119. On the north side was the Bishop's Palace, nearly completed before he died, and on the south side the Benedictine priory to house Prior Ingulf and his sixty monks. Bishop Herbert was buried in a sarcophagus in front of the new altar. His cathedral, when completed in 1145, was not only the largest and grandest building in East Anglia, but also one of the major Romanesque buildings throughout Europe. The King and the Pope had done well in recognising the potential of the young man, for his cathedral remains the supreme legacy for Norwich.

The Anglo-Saxon Chronicles describe Bishop Herbert as being 'handsome in his person and of bright countenance', even in middle age, and it is clear that he had a charismatic personality. We learn quite a lot about him from his letters.[2] They show that he based the organisation of his new priory on that of Fecamp in Normandy, where he had been educated, and also that he took a keen interest in its development and the welfare of his monks. Despite his busy role as bishop and in organising building plans, he chose to take a personal interest in the education of the young novices, and encouraged them to read and write Latin verse.

During one of his absences from Norwich on business, he commanded his pupils: 'Youths – submit humbly to the correction of your schoolmaster, and when absent from me, prepare suitable answers to the examination which I shall hold when I am with you again.' He chided two of them, Otto and Willelm: 'I am sick of your delays – the fear [respect] in which you stood of me seems to have vanished; you were wont to supply me with four or five hundred lines once in every two or three days; now at the expiration of two or three months, there came twenty or thirty verses as inferior in polish as in number.'[3]

In the Benedictine monastery, the daily discipline was strict. The monks had a strict routine divided between prayer and work, both day and night. They were awakened by the prior at 2 a.m.

in the morning for Matins and Lauds. They then returned to bed before arising again for another service, Prime, at dawn. The time of Prime would vary depending on sunrise between winter and summer. It was followed by a breakfast of bread and wine in the refectory, then Chapter Mass, then to the Chapter House to discuss the business of the day. This was also the occasion when punishments were dealt out to any brother who had been disobedient or lax in his religious duties. These could be severe, and included a strictly rationed diet, a flogging, and, if the bad behaviour continued, expulsion.

At 11 a.m. High Mass was celebrated in the Cathedral, then the brothers returned to the refectory for a vegetarian meal of bread, cheese, vegetables, perhaps fish. The afternoon was occupied in manual work, gardening, cooking, brewing, copying manuscripts or creating coloured illuminations for the texts. At six o'clock, they were back into the Cathedral for Vespers, then supper, after which Compline was chanted, and then to bed in a communal dormitory at about eight o'clock, when they could enjoy about six hours' slumber before being wakened for Matins, and the monotonous daily round commenced all over again.

For young novices, often compelled by their parents or guardians to enter the monastic life, the routine and discipline could be irksome, and no doubt they were often disobedient and got into scrapes, and were punished accordingly. But it was not an arduous life and in many ways preferable to what they could expect in the harsh everyday working world beyond the priory walls. After a time, once they settled down into the routine, and if they were of a religious inclination with a desire to spend time in the worship and contemplation of God, they could gain much enjoyment and satisfaction in their chosen way of life. They could also be assured of entering Heaven's gates, at last, as a reward for their virtuous lives, there to meet their Maker face to face, and join the everlasting throng of saints and angels surrounding His throne.

Not all could adjust to the strict way of life. Bishop Herbert refers in his letters to one monk, Godfrey, whom he deemed unlikely to enjoy Heavenly bliss. He writes to him in stern tones, following an adverse report from the Prior:

You are, they say, seldom seen in the cloister, often in the parlours;
slow in resorting to the church, swift in resorting to the grange and
to the public roads which skirt it; you are constantly getting leave
to have your blood let, constantly getting leave to have a bath ...
Is this the recompense which you pledged yourself to make for the
love shown you, in receiving and sheltering in God's house your
aged father, and your son of seven years old?

This letter makes it clear that charity was a strong aspect of the
Benedictine way of life. Here was a monk who had either been
married or had an illegitimate child before being admitted to
the priory, and the Prior and Bishop had been compassionate
enough to offer a home to his aged father and child as well. The
monasteries and convents of the medieval period were one of the
many sources of charity for poor people and those who had fallen
on hard times. But they expected beneficiaries to be grateful and
reward kindness with obedience and respect.

The rules of silence and of chastity were difficult to enforce:
'I do not lay upon you a burden which your shoulders cannot
bear ... You are free to talk in your cloister, but only at the
stated and customary hours.' With regard to lust, Herbert wrote:
'I hear there are some who are shocked ... who find fault with
the severity of the penalties I inflict.' Monks might often take
advantage of sexual activities with each other, or with female
servants or visitors should the opportunity arise – even perhaps
with prostitutes, who could be smuggled into their dormitories
when the Prior and Bishop were absent. This explains Bishop
Herbert's mention of 'penalties', which it is clear were inflicted
and resented. Both ecclesiastical and secular law punishments in
earlier periods of history seem shockingly extreme to us today;
but it was believed that after death, punishments inflicted in Hell
would be even severer, and if punishments in the earthly life
could prevent that, especially for monks dedicated to the service
of God, then harshness was justified.

Nor was it just high jinks in the dorm at night that incurred
the Bishop's wrath. He grew annoyed that, during his absence,
the work of building the Cathedral was not proceeding as quickly
as he would wish.

He writes in a letter to the monks, 'The work drags on and in providing material you show no enthusiasm. Behold, the servants of the king and mine are really earnest in the works allotted to them. They gather stones, carry them to the spot ... You, meanwhile are asleep with folded hands ... failing in your duty through a paltry love of ease.' So it seems that when they were not engaged in prayer and penitence, and their regular monastic duties, they were expected to be builder's labourers as well. Becoming a monk was not quite the easy option they anticipated when they signed up as fresh-faced young novices.

Still, Herbert's Cathedral was eventually built, and there must have been several monks who lived to see it completed, and were proud to announce when the last stone was laid, 'I helped build it you know.' They are all forgotten now. Only the fame of Herbert de Losinga survives.

According to the chronicler William of Malmesbury, the Jews arrived in England from France with William the Conqueror. They settled mainly in the present White Lion Street and Haymarket areas situated between the Market and the Castle sites, their dwelling-place becoming known as the Jewry. They remained a minority group, and prospered by lending money – an occupation forbidden to Christians. Among their profitable business in the city, they provided loans to pay for the building of the Cathedral. The community was protected by royal officials, because they were the 'king's chattels', very necessary to the royal finances.

Their place of worship, the synagogue, probably stood close to Dove Street. The most prosperous of the Jews were the Jurnet family, who had a flint-built house in King Street (a little distance away from the Jewry) built by 'Jurnet the Jew' in about 1175. His son, Isaac, is said to have become one of the wealthiest Jews in England. The property later became known as the Music House, and the original medieval undercroft still survives.

In 1144, members of the Jewish community were accused of the ritual murder of a boy aged twelve, who was later to be canonised by the Catholic Church as Saint William. A detailed account was written by Thomas of Monmouth, it is thought about thirty years after the saint's death. Thomas was a monk in the Benedictine priory, probably between 1150 and 1174.

M. D. Anderson, who provides a detailed history of the circumstances of the boy's death in *Saint at Stake* (1964), concludes that although Thomas was writing about the savage torture and death of a child, in a highly superstitious age, and when the tradition of recording the lives of saints tended to exaggerate the miraculous aspects, 'One gets the impression that he tried to record faithfully what had happened ... and was at pains to collect and check the testimony of other witnesses.'[4]

Thomas's opening sentence affirms the belief of his contemporaries, that the boy's death was predestined:

> The mercy of the Divine goodness desiring to display itself to the parts about Norwich, or rather to the whole of England, and to give it in these new times a new patron, granted that a boy should be conceived in his mother's womb without her knowing that he was to be numbered among the illustrious martyrs.

Thomas was clearly proud that his own city of Norwich should be blessed with a new saint, despite the horrible circumstances of the young boy's death. He begins his narrative by telling us that William was born the son of Wenstan and Elviva on Candlemas Day and was baptised at Haveringland, only a few miles from the city centre, and presumably also his place of birth.

His father died while he was still young, but he was educated by his mother, who had acquired learning from her father, who was a priest. When he was eight years old, he was taken to a skinner near his home to learn his trade. Thomas of Monmouth says, 'In a short time, he far surpassed lads of his own age in the crafts aforesaid, and he equalled some who had been his teachers.'

William then moved to the city to join the workshop of a prosperous master of the trade. The skin, fur and leather trade was an important industry for the city, serving the demand for products such as clothing, shoes and bed coverings. Leather was the most hard-wearing fabric available, so leather jerkins, breeches, aprons and caps were the normal wear for most manual workers. It was the custom for young unmarried employees to live with their master, often being obliged to sleep on the shop

floor in order to help protect the property from break-ins and theft. The area that William moved into was the Jewry, so it seems that both Gentiles and Jews were accustomed to work and trade alongside each other rather than being segregated.

William was well liked by his new neighbours, and by the customers, many of whom preferred to deal with him when they brought in their orders for leather goods. Because the boy had settled in so well, what happened next is even more shocking. Thomas, in his narrative, relates that the Jewish community believed they would never gain freedom or be able to return to their homeland unless they made an annual sacrifice of a Christian, in mockery of Christ. Where Thomas got the idea from we don't know. It was probably just malicious talk circulated by gossips who envied the prosperity of the hard-working race.

But Thomas goes on to report that at the beginning of Lent, in 1144, the Jews decided that William should be their victim. His young age made him an easy target, and, as a bright and attractive child, he seemed an ideal sacrifice to propitiate their God, and gain them the release from persecution they so strongly desired.

At daybreak on the Monday commencing Easter week, a messenger was sent to William, 'with cunning wordy tricks', informing him that the cook of the Archdeacon of Norwich wished to employ him in his kitchen. It was a good offer, and if William agreed, would provide him with more money and better prospects than if he remained in the skin trade. William was delighted, but being a sensible lad, first sought his mother's advice. Elviva suspected some mischief afoot. She mistrusted the messenger and pleaded with William not to go, 'but, partly overcome by her son's prayers, and partly seduced by the man's fair promises, at last was compelled against her will, to give way'. She was rewarded with three shillings, which must have gone a long way towards changing her mind, as it was a large amount of money for a poor widow.

William's aunt was also suspicious when she heard the news, and told her daughter to follow the pair as they departed for the city. The daughter did as she was told and was able to report that they returned to the area where William had been employed, and

disappeared into the house of the Jew called Eleazar. The next day was the Jewish Passover. The Jews celebrated the day with the customary prayers and hymns in their synagogue, and then returned home. Their chief members, however, made straight for the house where William was staying. He was peacefully eating his dinner when they suddenly seized him and commenced a series of tortures clearly designed to imitate the sufferings of Christ on the cross. They bound a spiked strap tightly around his jaws and neck, so he could not cry out, and a knotted cord was bound tight around his forehead. Then they shaved his head, and stabbed him with thorns, and bound and nailed him to a wooden cross, in a mock crucifixion. They also inflicted a wound in his side, like the one Christ suffered from the spear of a Roman soldier. After some time, due to loss of blood and his other injuries, the boy died.

Having carried out this cruel deed, the Jews realised that they must conceal the body away from their dwellings, for if the body were discovered in the Jewry, they would suffer a terrible retribution from the angry Christian citizens. They bided their time until Good Friday, when they thought that there would be fewer people out in the streets to notice them, and two of their number were chosen to carry William's body, concealed in a sack, on the back of a horse. A forest seemed the best hiding place, so they made their way to Thorpe Wood on the outskirts of the city.

Unfortunately for them, as they were entering the wood, they were accosted by Aelward Ded, a prominent citizen returning from a visit to the church of St Mary Magdalen nearby. He recognised them as from the Jewry, and wondered why they were far from home on a day when it was not the custom for Jews to leave their houses. Noticing the sack slung across the horse's saddle, he asked the men what they were up to. He grew suspicious enough to start groping around the sack and became convinced that it held a human body. At this, the two Jews 'in their terror not having anything to say, made off at full gallop and rushed into the thick of the wood'.

Surprisingly, Aelward did nothing – he may have been in a hurry to get on with his business of visiting all the city churches during Holy Week. In any case there was little he could do in the

circumstances – for, if he chased after them, being one against two in a dark wood with no one around to assist him, his own life might be at risk.

The Jews, now much frightened and acting in haste, simply hung the body in its sack on a tree in a wooded thicket and galloped home as fast as they could go. Aware that Aelward was now suspicious, their leaders decided that their best course of action was to gain the support and protection of the City Sheriff, John de Caineto, who, as the king's representative, was obliged to act on their behalf. He had proved supportive in previous incidents when they had been threatened or intimidated. They paid him a visit at the Castle, and promised that if he would assist them they would present him with a gift of a hundred fine mares. John was clearly not horrified by their admission of child-murder, as might be expected, but, wooed by the promise of the hundred mares, ordered Aelward to come to him immediately. He was sternly instructed to take a solemn oath not to divulge anything that he had observed in Thorpe Wood.

However, two local people, one a prominent citizen, Lady Legarda, and the other Henry de Sprowston, Keeper of the Bishop's stables, had already discovered the horribly mutilated body as they were walking through the wood. The news quickly spread through the city. The body was identified by William's uncle, Godwin, and Elviva, distraught on learning of her son's death, at once concluded that the Jews must be responsible. Her grief was terrible to see. As Thomas records:

> She went through the streets and open places, and, carried along by her motherly distress, she kept calling upon everybody with dreadful screams, protesting that the Jews had seduced and stolen away from her, her son, and KILLED him! ... Hearing her screams of pain, everybody began to cry out with one voice that all the Jews ought to be utterly destroyed as constant enemies of the Christian name and the Christian religion.

The discovery of the body was a sensation. A crowd of boys and young men raced to the woods to see it, and then, reports

Thomas, 'throughout the Saturday and Easter Day, all the city everywhere was occupied in going backwards and forwards time after time and everybody was in excitement and astonishment at the extraordinary event'.

Strangely, William's body was buried on the site where it was found, not returned to his mother. Godwin and the other family relatives now appealed for justice, insisting that whoever had carried out such an appalling murder must be arrested. At a diocesan synod held by the Bishop of Norwich, Godwin spoke to the assembled clergy and monks, referring to

> an outrage which has been done to the whole Christian community. I do not think it is a secret to most of you, my dear brethren, that a certain boy, a very little boy, and a harmless innocent too, was treated in the most horrible manner in Passion Week, was found in a wood, and, up to this time, has been without Christian burial.

The Bishop then replied that although those considered responsible must not be pre-judged, he would summon the Jews to a hearing on the following day, and if it was clear that they were responsible they would receive the punishment they deserved. On hearing of this summons, the Jews appealed to John de Caineto, the Sheriff. He sent a reply to the Bishop stating that the Jews would not attend because the Church had no authority over them. It was solely a matter to be dealt with by the King. He then afforded them protection from any arrest or mob attack by offering accommodation within the Castle.

There happened to be in attendance at the synod the Prior of St Pancras at Lewes, Don Aimar. When he heard the story of William's violent death, it occurred to him that it had the possibility to be transformed into a case of martyrdom and potential sainthood. For it appeared that the boy had been abused and murdered as a deliberate insult to Christ. He therefore went to the Bishop and begged to take away the boy's body to his own priory. The relics of saints were highly prized in the superstitious medieval period, and churches and monasteries could acquire huge prestige and wealth by attracting pilgrims who travelled to

worship at a saint's shrine, and seek miraculous cures for illnesses and other ailments.

This proposal caused Bishop Everard to view what had seemed a violent and disruptive catastrophe for the city in a new light. The body of the murdered boy clearly had a potential significance and value which had been overlooked. It was therefore of paramount importance that the body must be safeguarded by the Norwich monks. It must also be given a proper burial, because there had been instances of the relics of saints being robbed by other religious institutions – notably Saint Withburgha, whose body buried not far away at East Dereham had been secretly stolen away by the monks of Ely. The new Cathedral had been expensive to build and was proving a strain on the finances of the monastic community. A new shrine on the premises could prove a big attraction for pilgrims and a lucrative source of income.

So on 24 April, William's body was removed from the wood and carried by a team of monks on a bier to the Cathedral church. A huge crowd of people assembled at the city gates to cheer them in. The bier was laid before the altar of the Holy Cross in the main nave, and covered with a richly embroidered cloth. Candles were lit around it, and the monks chanted a Requiem Mass. The church was crowded with local people, and at the close of the Mass, they queued to kiss the bier on which the boy was laid. Later the body was washed, and clothed in new garments, and buried in a sarcophagus in the inner cemetery by the entrance to the cloister. It is thought that this stone coffin was probably similar to the one which stands in the north ambulatory of the Cathedral today.

The new status of the boy, and his transferral to the Cathedral, was not without criticism. There were many who felt that 'a poor ragged little lad, picking up a precarious livelihood at his tanner's business' was unworthy of such attention. In any case, the actual circumstances of his death were still a matter of controversy. In 1146, Everard retired from the Bishopric and was succeeded by the Prior, William Turbe, who had always been an enthusiastic supporter of the boy's saintly status. His views clashed with those of the newly elected Prior, Elias, who

remained cynical, and the monks probably also largely reflected his opinions.

Meanwhile, as with most medieval saintly shrines, miraculous events were experienced by the pilgrims who were starting to flock to the Cathedral. A rose bush planted at the head of William's grave continued to bloom at Christmas. A man called Lewis of Wells, suffering from a fatal illness, had a dream about the boy saint, and upon visiting the tomb was speedily brought back to health and strength. Others claimed similar amazing visions or sudden cures.

William Turbe's election as Bishop, and his belief that the Jews were responsible for the boy's martyrdom, motivated mob violence against the Jewish community. The same young men and lads who had rushed to view the boy's body at Thorpe Wood were probably now involved with the attacks. Some Jews fled, while others suffered violent deaths. One of these was Eleazar, a chief money-lender, and the man into whose house William had been lured during Easter week. Eleazar had gained the enmity of Sir Simon de Novers of Swanton Novers near Holt when Simon was pressed to repay a debt he owed him. So taking advantage of the Jew's unpopularity, Simon tricked him into believing he would be paid if he came to his house, and, on his journey, had him attacked and murdered by his servants.

The Jewish community was still expecting to receive the edict of immunity from prosecution from King Stephen. Eleazar's murder motivated them to plead for royal assistance. But although the King made some attempts to get involved, it was clear that it was a difficult matter to judge, and so, like many politicians today, he made some vague promises, but did nothing. Legally the case was dropped, with the consequence that Sir Simon was not convicted of Eleazar's murder, nor the Jewish community of the death of Little Saint William.

Thomas the Chronicler then goes on to record a vision that he personally received during Lent a few years later in 1150. In the dream, he was accompanied to Heaven by the boy William – whereupon, Herbert de Losinga, the founder of the Cathedral, appeared before them and declared:

Lo! the glorious boy William stands beside thee, the true imitator of
the Lord's Passion; he seeks to be transferred from the cemetery to
the interior of the church without any tarrying ... the place which
he has chosen for himself that he may abide in it, it is the Chapter
House, and his tomb is to be placed among the boy's seats.

When the Bishop and Prior heard of the founder's demand, they
arranged for the boy's body to be dug up and transferred to its
new resting place within the priory. William now had the status
of the first saintly shrine in Norwich: usually, only abbots or
very distinguished people were permitted burial in the Chapter
House. Nothing now remains of this part of the Norman building
to indicate where the body was newly buried. Thomas became
responsible for the care of the tomb, and was at one point advised
by another monk that William had complained in a dream about
the way in which visitors were abusing the site:

... for some presume to touch the stone of my sepulchre, or the
cloth, with muddy feet, nay, even to soil it; and the pavement round
me is defiled with the foul spittle of many. Be careful then, to warn
my Thomas, that he takes greater care of my tomb.

In fact, it was extremely necessary to keep a keen eye on visitors
because there were those who attempted to cut off bits of stone,
or fragments of cloth or wood and carry them away, believing
that they contained miraculous healing qualities. In particular,
it was believed that holy water in the font used for baptisms
was especially efficacious for healing if mixed with a little dust
brushed from a saint's shrine, or with crumbled pieces of stone
broken from the tomb. So, without efficient stewarding, there
might soon be little left of Saint William's shrine at all.

Thomas was partly guilty of this sort of behaviour himself. He
kept in his own possession, in his monk's cell, two of William's
teeth that had fallen out when his body was being transferred
from one tomb to the other, and also one of his shoes.

The greater part of Thomas's chronicle is concerned with the
miracles performed at the shrine. Many of these may have been
truly believed in at the time, but even if not, the monks and clergy

publicised them because it increased the church and priory's status and therefore the number of pilgrims travelling there with money and other gifts. The sorts of miracles that occurred throw light on the extent of disease and suffering in the medieval period in Norwich and throughout the whole country. Living conditions were similar to those existing in some Third World countries today, caused by ignorance, dirt, lack of hygiene and clean drinking water, vitamin deficiency and inadequate medical knowledge. It conveys a picture of life in the poorer quarters of the city. Many lived in little better than timber shacks, the floors of beaten earth, damp and cold, so the inhabitants were susceptible to all sorts of illness, including paralysis, arthritis, and the ague. They also suffered skin diseases due to their unhealthy diets – consisting mainly of bread and salted meat or fish, with no fresh vegetables or fruit available in the winter months to give them the vitamins they needed to stay healthy. So their skins often erupted in boils and abscesses, and leprosy was common. The Lazar House of St Mary Magdalene had been built in about 1115 especially for the accommodation and cure of lepers by Bishop Herbert de Losinga on the outskirts of the city (on the Sprowston Road) to prevent the sufferers from spreading their disease to others.

Thomas also refers to cripples, hunchbacks, the blind, deaf and dumb, and those with mental illnesses. At the time, it was often thought that mental problems were caused by evil spirits inhabiting the body and that the best cure was to beat them out, causing even more trauma and pain for the afflicted. So these were just some of the bodily ills that pilgrims flocked to have healed at the shrine of the new child saint. Because he was a child, and many children were susceptible to the illnesses outlined, they too were brought to the Cathedral for a cure. The sale of candles became an important part of the church's income. Visitors bought them to place around the saint's tomb, and it was also believed that rubbing the candles on the diseased or injured parts of their bodies could help effect a cure.

Thomas goes on to say:

Already, not only from the neighbouring villages but from those at a distance, so great a crowd began to assemble daily at the

tomb of Saint William who still lay in the Chapter House, that the brotherhood of monks who abode in the cloisters could no longer put up with the daily pressure of so great a multitude ... It was therefore decided in common council that the glorious martyr of God should be translated into the church and there laid, along with his sepulchre, where freer access to him could be provided for the crowds of people.

A place was prepared near the High Altar on the south side, and, dug up once again, there the boy's body was interred. One wonders whether Thomas took advantage of this to add a few more relics to his little collection, more teeth or a lock of hair. But even this wasn't to be the boy's final resting place. The area around the altar became so crowded that it was transferred to a chapel dedicated to the Holy Martyrs opening off the north choir aisle, an area later known as the Jesus Chapel. (Information about William is now displayed in the Chapel of the Holy Innocents.) Later, an altar was dedicated to the saint in front of the pulpitum, to the north of the central doorway, but the altar was subsequently destroyed, and the only trace of it now is the piscina on the north side of the central arch. In Thomas's account of the martyr, the last miracle he records at the boy's tomb was in 1172, and the book was completed when he wrote his prologue dedicated to Bishop Turbe, who died in 1174: so the date of publication must have been about 1172–73, approximately thirty years after the boy's death. It seems that his original manuscript no longer survives, but a unique copy, in two small folio volumes – written, it would seem, shortly before 1200 – is in the Cambridge University Library.

In the early years of William's cult as a saint, the financial offerings must have been considerable. There are no surviving records of the amounts, but by 1314, 170 years after his death, they had dwindled to only £1 1s 5d, and in 1343, to only 4d. The popularity of little Saint William had now run its course. This may have been partly due to his never acquiring official ecclesiastical recognition, nor was his name included in the calendars of saints' days, apart from the local one for Norwich itself. This lack of official recognition must have disappointed

the Cathedral monks. Another reason for his decline may be that, unlike many other saints, his name was not invoked for any particular cure, other than general healing. In a recent book recording the lives of saints, William's calendar day is entered as 26 March, and the brief entry concludes that 'his cult declined due to papal disapproval before the Reformation, and is now extinct'.[5]

In 1168, Bishop Turbe had built a chapel on the site in Thorpe Wood where William's body was originally buried, as an additional memorial for the saint. For some years it became a popular place of pilgrimage, but as William's cult waned, the chapel was neglected and fell into decay. When M. D. Anderson went to look in about 1960, she could find no trace of it, but a local historian, Mr. A. B. Whittingham, was able to point out the site, indicated only by a few grassy hummocks suggesting the original dimensions of the building. There was an outer enclosure, and it appears that the chapel was protected with a double line of ditches and banks.

Forgotten there, it is good to know that William is still commemorated in the Cathedral, where so many thousands of pilgrims believed that he could provide a cure for their ills.

# 1200–1400

'So tumultuous was the city that I meet
with many prosecutions of the citizens
for firing one another's houses by night'

One of the features that makes Norwich so appealing in character
is the way old and new buildings jostle cheek by jowl in cheerful
harmony. It adds picturesque variety to the side streets, while
the Market area is dominated by four magnificent buildings
of different periods but well spaced, so that their individual
attractions are seen to best advantage: the fifteenth-century
church of St Peter Mancroft with its elaborate wedding-cake
spire; the Guildhall (1407–24) featuring the knapped flintwork
for which Norwich is famous; the City Hall (1938), its tall, simple
brick tower contrasting with the elaborate design of Mancroft,
and dominating the brow of the hill; and the Forum (2001),
with its horseshoe shape and glass façade, a daring example of
twenty-first-century architecture that adds enormous vitality
to the streetscape. It replaced the Library – designed by David
Percival (1962) – which burnt down in 1994, and the Forum is
now one of the great design flourishes of a city centre already
rich in architectural variety.

These grand statements are made even more stately by their
context, viewed on the slope of the hill, with the colourful spread
of razzmatazz candy-striped market stalls dominating the greater
area, and the long row of shops and businesses that face the
market. The shops have typical modern plate-glass windows with
gaudy fascias and signage, which is what you notice at street
level, but viewed from the City Hall you can see the variety of
architectural designs above, with pigeons and starlings preening

and sporting around the roofs and eaves, all adding colour and vivacity to the scene.

The Haymarket has its own particular character somewhat set aside from the main market. It is partly enclosed by the churchyard of St Peter Mancroft, and shops including the large Next and Top Shop fashion stores, giving it a personal and friendly character. Its atmosphere is enhanced by benches and steps, where families can enjoy a sit down and a sandwich, and by the small array of stalls selling plants, crafts and other items, which seem like a spill-over from the market beyond. The open area is large enough for children to skip and play in, and is dominated by the statue of Sir Thomas Browne, with his lively companions, the pigeons, perched on his head and shoulders. The new sculptured marble features, which relate to his writings, also double up as seats or play features for children. It's another example of how generous Norwich is in providing contrasts, this relaxing intimate space just next to the great open sprawl of the crowded market site.

The Haymarket also provides an intriguing glimpse of the Forum. You view it from a narrow gap framed between St Peter Mancroft and the glass façade of Next. This is the only direct view from the market area; further along it is largely hidden behind other buildings. With its vast Crystal Palace aspect, and broad ascending steps and terraces, it looks unusual and inviting, tempting you in to see what it has to offer.

So much! A huge library and IT centre, art exhibition spaces, a coffee bar and first-floor Pizza Express commanding the best view of St Peter Mancroft and the spread of the city beyond, and street-theatre performances on the terraced steps at weekends and during the summer season. It's also a place where teenagers congregate, and you can enjoy just sitting and watching them mix and mingle, skateboard and shimmy, and wearing the most up-to-date, colourful and outrageous fashions and hairstyles. The Forum teems with life. It has become one of the most popular areas of the city to see, and be seen.

As already mentioned, the market developed in this area by Ralph de Guader gradually replaced the old Saxon trading area in Tombland. The new market served the needs of the Normans, who built houses near the Castle, and also the Governor, his

family, servants and soldiers. A building was needed to deal with the collection of tolls and taxes for the Crown, so a Toll House was established, and later on it was extended and dealt with civil and legal business as well.

Norwich continued to expand in size and wealth. It was the sixth-richest town in 1334, with an estimated population of 6,000. This was due to its status as the chief market town in one of the most densely populated areas of the country. The main market soon became so busy that subsidiary trading areas were established for particular types of business. Cattle, sheep and poultry were sold to the south of St Peter Mancroft church, and horses outside the churchyard of St Stephen's, the site still known as Rampant Horse Street. Hogs were sold on Hog Hill, now Orford Hill, near the timber market still known as Timber Hill. In the main market area, which was situated between St Peter Mancroft and the Toll House, which became the Guildhall, were the stalls of meat and fish merchants and linen drapers.

Surrounding these were stalls selling a variety of other provisions, and another large area accommodating the leather traders who formed part of one of the most important industries in the city. It included tanners, skinners, cordwainers, saddlers, gaiter and buskin makers. To accommodate country folk bringing in their wares for sale, the Lower Market was provided close to the area called the Nethere-Rowe, now known as Gentlemen's Walk.

The old city records mention a number of fascinating trade names no longer familiar today. They include the Bukmongere, a dealer in venison and game; Chaloner, blanket maker; Chaucer, hosier or stocking maker; Clubbere, club maker; Dubber, mender of old clothes; Fripperer, dealer in cast-off clothing; Girdler, maker of belts worn to contain a weapon or purse; Latoner, maker of thin sheets of metal; Panter maker, who crafted bird snares; Pudding wife; Punder-maker, who made balances; Skirmischur, a fencing master; and Sloper, a dealer in smock-frocks.

In addition to these goods locally produced and required by most citizens, there was also a demand for luxury items by important personages such as the Bishop, the Prior, the Sheriff, and the wealthier merchant class. They employed skilled craftsmen

to produce stone carvings and stained glass for their buildings, as well as jewellery and silver plates and vessels, fine furnishings and tapestries, and illuminated manuscripts.

Imported luxury items were also sold in the market and some foreign merchants were permitted to live in the city. These included woad traders from Amiens and Corbeil, and imported goods included Caen stone, timber and steel from France, olive oil from Spain, wines from Gascony, furs from Scandinavia, cloth from Flanders, silks from Italy and fine-quality beeswax, salt and sugar from the Mediterranean. The exports that local merchants exported were chiefly wool, hides and leather products, dairy produce and corn.

Market days were on Wednesdays and Saturdays, except for a period in about 1300 when there seems to have been a daily market. A Market Cross was erected soon after the market was granted permission by Edward III. The later building, dating from 1503, originally held a small chapel for a priest, but, during the Reformation in the mid-sixteenth century, the chapel was converted into a store house, and the building lost its religious significance and came to be known as the Market House. The arcade also served as a cover for traders and customers, and was used for travelling vendors to display their wares.

Documents from the thirteenth century that provide fascinating detail about the traders and their wares exist in the city archives. For example, a document of January 1288 (translated from the Latin) records:

Walter, son of Walter de Aswardeby, and Sarra his wife have granted to John de Sprouston, draper, citizen of Norwich, and Alice his wife a shed in the Drapery in the Omanseterowe, having other sheds on the north and south, the churchyard of St Mancroft on the east, and the King's Way west; to be held by rendering annually a clove to Walter and Sarra at the Nativity of the Lord, 2s to the community of Norwich, 5s to the Hospital of St Giles in Norwich, and 4d to the church of St Peter Mancroft.[1]

The Omanseterowe was the cloth-trading area of the market, omannesete being a kind of fabric sold there. The St Giles Hospital had been founded in 1249 and was a religious institution caring

for the needy rather than providing hospital treatment, but it did have thirty beds reserved for the sick poor.

Also in February 1288:

> Miriella, widow of Goscelin Godale, produces a deed of acquittance to Walter Oldbarlik and Steven de Stalham, executors of her husband's will, for the due execution of the bequests made to her; viz, two stalls on the east of the Fresh-Fish Market. Rents on the Castle Ditch, and two shops with revision to his heirs ... also, One half of his turves, heather, and meat. And twenty coombs of barley in the name of dowry. Two thousand green herrings and three thousand red herrings, one lesser cup of silver, a pillow, a mattress, two blankets, a coffer, and a girdle ornamented with silver.[2]

It seems odd to have been bequeathed a large quantity of fish, but as Goscelin Godale's stock-in-trade they obviously had a significant market value, and needed to be sold quickly for the widow's benefit, for 'green' fish refers to ones which are fresh and uncured.

And in September 1290:

> George de Yelverton, in his will, left to Nicholas his brother his seld in the Caligaria and his tongs and chest of tools, and all his tenter and place with the tools belonging to the tenter. This will was proved in the full court of Norwich, according to the custom of the city.[3]

Many of the names recorded in these early records, like 'de Yelverton', denote the area from which a person originated. The Caligaria was the area of shops where the makers of leather buskins (protective coverings for the leg up to the knee) did their trade. 'Seld' presumably means his trading site, 'tenter' his covered market stall, although a tenter was also a wooden framework on which cloths, and perhaps leathers, were stretched.

And in 1292:

> Katerine, daughter of James Nade, with the assent of Mariota her mother, has devised to William de Colton, merchant, two stalls

in the Nedlererowe which are conjointly between the stall of the
Society of Girdlers to the south. To have and to hold by rendering
8s yearly to Katerine and Mariota.[4]

St Giles Hospital, mentioned in the document relating to Walter de
Aswardeby, was frequently the beneficiary of gifts and bequests.
Known as the Great Hospital, and also St Helen's Hospital, it
was founded by Bishop Walter de Suffield in 1249, and granted
a charter by Henry III, as a charitable institution. It stands in
Bishopgate Street, not far from the Cathedral.

The main provision was not hospital treatment, although
the sick were cared for, but accommodation for those in need.
The statutes state that there shall be thirty or more beds with
mattresses, sheets and coverlets for the benefit of the poor and
infirm 'so that when any poor man beset by illness come thither
he shall be received kindly and taken care of honestly as befits
his illness until he is restored to health'. The Hospital was also
established for the benefit of poor priests of the diocese who
were 'broken with age or bedridden with constant sickness so
that they cannot celebrate divine service'; these men could be
provided with care and accommodation for the remainder of their
lives.

In addition, there was provision of a daily meal for 'seven poor
scholars of the schools of Norwich, apt to be taught in grammar,
chosen faithfully by the faithful counsel of the schoolmaster on
oath' – in other words, only the most needy should be chosen.
The statutes indicate that there must have been several schools
for boys in the city in the thirteenth century, long before the King
Edward VI Grammar School was established. One is thought to
have been situated near the Cathedral on the site where the Adam
& Eve pub now stands. Priests often organised tuition for boys
so that they could learn reading and writing and take up clerical
work or train as priests themselves.

The meal was provided every day of the year while the school
was in session, and once the boys had completed their grammar
studies they could be replaced by others who were equally needy.
This indicates that the boys attending the schools came from
poor families where the food was scarce, and the founder of the

Hospital realised that if they were to prosper in their studies they needed a good meal to keep them strong and healthy.

The meal provided was probably the same as that given to another group of beneficiaries, thirteen poor men of the city; in fact, they may have all dined together at the same table. They were given 'good bread and drink and one dish of meat or fish, and sometimes of cheese and eggs'. The bread would be baked on the premises, and the drink would be ale. It seems strange to us today that children should be given alcohol, but beer was the staple beverage for all ages: water could have impurities and wine was only for the wealthy. The schoolboys were probably given 'small-beer', a watered-down version. The thirteen poor men also had the privilege of sitting by the fire in front of the chimney in the cold winter months, and similarly in the same place in the summer. Sick residents were provided with a special diet that included wine and cinnamon – expensive items usually only enjoyed by the wealthy, indicating how well all the inmates of the Great Hospital were cared for.

Apart from these generous provisions for the poor and sick, an 'Ark of the Lord' was provided. This was a charity box from which poor people passing near the Hospital could receive small amounts of money to buy food or other necessities. And every Saturday, from the feast of the Annunciation of the Virgin Mary on 25 March to her Assumption Day on 15 August, the great bell of the hospital would be tolled to let poor people know they could gather for a distribution of bread, 'as much as may banish the hunger of the recipient for that time'.

The will of William de Dunwich, a citizen of Norwich, dated 1272, includes his wish to be buried in the Hospital of St Giles, near the altar dedicated to St Catherine. In the medieval period it was believed that being buried in a church or similar building close to an altar would help in ensuring speedy salvation in Heaven. In return for this privilege, William bequeathed to the Hospital the following:

My messuage in Conesford which I purchased of Richard de Norwich, the messuage which I purchased of Nicholas, son of Nicholas de Hakeford, my messuage in the parish of St. Mary

Combust and certain annual rents ... I leave also to the same Hospital 35 marks and 8s which the Rector of the Church of Bothone [Booton] owes me, and £16 and 12s ... for supporting five poor infirm persons in all their necessaries for my soul and Catherine's my wife forever. Which poor persons shall lie in the said hospital in five beds so that when anyone of them shall have been restored to health or entered upon the way of all flesh, another infirm person shall immediately be substituted in his place and shall be suitably supported as is aforesaid. Also I leave to the same hospital all the annual rents [mentioned earlier] ... for supporting two chaplains who shall celebrate every day for ever the welfare of my soul and the said Catherine's, formerly my wife, and the souls of all the faithful ... Also I leave for my funeral and for good deeds to be done to the poor on the day of my burial, on the seventh day and on the 30th day, £30 ... and to every priest celebrating in the said Hospital of St. Giles, 2s ... Also to Sir Hamon, Master of the said Hospital, one silver cup with a foot, one gold brooch, and the better cup of mazer [maple wood] Also I leave to the support of four wax candles burning before the altar of St. Catherine in the said hospital at the mass of St. Mary, 1 mark of annual rent, which my executors shall provide for the said Hospital: also to the same altar one chalice of the price of 2 marks and one silver salt towards making the phials [small vessels used for wine and water for cleansing the chalice].[5]

William was a wealthy draper with shops in Norwich. He also owned various houses in the city for which he received rents, and farms and lands at Sprowston and elsewhere. In 1259 he had bought one of the smartest houses in the city, that which was built by Jurnet the Jewish money-lender, in Conesford Street (and now part of Wensum Lodge). Although William was exceptionally wealthy, his will is similar in kind to those of other men and women who left money and gifts to benefit the Great Hospital.

St Helen's church, which originally stood across the road, was given to the Hospital in 1270. It was rebuilt, a refectory and cloister were added, and the nave and chancel were adapted for use as hospital wards.

The Hospital was run by a salaried Master, and four chaplains conducted divine services in the choir with a deacon and chaplain to assist. Mass was celebrated three times a day, including one for Bishop Suffield's soul. The chaplains helped to train the poor scholars as choristers. Four Sisters, all aged above fifty, took care of the clothing, beds and other things that were needed for the sick inmates. The Master and chaplains lived together, eating in the communal refectory, and sleeping in a dormitory. There were also four laymen whose role was to deal with the outside business of the Hospital management.

The grounds contain a swan-pit, where swans were reared to end up as a festive annual feast for the residents. There was also a goose feast, and the x-shaped knife still survives which was used to quarter each goose into four portions.[6]

For youths from good backgrounds, or for those who were fortunate enough to attract patrons, education and livelihoods of one kind or another were usually provided. But there were many who had no particular occupation, and rather like the NEETS of today (those not in employment, education or training) could become a problem for society. Many grew up illiterate, undisciplined and bored. Their homes were usually small shacks accommodating large families living at subsistence level, and they would find it difficult to earn a living, just getting a penny here or there when the opportunity arose. So they had a lot of free time on their hands, which they spent roaming around the city in gangs looking for fun or excitement – petty theft, fights with rival groups, bullying younger boys, or mocking and playing tricks on the poor and disabled.

At times their behaviour could become more dangerous. If an incident occurred in the streets which led to tempers being raised and weapons drawn, they might join in, egging on the opponents, turning a quarrel into a brawl and making a bad situation worse. The fight scenes in Shakespeare's *Romeo and Juliet* are an example of how ill-feeling between two families can quickly get out of hand, resulting in street quarrels, spurred on by bystanders and quickly resulting in violent assaults and fatalities.

Incidents like this flared up from time to time in the Norwich streets. Some are recorded, many were not – it depended upon

whether any legal intervention was required. In the case of the life of Saint William, mentioned above, the boys and youths who raced off to see the site where the boy's body had been found in Thorpe Woods were probably some of the same who joined in the bloody attacks on the residents of the Jewry.

Francis Blomefield records in his *History of the City of Norwich* (1806) that while looking through thirteenth-century documents relating to the city, he was shocked to discover that

> so tumultuous was the city that I meet with many prosecutions of the citizens for firing one another's houses by night, cutting the bell-ropes off, that they should not ring when they had fired the houses and suchlike ... it was a dangerous time to live in.

In the next chapter we shall see how violence relating to the Paston family erupted in the streets.

Violence in the city also occurred due to prosperity and status. There was a big division between rich and poor, and the poor had little opportunity to improve their circumstances. Two areas of the medieval city had special status. The Castle keep, whose governor, as we have seen, was appointed by the King, had a large retinue of servants and soldiers, and was largely independent of the city authorities and Church. It is recorded that in 1260 when city officials (comprising four bailiffs and a Common Council that governed the city and collected taxes) dared to enter the Castle 'Fee', or precincts, they were obliged to seek the King's pardon for trespass.

The other privileged area was that of the Cathedral priory. The Norwich citizens were in no way involved with the priory, but the Prior had certain financial interests in the city, owning the common land, later called the Town Close (between Eaton and Harford bridges), and the rectories of various city churches. In particular, the Prior claimed rights over Tombland and the fairs held there, which caused all sorts of problems. And in addition anybody who died in the Prior's Fee, regardless of the circumstances, became the responsibility of the ecclesiastical court, not of the city coroner. A case had occurred in 1251 when no inquest followed the death by drowning of Gerard Goldfolde

because it had happened in a section of water that belonged to the priory. So even if it had been foul play and inmates of the priory were responsible, his family and friends could get no satisfaction through the normal legal channels.

Thus tempers and hostility often flared between the priory and the citizens. In 1234, there was an attack on the priory and some of the buildings were burned down, but a more serious episode occurred in 1272.

An ancient account commences:

> On the day of the Holy Trinity [3 July], there was according to custom a certain fair in the town of Norwich in a void place before the gates of the Priory and in a churchyard, and the same day after dinner the young men of the town came as they were accustomed with horses and ran at a certain quintain with lances. And by means of the broken pieces of lances an affray arose between the men of the Priory and the men from the town, so that many of them were wounded and certain men from the town died.[7]

The 'void place' was Tombland and the churchyard was that belonging to St Michael's church, demolished in 1096 to make way for the Cathedral buildings. It seems that this area was used as a recreation space for the young men of the town. The quintain consisted of a vertical wooden post hammered into the ground from which was suspended a horizontal swinging beam of about six feet in length. A bag of sand was attached to one end of the beam, and a square board at the other. The young men charged at the beam on horseback and struck the board with their lances and had to pass through before the sandbag could swing and hit them from behind. It sounds both exciting and dangerous, the sort of game that young men love. It seems that some of the priory servants must have come out through their gate and complained about the bits of broken lances littering the ground. The townsmen objected and refused to pick them up, a fight broke out which became serious and bloody, and deaths and injuries resulted.

An inquest was held and the priory servants were accused of murder. It was decreed that those responsible would be arrested

if they came outside the priory into the city area. This order was breached, and two men from the priory were seized and imprisoned. The Prior then retaliated by ordering that the entire city would be excommunicated for a breach of his privileges. He shut the priory gates and stationed some of his men along the top of the wall. The monks hung 'scutcheons, targets and bucklers' over the gates and started aiming their crossbows at any citizens passing by. It seems extraordinary that monks and novices who were being rebuked for minor offences by Bishop Herbert a century earlier should now be behaving in such a manner – entirely contrary, it would seem, to their monastic vows and Christian creeds. But the conduct of a priory was very much the result of the character of the Prior, and some could be assertive and militant in asserting their rights, believing of course that they had God on their side.

This hostile attitude lasted from July until August. Then, on a Sunday evening, 7 August, a group of priory servants decided to become even more aggressive and taunt the enemy. They went on a rampage through the city streets and robbed a merchant, Alfred Cutler, of more than £20. Then they broke into a tavern owned by Hugh de Bromholm, and having got even more stupidly drunk, proceeded to break the casks and let the wine drain out onto the streets.

There is no doubt that this was outrageously provocative. The city Bailiffs arranged a meeting of the Common Council to instigate emergency action. They sent messengers to the King's court, and took the precaution of assembling a militia that was to be stationed throughout the city streets to prevent the priory men from causing more violence. One of the Bailiffs responsible for this action was William de Dunwich, the wealthy benefactor of the Great Hospital.

The Bailiffs also summoned the citizens to assemble in the Market Place so they could inform them of their resolves, and organise them into a militia to patrol the streets. But the outraged crowds wouldn't wait for instructions. An angry mob raced from the Market Place to Tombland, eager to exact revenge. One of the monks inside the priory recorded what happened:

They fired the great gates with reed and dry wood, and burnt them
down, with St. Albert's Church [St Ethelbert's] which stood near
them, and all the books in it ... Others got upon St. Georges's
steeple and threw fire with slings, and fired the great belfry beyond
the quire so that the whole church was burnt, all but the Virgin
Mary's Chapel.[8]

The monk was of course eager to lay all the blame on the citizens,
but it was in fact the monks who caused the fire, damaging the
tower of the Cathedral when they were preparing weapons of
warfare to retaliate. A number of inmates of the priory were
reported killed and injured – deacons, clerks, and laymen in
the cloisters and the Cathedral precinct, while the mob dragged
others out and slaughtered them in the streets.

The Prior, William de Burnham, realising that the mob were out
of control, galloped off to Yarmouth to summon armed forces to
come and assist him. It is said that the Yarmouth troops hastened
to the city by barge, probably the fastest way. William then led
the forces into the streets, blowing a trumpet and brandishing
his sword, and they set about attacking people in the streets,
wounding, killing, and even attacking those sheltering in their
houses, destroying their homes as well.

News of this disaster came to the attention of the King, Henry
III, and in consultation with the Bishop, Roger de Skerning, an
excommunication was announced against the whole city, including
the Bailiffs and all the members of the Common Council. The
King himself, with an armed force, then arrived in the city and
passed sentence on the rioters, resulting in terrible punishments.
Some were hanged, drawn and quartered, others – including
women – were burnt alive. He was not solely punishing the lay
people, for the Prior was imprisoned for committing murder and
all his lands were confiscated.

Drastic changes to the city's administration were also ordained.
The four Bailiffs were dismissed from office and replaced with
Keepers appointed by the King. In addition, the city was required
to pay compensation to the priory for all the damage that had
been caused, and until this was arranged it was forbidden to
participate in the sacraments of the Church. This was a very

serious matter in the medieval period when exclusion from Church ceremonies – and, in particular, the forgiveness of sins – was thought to result in a spell in Purgatory or suffering eternal agony in the fires of Hell. As it happened, William de Dunwich fell ill and died during this period of exclusion, and one wonders what agonies of fear he went through before his death. But, as a wealthy man, he may have been able to purchase the rites of absolution from a willing priest in return for a generous fee. Still, his conscience could not have been easy, having waged war with the priory and Cathedral and God's representatives in the city so shortly before his death.

Henry III also died at about the same time and it was his successor Edward I who had to sort out the compensation due to the priory. The citizens were ordered to pay 500 marks a year for six years for the rebuilding of the Cathedral church. In addition, a gold cup, or pyx, worth £100, was presented for use in the sacraments at the altar, and the gates at the entrance to the precincts had to be replaced. This is the present-day Ethelbert Gate, and it was built to incorporate a chapel above the arched entrance as a substitute for the church of St Ethelbert, which had been destroyed in the riots and attacks. Some of the leading citizens were obliged to go to Rome to seek forgiveness for the whole community from the Pope.

In the final agreement, the Prior was granted control of Bishop Bridge, and the Tombland fairground area was divided between the local people and the monks. So maybe the young men could resume their game of tilting at the quintain which had caused all the trouble in the first place!

Once all this was agreed, the King's pardon was granted, and the privileges of the city restored. In December 1276, the Pope's Absolution was declared on Palm Sunday by the Priors, and normal life was finally resumed. But the grievances on both sides must have continued to fester, and it seems clear that it was the arrogant and bloodthirsty attitude of the Prior and his monks which was to blame.[9]

# 1400–1500

## 'They shall either hop headless or fry a faggot'

The Dominicans – or Black Friars, as they were called because of the colour of their robes – established a church and priory in the city in 1307. The site, near Elm Hill, had previously been occupied by a minor group, the Friars de Sacco, in about 1250, but the Black Friars developed it more extensively for the sixty members of their fraternity. It was mainly funded by local donations because they were sworn to vows of chastity and poverty. Their main purpose was to preach, and the surviving buildings are the nave and chancel of the great conventual church dedicated to St John the Baptist, considered the best example of friar architecture surviving in this country.

The spacious nave, St Andrew's, was used for holding services and preaching to the city congregations, and the smaller chancel, Blackfriars', was where the fraternity held their private services. Their mission was to get involved with lay people, and, in addition to preaching, to hear confessions, so their monasteries tended to be built in town centres. Both their church and priory were badly damaged by fire in 1413, but rebuilding soon commenced and was finally completed in about 1470. The two halls remain the same size and shape today as they were when the main building work commenced in 1325.

The donors who helped towards the rebuilding costs included John Paston and his wife Margaret, whose lives are covered later in this chapter. The south door is carved with their coat of arms.

Following the Dissolution of the Monasteries in the 1530s, Augustine Steward, Mayor of the city, requested permission from Henry VIII to purchase the Black Friars buildings as 'a fayer and large hall, well pathed, for the Mayor and his bretherne, with all the citizens of the same to repair thereunto for their common assemblages as often as shall be expedient'. This was granted, as the King was eager to gain the income from all the dissolved ecclesiastical sites, and the buildings were subsequently used for a school, a workhouse, and stores, while the St Andrew's and Blackfriars' halls were used for civic events, banquets, law courts, and other community needs. However, in the reign of Elizabeth I, Blackfriars' Hall was approved for use as the church of the Flemish Protestants who had fled to England following persecution by Spanish Catholics in the Netherlands.

Today the Halls remain very much in use in the same way 'for common assemblages as often as shall be expedient'. The area in front of the Halls has been recently converted into a wide, paved pedestrian area, which shows the fine flint-faced buildings to advantage and provides a pleasant area for visitors to congregate.

By the beginning of the fifteenth century, Norwich had become England's second largest city, after London, with a population of about 10,000. The Guildhall was built to replace the old Toll House. Building commenced in 1407 and was completed in 1424. Used to accommodate council meetings and law courts, the Guidhall was the largest and most prestigious city hall outside London, and emulated the great city halls in Flanders and Holland with which the city merchants had close contacts.

As the market in the city centre developed and prospered, strict rules were ordained for its regulation and fair trade. Most buying and selling was concentrated there because it enabled both the authorities and the traders to keep an eye on what was happening and intervene if necessary. The different sorts of trades had their own sections within the market which facilitated management, and allowed shoppers to compare prices more easily. If Dame Mandevill, for example, complained that the needles in John Spink's stall in Nedlers Row cost a groat more than those in Goody Twofellow's stall nearby, it obviously led to price bargaining that

wouldn't have happened so speedily if the stalls were separated on opposite sides of the market. And so, the lady went away well pleased with the price she had paid.

Rules for the regulation of the market were written and proclaimed. No foodstuffs were to be sold before the bell was rung for the Lady Mass at the Cathedral. No citizen was permitted to purchase goods with more than one servant in attendance, otherwise he could get various servants to trot around and scoop up the bargains, thus disadvantaging others less fortunate. Traders, including butchers and tavern keepers, must pay country folk in advance for any goods they wished to purchase. No goods must be stored away in houses to escape payment of tolls. All weights and measures must be tested at least twice a year, and certain heavy goods such as wool and lard, sold wholesale, must use the King's official public weighing apparatus set up in the Market Place. Only recognised citizens were permitted to trade in the Market Place. In the case of those rural dwellers who came to the market to sell their produce, they had to pay a toll fee when they entered the city gates.

The city archives have a wealth of interesting details about matters relating to the markets. In 1288 it seems that a youthful entrepreneur – who would probably aim to be a *Dragons' Den* candidate on TV in the twenty-first century – got caught out:

> Simon, son of Seman Wrinel, has granted a stall to Richard, son of Adam le Gardiner of Salle, but since it appears to the Bailiffs that Simon is under age, the conveyance is not endorsed by the court.[1]

There is an interesting case in 1330, when two chaplains are granted shops and stalls in the Market Place in return for religious favour:

> John Cusin, with the license and consent of King Edward II, and of John de Burcestre, rector of St. Peter Mancroft, has granted in frank almoine [perpetual tenure by free gift of charity] to John Gilbert of Foulsham, and John Bolour of Hemenhale, chaplains, a shop in the Worsted-Row, another in the Spicery-Row, two adjoining stalls

in the Meat-Market, and two others also adjoining one another in the same market ... and 2*s* from a stall in the Fish-Market.

Also included are rents from various other messuages and stalls:

To have and to hold while they celebrate divine service daily for the souls of John Cusin, and his father, and mother and wife, of his ancestors and successors, of all to whom he is obliged, and of all the faithful departed. And Margaret his wife, although not nominally joined with her husband in the grant, came and confirmed it of her own free will.[2]

There were, of course, all sorts of squabbles between different traders. The city butchers protested at an Assembly held in Pentecost Week, June 1373, about cook-houses serving boiled and baked meats and pies:

The butchers complain against the cooks of the city because the said cooks feed calves, lambs and other animals, in their houses to the great hurt of the said butchers and of the whole Community. And it is ordered by the whole Community that it shall be prohibited to the cooks by the Bailiffs that until the next Assembly they shall no longer feed any beasts in their houses, and that the said cooks shall be forewarned to attend the next Assembly to answer to the Bailiffs, the Community, and the said butchers by what warrant they thus feed, as has been said, or why they ought not to do so.[3]

It is clear that the butchers felt it was their right to rear animals and then sell to the cooks, and that by rearing their own the cooks were undercutting their trade. The result of this interrogation was that it was decreed at the Assembly a week later that:

If any cook shall feed ox, pig, calf, sheep, or lamb in his house that for the first time he shall be amerced [fined] 20*s*. If he is found guilty for a second time he shall be amerced 40*s*. And that one half of the amercement shall remain to the Community, and the

other half to the Bailiffs. And if he is found guilty for a third time he shall abjure [give up] his occupation, save by the special grace of the Community.[4]

It was further ordained that 'no cook ... may buy any victuals before the bell of St Peter Mancroft is rung for mass'.

During this period, trade was carried on in the market on Sundays, which seems strange to those of us who remember Sunday as being a day when most shops remained closed for religious observance. But in 1422 the Assembly ordained that

the common market viz. for butchers, fishmongers, and others such like, shall not be held henceforth in the City of Norwich on Sundays ... And if anyone of the butchers shall do the contrary of such ordinance he shall pay for every default, 20*s* ... Also, it is ordained that no one of the said city of whatsoever state, position, or condition he may be for the future shall keep any open shop on Sundays in Lent, nor on any Sunday of the whole year for selling anything there, cooks, brewers, and taverners nevertheless excepted.[5]

The reason why the cooks and brewers were exempted was because, at a time when not every home had facilities for cooking, families liked to take their Sunday midday joint to the local cook-house for heating. This had become such a Sunday tradition that there would have been a public outcry if it ceased. Similarly, others might prefer to go to a tavern and get a cooked meal and ale there rather than having to bother to prepare food at home.

There were sometimes problems with quality control. At an Assembly held in March 1471:

It was notified by the Mayor to the Common Council that a grievous complaint is abroad in this city about the common brewers, concerning and about their weak and unwholesome brewing. And upon this, the persons underwritten are elected to taste and assay all and singular the brewings of the said common brewers, upon due warning to be given them ... at a suitable time. [Also] the common ale brewers of this city shall not brew to sale

but tweyn manner [two varieties] of ales. And also that they shall
not brewe neither with hops nor gawle [presumably oak-apples
used as a flavouring but with a bitter taste], nor no other thing
which may be found unwholesome for man's body upon pain of
great punishment.[6]

As a result, two people were elected in each ward as tasters:
a nice little earner. Still, they might have ended up with severe
tummy aches if some beers did indeed contain unwholesome
ingredients.

There were also problems associated with public health, and
in May 1473, at the Assembly, it was ordered that:

The buyers of victuals for the lepers near the city for the future
shall not touch any victuals with their hands, but with a wand, and
that the butchers and fishmongers permitting the contrary shall be
punished according to the discretion of the Mayor.[7]

Leprosy was quite widespread and very contagious. The principal
diet of salt meat or fish for the winter months of the year (and
other months as well), the lack of fresh fruit and vegetables,
and unhygienic living conditions made diseases of the skin
common among the poor. All virulent skin diseases tended to be
thought of as a sign of leprosy, and a great many leper houses
were situated around the city to help the sufferers and prevent
the disease from spreading. Apart from the twelfth-century
Magdalen Leper House, other hospitals were built outside the
gates of St Stephen's, St Benet's, and St Augustine's. Another was
situated outside St Giles' Gate in around 1343 and was funded
by Baldric de Taverham. The 1272 will of William de Dunwich
states that 'also I leave to every leper's house round the town of
Norwich, 6*d*'.[8]

The city authorities also dealt with various crimes, which
included begging in the market areas: 'John Davyson, John Hyll,
John Marsyngale, Robert Burnham, mighty beggars were set in
the stocks by the Mayor on the 18th March, 1496'.[9] And on
the following day, Simon Jonson and William Thornham, also
'mighty beggars', suffered the same treatment. The term 'mighty'

presumably means persistent, so a continuing public nuisance. Also beggars could be licensed, but these men apparently didn't qualify or had failed to apply.

In April of the same year, two others were dealt with:

John Mathewe, sawer, mighty man a vagabond, and Elizabeth Herley, harlot, to be set in the stocks on the Thursday next before the Feast of St. George, at the 10th hour before noon.[10]

It is not known whether these two people were connected. A vagabond was different from a beggar, being a person who had no fixed abode and wandered about from place to place. John Mathewe had an occupation as a sawer of wood, and had perhaps come to the city looking for employment but been unlucky. The Assembly proceedings do not mention for what length of time the culprits must remain in the stocks.

In 1404, Henry IV awarded a charter to the city, taking control away from the county officials and creating Norwich as a county in its own right. The bailiff was replaced by two Sheriffs and a Mayor, and four other officials who acted as justices of the peace. The charter also created a corporation of twenty-four men, and later it was affirmed in a charter of 1417 that there should be a Common Council of sixty members elected annually by the people from the various wards of the city. The Mayor and one of the Sheriffs had to be elected by the section of the population entitled to vote, and the Mayor would convene with the council men and the Aldermen at least four times a year, the twenty-four Aldermen also being elected by the voters. Although the Council had the role of ratifying decisions, it was the Mayor, Sheriffs and Aldermen who held the control of power, and this situation continued unaltered for the next 400 years.

One of the most revered characters connected with the city in the medieval period is the mystic Julian of Norwich (1342–1413). Her meditations, later published as *Revelations of Divine Love*, were written while she was living in solitude as an anchoress, and they continue to inspire many readers today. The book remains one of the most popular that is sold in the Cathedral shop.

She was born in 1342 and, it is thought, educated at the Benedictine priory in Carrow. The ruins and rebuilt Prioress's house are in the grounds of Reckitt & Colman's factory premises in Bracondale Road. At the age of thirty-one, in May 1373, she suffered a severe illness, and while it lasted was granted sixteen revelations of God. She therefore decided to devote the remainder of her life to prayer and contemplation, and retired to live in a cell attached to St Julian's church, which is in St Julian's Alley off Rouen Road. She spent the remaining forty years of her life there, and was not entirely cut off from the world, because through a small window she could watch Mass being celebrated at the altar. Those connected with the church provided her with food, and at another small window visitors appeared with whom she could converse, and to whom she could offer spiritual advice and describe her own experiences of the love of God.

One of the people who came to seek her out was Margery Kempe. Margery was born Margery Brunham in King's Lynn in around 1373 and married a burgess with whom she raised fourteen children. She suffered fits of insanity during which she experienced a religious revelation and became a mystic, deciding to redeem her life by undertaking pilgrimages to various holy shrines, including the cell of Julian, who must have developed a significant reputation by this time. Margery also travelled as far as Germany and the Holy Land. She dictated her spiritual autobiography to a scribe, later published as *The Book of Margery Kempe*. In it she describes how she was bullied by evil spirits as well as by men, and she gave her views of the Lollards, whom she deemed – like others of her contemporaries – to be heretics sinning against the views of the established Church. Thus, the two women had much in common and it would be fascinating to step back in time and be a fly on the wall listening to their conversations.

Julian was also occupied in writing down her own religious experiences, and *Revelations of Divine Love* is thought to be the first book written by an English woman. In one part she describes how the Lord

shewed me a little thing, the quantity of an hazel-nut, in the palm of my hand; and it was as round as a ball. I looked thereupon

with the eye of my understanding, and thought: 'What may this be?' And it was answered generally thus: 'It is all that is made'. I marvelled how it might last, for methought it might suddenly have fallen to naught for littleness. And I was answered in my understanding: 'It lasteth, and ever shall last for that God loveth it'. And so All-Thing hath the Being by the love of God. In this Little Thing I saw three properties. The first is that God made it, the second is that God loveth it, the third, that God keepeth it. But what is to me verily the Maker, the Keeper, and the Lover – I cannot tell; for, till I am substantially owed to him, I may never have full rest nor very bliss: that is to say, till I be so fastened to Him, that there is right nought that is made between my God and me.

It is extraordinary to think of her quiet and self-contained life, while in the city beyond the walls of her convent the people were experiencing great turmoil, the Peasants' Revolt, and all the agonies caused by eruptions of the Black Death, with whole families being wiped out. These events would have been reported to her, and her advice and prayers may have helped to ease the sufferings of many.

What is thought to have been the site occupied by her cell is now a chapel, incorporating the original rough cast stones, within St Julian's church. The church is not named after Julian, nor she did she necessarily take her name from the church, as Julian or Juliana was quite a popular name for women in the medieval period. It is thought that a church may have been on the site since Anglo-Saxon times, and may have been dedicated to St Juliana, a fourth-century martyr. But the church Dame Julian inhabited no longer exists. It suffered a direct hit by a bomb in 1942 and has been entirely rebuilt, although the north wall of the nave is part of the original building.

Julian is depicted in glass in a window in St Luke's chapel in the Cathedral and in the modern statue near the west entrance door.

The Black Death, as the bubonic plague was called, is said to have reached England in the summer of 1348, spread by the galley crews of ships returning from ports in Asia Minor. Outbreaks occurred in Norwich in January 1349, and continued

throughout the year. Norwich was one of the worst-hit dioceses in the country. There were further outbreaks of the epidemic in 1361–62 and 1369. It has been estimated that about two-fifths of the population died as a result, and at least half the clergy. Four of the parish churches closed because they had no priests and no parishioners. Records show that in 1357 many shops and market stalls had fallen into disrepair because they had been left unoccupied for so long, and following the plague and famine of 1369 the churchyard of St Peter Mancroft had to be extended because it no longer had sufficient room for burials.

The introduction of the Poll Tax in 1380 caused outrage. It was due to the costs of the ongoing war with France, and in 1377 it imposed payment of one groat (four pence) on every lay person aged over fourteen. The third Poll Tax of 1380 raised the rate to twelve pence a head, and when many resisted payment the government took action to enforce it. In some places the clashes resulted in armed rebellion, and in London one of the ringleaders, Watt Tyler, was killed during a conference with the King's delegates at Smithfield in London. One of the demands was that serfdom should be abolished; serfdom entailed compulsory service due to the lord of the manor, and this was increasingly perceived as demeaning and restrictive because there was less time for working for one's own family and benefit.

The desperate situation of the poor had been aggravated by famines following poor harvests, notably in 1315 and following years, when the city governors tried to restrict the price of essential foods, but it was also a time when servants and employees were discharged and made unemployed – and they could form a dangerous insurgent group within the wider community. The situation got worse after the outbreaks of the Black Death. The scarcity of labour was so great that labourers were unwilling to work for the wages offered, and this contributed to the national Peasants' Revolt of 1381.[11]

There were local outbreaks of violence in East Anglia, which affected Norwich. The targets of the rebel attacks in Norfolk were numerous but scattered and disparate. The houses and farmlands of certain prominent legal and local government officials and some manorial lords were stormed and damaged.

Carrow priory on the outskirts of Norwich was attacked and the muniments (court rolls and title deeds) destroyed because the rebels were eager to eliminate any records confirming and perpetuating their serfdom. Their leader was Geoffrey Litester.[12] The name Litester means a 'dyer', and Litester was employed in the Norwich woollen trade. His band of supporters gathered outside the city on Mousehold Heath. They were probably a disorganised rabble, not very sure of their aims but eager to protest about their poor living conditions. Due to the general unrest in other parts of the country, the city Bailiffs took action to quell the rebellion. They issued swords and bows and arrows to citizens and the city gates were provided with guards, consisting of two men-at-arms, a lancer and four archers. Sir Robert de Salle was made the commander of the defensive forces. Initially, because de Salle was of humble birth, the peasants outside the city gates thought that he might come to their aid, and sent in a messenger requesting that he come out to parley with them. They added the threat that, if he refused, they would burn the city to the ground. When de Salle arrived at the enemy encampment, Litester asked whether he would join them as leader, to which the lord retorted, 'I had rather ye were all hanged, as ye shall be.' However, as he stepped back and mounted his horse, his foot slipped in the stirrup. He fell forward and the horse, frightened by the sudden tumble, reared up and shied away.

Realising that he was now likely to be the victim of attack, de Salle rose and drew his sword, and he was instantly surrounded by the rebels. One chronicler gives their number as great as 40,000, but this was probably a gross exaggeration. He struck out bravely, and it is said killed and wounded several, but their numbers were too great, he fell, and his body was hacked to pieces.

Litester and his forces then entered the city, easily defeating the small number of defenders at the gate. They attacked and destroyed a number of properties belonging to wealthy citizens, nobles and lawyers. It seems that Litester had already taken several notable men hostages in the countryside around the city. Now, he forced two of his prisoners, Lord Morley and Sir John Brewes, to ride to London to request 'letters of Manumission and

*Norwich*

Freedom' from the King on behalf of the insurgents, and three of the chief men supporting Litester accompanied them. Once this group had departed, most of the other rebels marched off to North Walsham, fourteen miles away. But now, Henry Despencer, Bishop of Norwich, took on a military role, determined to quell the rebellion. He was described in the contemporary *Holinshed's Chronicles* as 'a man more fit for the field than the church, and better skilled in arms than divinity'. On his way into the city with just a small group of supporters, he intercepted the three men escorting the two lords to London. They were attacked, overpowered and slaughtered. Then their heads were struck off, stuck on poles, and carried to Newmarket to be publicly exhibited as a warning to any others who might try to join the rebellion. Despencer was also able to seize the purse of money given to them by the frightened Norwich citizens in an attempt to stave off an attack. Norwich welcomed their defender with grateful cheers, and he was rewarded with a large sum of money from the purse that he had captured.

Despencer had gathered together a much larger force of supporters by this time, and they set about dealing with the rebels who remained at the city gates. They were soon overpowered, mainly due to Despencer's charismatic power over his militia. Many rebels were killed and wounded; some managed to escape. Litester was found hiding in a field of corn and was dragged before the Bishop for judgement. In his role as a priest, Despencer heard the victim's confession of guilt, and absolved him from sin. Then in his role as military commander, he had him savagely hanged, drawn and quartered, and finally beheaded on the spot.

Henry Despencer was always much more a vigorous soldier than a compassionate and peace-loving cleric. Two years later in 1383 he led the 'Norwich Crusade' to fight the French as supporters of the 'anti-pope' in Flanders. The failure of the campaign resulted in his criminal trial, and the forfeit of the secular possessions of his Norwich diocese, although they were restored two years later.

His next campaign was to deal with the Lollards. The Lollards were influenced by the views of John Wyclif (*c.* 1320–84), an Oxford theologian who questioned papal authority and the

wealth of the clergy. Wyclif argued that the true source of authority in religious matters was not the papacy and clergy but the word of God as revealed in the Bible. His ideas were condemned as subversive by the Church, but gained support from various strands of society, including members of the gentry, merchants, the poorer clergy, and tradesmen. Wyclif and his Lollard supporters also believed that the Bible, only available in Latin or Greek, should be translated into English so that all those who were literate could read it for themselves, and make up their own minds about the scriptures, rather than having them interpreted by the clergy.

Some of the rebels involved with the Peasants' Revolt may also have supported Lollard views. In 1384, Despencer proclaimed that any Lollards detected preaching in his diocese must repent or be burned at the stake. If found, 'they shall either hop headless or fry a faggot'. His savage words were not intended as a joke. In 1396, the Lollard version of the Bible in English translation was published, and certain groups were able to obtain copies and spread their views. In 1399, William Sawtrey was convicted for heresy in a trial at the Bishop's Palace at South Elmham, and taken to Smithfield in London to be burnt at the stake.

Despite the martyrdom of some of its supporters, the Lollard movement continued to gain support. Those convicted in the Norwich diocese were taken to be burnt in the 'Lollards Pit' just across the river from Bishop Bridge. George Borrow described it in his book, *Lavengro* (1851):

Observe ye not yon chalky precipice to the right of the Norman Bridge? On this side of the stream, upon its brow, is a piece of mined wall, the last relic of what was of old a stately pile, whilst at its foot is a place called the Lollards' Hole; and with good reason, for many a saint of God has breathed his last breath beneath that white precipice, bearing witness against Popish idolatory, midst flame and pitch; many a grisly procession has advanced along that suburb, across the old bridge towards the Lollards' Hole: furious priests in front, a calm pale martyr in the midst, a pitying multitude behind. It has held its martyrs, the venerable old town.[13]

The Lollards Pit is marked by a plaque on the Bridge House pub in Riverside Road.

William Alnwick, a later Bishop of Norwich from 1425 to 1436, was responsible for a commission set up to arrest Lollards in the Eastern Counties, and there was particular activity between about 1428 and 1431, especially in the Waveney Valley regions of Norfolk and Suffolk. About 120 people were arrested, and the perceived ringleaders, Sir William White of Loddon, and John Wadden of Kent, were arrested in Bungay and burned at the stake.[14]

In Norwich, the city records report in 1427/28:

> For two cart loads of wood bought in the market for burning William Qwytte, heretic, 4s 8d. To John Jekkes for the carriage of the wood from the city to Bishop's Gates for burning William Waddon and Hugh Pye, heretics, by agreement made with the said John, 16d. To John Pecok for bread given to William Babyngton and John Cheneye, Justices of the Lord King, 2s. To Edmund Sterr for a potell of rupney [a sweet Italian wine], put into the said bread, 8d. To Master John Excetre for half a hundred fagottes bought from him for punishing the said Lollards, 18d. To Edmund Snetysham for two logs to which the said heretics were bound, 6d.[15]

It is shocking to think of men providing logs all the while knowing they would be used for burning to death their fellow men, purely for their religious and social beliefs. But like the manufacturers of armaments today, they wanted the money and didn't worry too much where it came from. The Lollard movement continued to smoulder underground, and, eventually, many of the religious reforms they had fought and suffered for were achieved in the reign of the Protestant king, Edward VI.

We know a great deal about one of the wealthy and prominent families living in Norwich in the fifteenth century, the Pastons, because many of the family letters they exchanged have survived.

The Pastons originated from the village of Paston in Norfolk. William Paston, born in North Norfolk in 1378, was of prosperous

yeoman stock, and as a result of purchasing land and manors in various parts of Norfolk soon rose to the class of local landed gentry. He also became a judge, a justice of common pleas. John, William's son and heir, married Margaret in 1440, when they were both aged about nineteen. Margaret was related to Robert Toppes, a wealthy cloth merchant who served four periods of office as Mayor. He built Dragon Hall in Conesford Street, now King Street. John had inherited a number of properties but the couple lived principally in Norwich, and at Drayton Lodge on the outskirts of the city. Their main dwelling in the city was on Elm Hill. That building no longer exists, having been destroyed by fire in 1507, but a fine sixteenth-century house built by Augustine Steward now stands on the same site.

The Pastons' parish church was St Peter Hungate, in what is now Prince's Street between Tombland and Elm Hill. The surviving church is mainly of the fifteenth century. The nave and transepts were rebuilt 'as a neat building of black flint' by John Paston in 1458, and a stone in a buttress near the north door records the construction. It depicts a bare tree trunk, representing the decayed church, sprouting a new shoot, representing the new building, and it bears the date of completion, 1460. Two carved stone corbel heads in the south transept are believed to represent John and Margaret Paston. The building is today in the care of the Norwich Historic Churches Trust and houses displays of the Hungate Medieval Art collections, promoting the medieval art and architecture of Norfolk.

Margaret's husband John was frequently away in London dealing with business and legal affairs, while she remained in Norfolk dealing with family affairs and property. They were consequently obliged to keep in touch by letters. In June 1451, she writes to him, saying:

It was told me this week that there is a fair place to sell in St. Lawrence parish ... near the church, and by the water side, the which place Toppes [her relative] hath to sell. Pyte, a lyster [dyer of cloth], bought it of Toppes, and now, for default of payment, Toppes hath entered again therein, and shall sell it in haste, as it is told me. The said lyster dwelleth therein at this time, but he shall

[be put] out … I suppose if ye like to buy it when ye come home, ye might have it of Toppes cheap, or better than another should.[16]

This letter illustrates how Margaret did not just deal with the children and domestic matters, but took an active part in her husband's business and financial interests, here recommending purchase of a property going cheap that might be sold for a profit later on. Indeed, the practical management of the family lands as well as the household became largely her role during John's absence. Apart from ordering provisions and making sure the animals were well housed and foddered, she supervised the buying and selling of property and also ensured that the family were dressed according to their station as fashionable gentlefolk. She wrote to John in 1455 regarding a request to purchase cloth for uniforms for his servants:

As touching your liveries there can none be got here of that colour that ye would have of, neither murry, nor blue, nor good russets, underneath 4*s* the yard at the lowest price, and yet is there not enough of one cloth and colour to serve you.[17]

The husband and wife's affection for each other shows strongly in their correspondence. In a letter written in around September 1443, Margaret says to John that she is 'desiring heartily to hear of your welfare, thanking God of your amending of the great disease that ye have had'. She continues that her mother had bought an image of wax, of the same weight as John, for the shrine of Our Lady of Walsingham, and she sent four nobles, gold coins, one each to the four orders of friars in Norwich, to pray for his recovery. Margaret herself was planning to make a pilgrimage to Walsingham and St Leonard's in the hope that this would also contribute to her husband's cure.

The Shrine of Our Lady of Walsingham, near Fakenham, was a celebrated place of pilgrimage throughout the Middle Ages, and continues to be so today. The four orders of friars in Norwich were the Dominicans, Franciscans, Augustinians and Carmelites. John recovered from whatever illness afflicted him, and Margaret and her mother firmly believed it was a result of their prayers, the wax image, the gold coins and the proposed pilgrimages.

Margaret also suffered considerable difficulties caused by conflict relating to her husband's properties. In May 1448, she wrote to John concerning a frightening episode that occurred when she was attending morning Mass at St Mary Coslany church in St Mary's Plain, off Duke Street in Norwich. James Gloys, their family chaplain, was walking past the gate of a house owned by John Wymondham. Wymondham was an MP and associated with John Heydon and Sir Thomas Tuddenham in various violent episodes in Norfolk. Wymondham was standing in the street, with two menservants. They exchanged quarrelsome words with Gloys, whereupon Wymondham called the priest a knave, drew his dagger and threatened him. Gloys had to retaliate and draw his dagger to defend himself. He then hurried towards the house of Margaret's mother, which was nearby, while Wymondham and his men pelted him with stones.

He was followed into the courtyard by the three men, who hurled at him another stone the size 'of a farthing loaf'. Angry words were again exchanged, and one of the menservants ran back to Wymondham's house and armed himself with a spear and a sword. Just as all this was happening, Margaret and her mother emerged from church, and were horrified by the affray. Margaret ordered Gloys back to her mother's house, and then Wymondham swore at the two women and called them 'strong whores', adding that 'the Pastons and their kin are all ——'; but what further foul language he hurled at them we shall never know because about ten words are missing due to a hole in the original letter, perhaps a worm hole. If so, it must have given the worm serious indigestion.

This was very aggressive behaviour indeed, especially when directed at two defenceless women. In the afternoon, Margaret and her mother paid a visit to the Prior of the Cathedral, John Heverlond, who immediately sent a message to Wymondham demanding his presence and an explanation. Margaret and her mother were escorted home by a family friend. When they arrived, they saw Gloys standing by her mother's gate. One of Wymondham's servants also spotted him there, from an upstairs window, and ran out with a two-hand sword and again assaulted Gloys, and also the mother's manservant, Thomas, slicing his

arm with the weapon. All this, adds Margaret in her letter to her husband, was witnessed and affirmed by the parson of Oxnead, who happened to be in the street at the time. Margaret was naturally anxious as to how these attacks would end and whether the family property would also be targeted.

This episode illustrates how easily violence could break out in the streets at a time when every man was armed with a weapon to protect himself. It was the period of the Wars of the Roses, when there was much turbulence throughout the country. But the Pastons seem to have suffered more than most in the recurrence of violence connected with seizure of their lands in the most unlawful fashion.

John Paston had inherited great wealth in 1459, on the death of Sir John Fastolf, a relative of Margaret. But his claim was contested by other executors of Fastolf's will. Some of these opponents gained support from the powerful Duke of Norfolk, lord of the manor of Costessey, who was eager to obtain the neighbouring manors of Hellesdon and Drayon belonging to the Pastons – not by fair means, but foul. John Paston was obliged to remain in London, sorting out the terms of the will, and the Duke felt that it was an opportune time to seize the properties when there was only a woman, Margaret, in charge to reckon with. Two of the Fastolf manors were seized by force, Hellesdon in 1465 by the Duke of Suffolk, and Caister after John's death in 1469 by the Duke of Norfolk. In addition, the manor of Gresham was attacked by Lord Moleyns in 1448, although John was able to recover it, but he received no compensation for the crime due to Moleyn's superior status.

With regard to the conflict with the Duke of Suffolk, Margaret informs her husband in a letter of October 1465 that the Duke had arrested three of the Pastons' servants and taken them to Eye prison. It seems clear there was little the Pastons could do to protect themselves against so mighty a lord as the Duke, especially when he claimed to be acting in the King's name. The Mayor, Thomas Ellis, was wholeheartedly in support of the Duke, and Margaret reported that he had been heard to assert that if the Duke of Suffolk needed a hundred more men, the Mayor would provide them; and if any Norwich man supported the Paston family, he would have him clapped in prison.

Margaret then wrote to John, in October 1465, describing how the Duke's men had ordered the Pastons' tenants at Hellesdon and Drayton to break down the walls of their properties, and then he and his servants ransacked the church, seizing anything of value, and then 'ransacked every man's house in the town five or six times'. She asks John if he could contact some eminent intermediary to speak to the King on their behalf and inform him how greatly they and their possessions were being abused.

It is amazing how feisty in spirit Margaret remained in the most frightening of situations and despite the fact she was not in good health at this time in 1465, for at one stage John writes her an anxious letter referring to her being 'sickly' and begs her to take her ease and not drive herself beyond human endurance. Clearly, he felt he could entirely depend upon her to act on his behalf while he was absent; but what would he have done, one wonders, if he had not such a formidable wife at the helm? The situation is reminiscent of Emma de Guader being left to 'man' the Castle in 1275 while her husband Ralph was away. A novel new history of Norwich deserves to be written in which the involvement of women in all the main developments of the city's history is highlighted.

John died in London, aged forty-five, in May 1466. It turns out that Margaret was the stronger of the two, both in personality and health. Having endured far more strife and hardship than he had done, she survived him by eighteen years.

Elm Hill still retains much of the character it must have had when the Pastons were resident there. Dragon Hall – the property owned by Robert Toppes, Margaret's relative – is now one of the most beautifully preserved medieval buildings in the city. It is also the only surviving example in Western Europe of a medieval trading hall built by an individual merchant rather than a guild. The great hall has a superb crown-post roof and seven bays. The building acquired its name from the fourteen finely carved dragons between the beams, but now only one of these remains.

It was sold after Toppes' death in 1467, and became a dwelling house for succeeding wealthy citizens. By the twentieth century, it was divided into smaller residences, including a butcher's shop,

and the area to the rear was occupied by cheaply built dwellings for the poor. These were demolished by the city council as part of a slum-clearance programme in 1937. Dragon Hall itself had been increasingly neglected, but in 1954 it was designated a Grade I historic building, and was acquired by the council, who arranged for its basic renovation. Since 1987, the Norfolk & Norwich Heritage Trust has taken it in hand, and the building is now not only fully restored and improved, but has a new lease of life as a visitor attraction, with facilities for educational visits and activities, meetings and functions.

# 1500–1600

## Norwich in the Tudor Age
'I have laid up in my breast such goodwill
as I shall never forget "Norwich" '

The sixteenth century was a period during which the city
experienced both improvements and decline. The city was
devastated by fires during the first decade. One occurred in
1505, and two more in 1507, of which the worst commenced on
25 April in Tombland near the Popinjay tavern, and, spreading
towards St Andrew's parish, raged for four days. The second fire
commenced on 4 June in the Colegate area. Many of the city's
medieval buildings must have been destroyed, and the Britons
Arms tavern is said to be the only building in Elm Hill that
escaped the flames. More than 700 houses were lost in the two
blazes, and it was some time before these areas could be rebuilt
and occupied again.

The fires had one advantage in that they provided an
opportunity for developing the sites in more up-to-date style.
The City Assembly ordered that new properties should be roofed
with tiles rather than easily flammable thatch, and later on in the
century these orders were reaffirmed and buckets and ladders to
fight fires were made available in every church. The sixteenth
century generally was a period in which the wealthy trading
classes lived in opulent style and were keen to build fine houses
to display their prosperous status. They also provided funding to
renovate local churches and other public buildings. St Andrew's
church contains a fine chapel and memorial to Sir John Suckling.
St George's, Colegate, has the terracotta tomb chest of Robert
Jannys, Mayor in 1517 and 1524, and St Peter Parmentergate in

King Street was completely rebuilt in the early sixteenth century, probably with contributions from the wealthy 'parmenters' who lived in the area – 'Parmentergate' was the street occupied by the leatherworkers or parchment makers. An elaborately decorated council chamber was provided for the Guildhall in 1535, emphasising the prosperity and enhancing the prestige of the city, with its fine oak panelling, a sixteen-bay roof with ornamental carvings, and magnificent stained-glass windows.

However, despite the wealth of the few, there was a slump in trade, and the poverty of many of the inhabitants is made clear in the frequent references to poor relief, and punishment of beggars and vagrants in the official court and Assembly records of the period. Worsted cloth exports were declining, and those involved in the weaving and building trades were moving away, often to avoid payment of city rates. The craftsmen's conditions of work were controlled not only by their guilds, but by the city Corporation and central government, and the number of regulations involved tended to stifle productivity. For example, in 1511 the Worsted Weavers' Guild ordained that all members must have served a seven-year apprenticeship, and master weavers were restricted to four apprentices and five looms so could not expand their business even when demand for their products was high. Despite the official regulations, locally produced wool was often smuggled across the sea to the Low Countries or sold to weavers in Suffolk or Essex, resulting in reduced employment for the city weavers.

Today, as you wander about the market area and the city streets, everybody seems affluent, well dressed, well fed, with plenty of money to spend. The exception is the few who beg or busk at street corners. Some sell copies of the *Big Issue*, calling out to passers-by; some just sit with cap in hand awaiting the jingle of coins; and some busk on the pavements, often accompanied by a dog, strumming a guitar and singing popular songs, old Beatles or Bob Dylan numbers. Most have surprisingly good voices (the buskers, not the dogs). They are largely ignored by the passers-by, who, intent on shopping, don't like to be reminded about poverty in the prosperous city streets. Also, it's often believed that those who beg need to get off their backsides and do a decent day's

work, or worse, that they are already doing well from social security benefits. But the buskers in particular add variety to the scene, and it can be joyfully uplifting or poignantly sad to hear snatches of favourite songs drifting above the continuous rumble of footfall and traffic.

In the past, before the twentieth century and the welfare state, you would be keenly aware that most of the people around you, men, women and children, were pitifully poor: ragged, dirty, half-starved, even barefoot. Some begged; some might have a few paltry items to sell, such as bunches of flowers or bundles of sticks; some, like the buskers of today, might be singing or playing a tune on a penny whistle or fiddle. But most would just be wandering the streets, hoping for an offered penny or a rotten apple dropped from a stall to eagerly snatch and run off with before some other urchin grabbed it. Often, they were wandering the streets because they had nowhere else to go, like those who 'doss' rough today and can be seen in sleeping bags or wrapped up in cardboard in the shelter of shop doorways. Many were homeless or else living in cellars or garrets in such dirt and squalor that they spent as little time there as possible. Their lives were mere subsistence. Like sparrows, they survived by pecking up discarded crumbs from the pavements; and like the sparrows, they often died quietly in a garret or a gutter during a freezing winter night.

In the early sixteenth century, Norwich was paying £1,704 in taxes – more than any other provincial town in the country. But this was largely paid by the small number of wealthy citizens. The division between rich and poor is made clear in some of the city records. For example, in May 1543, at the City Assembly:

> It is enacted that the Mayor of this city and his successors nor any of them shall not exceed the number of six dishes at dinner nor at any other meal. And that the Aldermen and Sheriffs and any other inhabitant within the said city under the degree of a knight, their successors nor any of them shall not exceed the number of five dishes at any one meal ... And the said diet and number of dishes to be had at Guilds within the said city. And this act to begin from and after Trinity Sunday next ensuing [20 May].[1]

Presumably this was ordained either for reasons of economy or because the poor were suffering severely from lack of food, and riots might occur if the wealthy were known to be greedily stuffing themselves. Even with the restrictions in place, they were probably eating enough at one meal to feed a poor family for a whole week.

References to the hunger and needs of the poor are frequently reported in the city records. In August 1532, the Convocation of Aldermen reported:

> Elizabeth Barret, widow, sayeth that the Saturday Saint Margaret Day [20 July], it chanced her by the Cross in the Market where she see one Hede servant beat a stranger, being a woman, for measuring of corn, and she having pity of the woman helped the same woman, and beat the said servant and so departed thence. And after that she saw one Mother Perne and other women come with a cart with wheat from Conesford, which wheat was taken down out of the cart, by whom she cannot tell, and laid in the Cross upon an heap [i.e. the Market Cross, which provided cover for traders and goods], and the people trade upon the sacks, and much words there were amongst how they sold the wheat [i.e. the price they asked]. And after that they agreed to sell for 4 shillings whereupon the said deponent [i.e. Elizabeth Barret, making the testimony upon oath] set the sacks abroad in the Cross. And after one, Hawes wife, sold a comb of wheat, to whom she knows not, and after that the said Hawes wife delivered the money to this deponent, 4 shillings, and she desired John Rede to keep the same 4 shillings for that she thought if she had put it in her purse … [it might have been thought it was] stolen. And after that this deponent sold another comb after the said price, that is to say to Thomas Sketo, and to one Alys … and to other two persons whom she knows not and received the price thereof and also delivered the same to the said Rede to the intent aforesaid.[2]

The report goes on to say that other women were involved in selling the wheat, and because the wheat was cheaper than the current price they attracted a large number of buyers. The report continues:

These being the principal offenders, as well proved by examination as by witness, and otherwise which caused the late insurrection within the city of Norwich of women there in the market committed and done in selling of diverse men's corns against their wills and setting of prices thereof at their own minds contrary to such prices as the Mayor of the said City had set before that time. In primis Agnes Oldman, Agnes Haddon, Agnes Meredith, Alianora Yong [respited due to infirmity], Alice Pern, Kateryn Tolle, Alice Hawes, Ester Rowe?, Elizabeth Baret, Anna Waryns, Margery Heynes. These shall be tied at the cart's tail and whipped surely with whips round about the market.

The letters 'ff' are marked against some of these names, meaning perhaps *fecit finem*, and suggesting that they paid a fine and were excused the savage and humiliating punishment. The report makes it clear that there was always a big demand for cheap grain, the staple diet of the poor, and these poor women saw an opportunity to make money from it, but suffered the consequences.

However, in May 1550, at another Assembly, cheap wheat was made available for the needy:

This day is granted as well by the aldermen as by the common council now assembled, that certain numbers of quarters of wheat and other grain shall be provided and bought for the city to avoid a great dearth and scarcity that is thought to be, and like to ensue hereafter within the said city according to a book thereof made. And certain sums of money to be collected by way of loan towards the same. Which grains shall be sold in the markets at such reasonable prices to the poor, as shall be thought most convenient.[3]

And in the following year, May 1551:

There shall be baked of the common store of the City of grain at the Common Hall, certain bread for the poor people to be sold to them for the term of a fortnight and as then shall seem good to continue.[4]

That is, for as long as there was a need in a time of food shortages.

But the numbers of the poor and providing for them was an increasing problem and other measures had to be introduced. The Assembly in January 1557 stated:

> Upon consultation had by this house as well for the relief of the poor as also to see them set on work, and not to lie idly: It is ordered that (certain named people) shall see such poor folks as be able to work and take order in every ward how they shall be set to work from henceforth from time to time.[5]

And in April of the same year:

> Whereas the City has of late been charged with diverse and sundry poor folks come out of the country[side] which hath not continued here by the term of three years, according to the statute; for reformation whereof, be it enacted by this Assembly that no person or persons having any tenements or tenantry in his or their hands shall let his tenement or tenantry to farm to any strange poor person not having to live of himself nor to get his living, nor suffer any such poor persons being strangers that have not had their most abiding here within this city three years last to remain or dwell in any such tenement or tenantry, upon pain to lose and forfeit for every tenement so let, 20 shillings ...[6]

And in August of the same year:

> Upon consultation held for the relief of the poor, it is ordained that the Aldermen of every ward shall confer with every inhabitant there what he will quietly be content to give to the relief of the poor weekly, and make a book thereof, and certify the same, and that money to be given and distributed weekly to such poor people as be blind, lame, sick and bed-rid. And besides it is ordered that no poor folks shall go about a begging, but such as shall have and wear a badge, and that in such circuit as shall be appointed them.[7]

This new ruling discriminates between the poor – who are clearly unfit to work and therefore deserve support – and those who

might be able to earn a living and were increasingly expected to do so. Apprenticeships were provided for poor youths, and women and children were employed in spinning and knitting under the supervision of overseers appointed by the city officials. Those who had recourse to begging in the streets now had to receive official permission from the city authorities, be identified as such, and could only beg in those areas allocated to them.

The winter of 1570 was particularly harsh. During the Tudor period, British winters were colder than today, the climate affected by the 'Little Ice Age', and even the River Thames in London froze over from time to time. Snow fell throughout Christmas more heavily than anybody could remember and piled up so deeply in the narrow streets that the citizens had to cut a path between the piles of it banked on either side.

The fierce frost continued for nearly eight weeks, with the first thaw occurring on Candlemas Day and causing such a rush of water from the melted snow that the River Wensum burst its banks and flooded Coslany to the north. The flood brought down houses and buildings, and 'removed the stools in all the churches on the other side of the water except St Augustine's'. Families trapped on the upper floors or roofs of their homes had to have ale, bread and fish brought to them by boat in order to survive until they could escape by boat, or until the waters subsided and they could descend to ground level again.[8]

In addition to providing for the needs of the poor in these periods of severe winters and poor harvests, the city officials also had to cope with a growing number of vagrants. Towards the last quarter of the sixteenth century, the Mayor reported that the city was swarming with tramps, and in 1570 a census recorded 2,300 poor residents, excluding vagrants, in a total population of about 12,360. During this decade, begging was forbidden, and anybody found giving to beggars was fined. Local residents found begging were committed to the Bridewell, a gaol and 'house of correction' for the idle and unemployed. Tramps were arrested, whipped and turned out of the city, and any strangers who arrived and were without employment were expelled so they could not become a burden on the parish rates.

Even those found lodging beggars or vagabonds were punished. At the court sessions in April 1562:

> Robert Morgan, labourer, was committed to prison for lodging and harbouring young and idle vagabonds. And to promise that if he at any time after be taken lodging any stranger or vagabond then he is contented to lose one of his ears.[9]

'Contented' was probably not the word Robert Morgan would have used. One wonders if he was a sort of Fagin character, sending his young urchins out on the streets with the message, 'You've gotta pick a pocket or two, boys. You've gotta pick a pocket or two!'

One beggar who was treated rather differently was Edmonde Abbott. The court sessions dealt with his case in December 1561:

> Edmonde Abbott being examined this day of the order of his begging sayeth that it was in the manner as followeth:
> 'I desire your Mastership to be good and friendly to a poor man that hath been hurt and maimed in the Queen's affairs, maimed in my arm, as your Mastership may well perceive.'
> 'Alack, good fellow, that is great pity, how came it to pass?'
> 'I was hurt with a piece of ordinance [i.e. resulting from gunfire], if it may please your Mastership.'
> 'Where did you serve when that you were hurt?'
> 'I served in one of the Queen's galleys, called 'Spedewell' and was hurt being on the narrow seas.'
> 'How long is it since you were hurt?'
> 'I was hurt at Whitsuntide was twelvemonth.'
> 'Who was then the Captain of the galley?'
> 'Captain Holden was Captain of that galley.'
> 'In what conflict were you hurt?'
> 'I was hurt between Portsmouth and the Isle of Whyte, being matched and coupled with one of the French King's ships.'[10]

It seems clear from this dialogue that the Mayor (his 'Mastership') treated the wounded seaman courteously, and although the result

of Abbott's appeal is not recorded in the published transcripts of the Records of the City of Norwich, it is likely that he was awarded an annual allowance for his maintenance, as other incapacitated officers and servants often were. No doubt, checks were first made to ensure that the sailor had provided an honest report and really had served with Captain Holden on the *Spedewell*.

There was also unlawful lodging of gypsies, or 'Egipcions' as they were termed in the city records. The court books for July 1544 record:

> Bartholomew Bale sayeth that Mr. Chasye desired him to go with him to Debney's house and so he did, and then and there Mr. Chasye said to Debney that he ought to have had commandment as well of my lady as of Mr. Mayor, to receive and lodge the Egipcions, and that he, the said Bale at the commandment of my lady, searched Banyard's house, and that he said that 20 Egipcions had been enow [enough] for that street.[11]

Apart from the 'idle poor', beggars and vagrants, being imprisoned or expelled – even those who clearly couldn't cope without charitable or medical support – were sometimes treated in the same way. The court in March 1541 banished a man because he was behaving in a threatening manner in public places:

> It was agreed by Mr. Mayor … the Monday next after Passion Sunday in the 32nd of King Henry VIII [4 April], that Raff Chamberleyn being vexed with a devil and being lunatic and so thereby misusing himself to the great peril of the King's liege people within this City of Norwich, shall be banished from the said city. And it is further agreed that the same Raff shall depart from this said city on this side Thursday next following, and thereto not to repair [return] upon pain of imprisonment by the space of one month.[12]

It seems odd that Raff was only banned for one month, because if he was deranged it was unlikely that he could recover in such a short time, and he was likely to reoffend again. But the understanding of mental illness was very limited at that time,

and maybe the authorities thought that the 'devil' might cease to torment his mind and that he could be a peaceful, law-abiding citizen again. It is more likely that he went off to another town and annoyed people there, and was similarly expelled and maybe ended up in prison or a permanent asylum of some sort. This was often the fate of those in Raff's condition, unless they had a family to care for them.

Sometimes it is not clear in the court accounts exactly what crime a person has committed that required punishment. One such is the case of John Wyllows, who was sentenced in January 1549:

> This day Mr. Mayor hath commanded that John Wyllows for his evil demeanours to be set on the cokestoole with a ray hood (striped) upon his head and so to be carried about the market. That done, to be set in the stocks.[13]

The cock-stool, or cucking-stool, was usually for the punishment of scolding wives, or those who quarrelled with their neighbours. Perhaps John Willowes had a surly temper and was taken to court for upsetting his family or fellow workers. It seems strange to us now that, in earlier centuries, public punishment and humiliation was the way of dealing with offenders. Today, those who commit crimes are usually only publicised by the media, newspapers or TV, and their punishments hidden from view, apart from the few who are sentenced to perform 'Community Payback' work.

The courts also had to deal with the punishment of servants. In January 1559, the records state that:

> Thomas Huson, servant to Nicholas Baker of ye parish of St. Stephen, was committed to ward and ordered that he shall have a clog on his leg for that he with one of his fellows upon Wednesday the 4th of January about 9 or 10 of the clock in the night, their master and dame being from home, went to the house of Margaret Rose in the parish of Alderhallowes [All Saints], and had a capon lying at the fire at such time as Mr. Myngey entered into the house which was after 10 o' clock in the night.

Memorandum: that where the 5th of February anno 1557, Margaret Rose of the parish of Alderhallowes was appointed to sell beer, ale and bread as in the book of Recognisances appeareth: It is ordered that from this day forth, the said Margaret shall not use to sell any bread, beer or ale upon pain of [words missing] for that she harboured and housed the servants of Nicholas Baker of St. Stephen's at unlawful times, contrary to her bond. And she with her suertes [sureties, those who agreed to assure the payment] paid their fine as in the hamper book appeareth.[14]

A clog was a thick piece of wood attached to the foot of miscreants to prevent them from running away. A capon was a cockerel, in this case obviously being cooked to eat – the word also sometimes refers to types of fish. The 'book of Recognisances' was the official court record of those permitted licences for certain trades and services. The 'hamper book' was perhaps a record of fines relating to the catering trade.

In June 1561:

Marget Bryne, about the age of 8 years abiding with Mr. Holl was brought before Mr. Mayor for picking of a purse of one Mrs. Holle's servant. And upon the first examination, she declared that her mother and her grand-mother had the money. Howbeit, upon further examination, she declared and confessed that she delivered the money to one Elizabet Seman abiding with Gose of Higham of the age of 10 years. Who, being examined, confessed that she received [word missing] pieces of the same money. Whereupon they have had punishment of whipping with rods.[15]

July 1561:

Whereas one John Felde, servant to Robert Crispe of Saint Stephen's, confesseth that he did absent himself from his master, his service and went running about the country with a gitterne … for that default he was committed to prison and there remained three days, and thereupon was admitted to his master again.[16]

A 'gitterne' was a cithern, a sort of stringed instrument similar to a guitar. Like some teenagers today who run off to form rock bands, it seems John was more interested in playing music than settling down to the drudgery of his master's trade. No doubt he had his gitterne confiscated before he could start work again, or smashed over his head.

Like John Felde, there was a large number of apprentices receiving training in a variety of trades in the city. Some had good masters, did well and prospered, maybe taking over the management of their master's business when he retired or died, or setting up in business on their own account. Because they led God-fearing lives we learn little about them, but other apprentices often appear in the court records, either because they were badly treated, or because they misbehaved and got into trouble.

In December 1561, William Bannocke was apprenticed to Brian Talbott. He ran away from his master three times, and was no doubt caught and punished, but after the third occurrence Talbott decided that he needed official punishment and, following the court appearance, Bannocke was 'ordered that he shall have a ring about his neck according to the statute'. We don't know the details of the case, but it may be that Bannocke was badly treated, which was why he ran away. Despite abuse, he was legally his master's 'property' and compelled to return to his service.[17]

Another apprentice, Edward Cheney, may also have been so badly abused that he retaliated and attacked his master. The court case in December 1561, reports:

> Whereas one, Edward Cheney, being servant and journeyman with Thomas Jackson, confesseth that on Monday seven-night being the 24th day of November, did break the said Thomas Jackson's head with a pair of tailor's shears, is committed to prison.[18]

The case is curious, because three days later the court ordered that William Cheney, servant to Thomas Jackson, should be set in the stocks 'for that he break his master's head'. Had the clerk recorded Cheney's name incorrectly, and are William and Edward the same apprentice? Or was it two separate attacks by brothers? The report adds that Jackson employed a total of eight journeymen

and nine apprentices, so he had a considerable business, obviously in the cloth trade, as tailor's shears are mentioned. He, too, was imprisoned on 6 December, 'for that when William Cheney his servant had broken his head [he] did not complain to Mr. Mayor so that justice could not be ministered in due time'. Presumably the poor chap had such a sore head he was in no fit state to complain immediately. What a sorry business it was. There must have been a great deal of ill-feeling when normal work was resumed after the miscreants were released from prison, unless Jackson decided to expel them from his business.

One homeless vagrant, Robert Browne, aged twelve, was found living rough in the streets having travelled to the city, it seemed, from his home in Suffolk, and was then unable to find employment. But he had a happy ending. The court report of January 1559 states that:

> One, Robert Saborne of the Parish of St. George of Muspole, within the Ward of Colegate, being moved with pity, was contented to accept and take the said Robert Browne into his house and service and to use him with meat, drink and cloth [clothes], as is meet for one of that years. And after when he shall come to the years of 14 years, to take him to prentice for 9 years and to teach him in his occupation of dornix weavers craft, as he hath done other of his prentices heretofore.[19]

'Dornix' was a type of thick cloth used for bed curtains, coverlets, wall-hangings, and the carpets used for covering chests and tables.

As you wander around the city centre today, how does it smell? Very nicely, thank you. There are usually no prevalent pongs, although different areas have their own flavourings depending on their situation and the types of businesses located there. You get a general whiff of car fumes, and then those wafts of assorted fragrances wherever numbers of people congregate – body perfumes, aftershaves, deodorants, hair lacquers and gels, which can sometimes take your breath away and be almost as offensive as toxic smells.

The different shops breathe out the aroma of their trades – the rich smell of coffee from street cafés, the smell of beer from

pubs, medicines mixed with cosmetics from the chemists, the nose-tingling and refreshing aroma of fresh fruit and veg, and the sweet fragrances of brightly coloured flowers from the market stalls. One of the strongest perfumes comes from LUSH, which sells hand-made soaps and cosmetics on the corner of White Lion Street. Fish stalls have particularly pervasive odours and then there are the pongs from the gent's toilets in the Market, and those places where lads urinate on the street after a skinful of lager. Indeed, to walk around the city centre and concentrate on absorbing the variety of smells can be a fascinating experience. Why not get a friend to guide your arm, and do it with eyes closed, then appreciate how powerfully the city conveys this aspect of its character for the visually impaired, and for animals, such as your dog?

But if you were living in the medieval and Tudor periods, you would find the pongs of the city centre almost overpowering in their horribleness. They were only endured because residents were used to them. Visitors, especially from the rural areas, found them much more offensive. In the medieval period the streets in the city centre were often covered with human excrement tipped out of windows, and animal dung from farm beasts and wandering dogs. In addition, there was waste matter, offal, from the killing of beasts in the butchers' quarters, and fish bits from the fishmongers, and tanning and leather-working of all kinds was a major business and would have produced its own waste and offensive smells. So bad were the odours that richer people and visitors found it necessary to walk around with a handkerchief to their noses, or with an orange stuffed with spices, or a handful of herbs, which would also prevent breathing in odours of toxic waste too deeply and thus causing illness. The streets were often so messy with accumulated mud and filth that those who could afford it wore clog shoes or pattens to protect their footwear and stockings.

As the situation got worse in the later medieval periods, regulations were introduced for restricting the dumping of waste matter in the streets, for cleaning of gutters and for employing street cleaners, 'scavengers', as they were called. Traders were expected to wheel their waste products outside the city in barrows to dumps. There was always a tendency to dump waste

and rubbish in the river, which could cause pollution and affected the drinking water supply, apart from itself creating nasty odours – especially in hot, dry weather.

In March 1380, the City Assembly had decreed that: 'No one, of whatsoever condition he may be, shall carry any muck by ship or boats, by night or day by the King's river',[20] and heavy fines were imposed on offenders. In addition, no heaps of muck or refuse should be left in the Market Place, with similar fines imposed. The word 'muck' usually implied manure, i.e. animal droppings from the beast markets, but also any form of smelly waste. It is interesting to note that roaming beasts not only caused the streets to be smelly and unhygienic, but could also be a hazard of other sorts. An Assembly meeting in 1354 decreed:

> Whereas great injuries and dangers so often have happened before this time in the city of Norwich and still happen from day to day in as much as boars, sows, and pigs before this time have gone and still go vagrant by day and night without a keeper in the said city, whereby divers persons and children have thus been hurt by boars, children killed and eaten, and others when buried, exhumed, and others maimed, and many persons of the said city have received great injuries as wrecking of houses, destruction of gardens by such kind of pigs, upon which great complaint is often brought before the said Bailiffs and Community … it is ordained and established that each man or woman … who has boar, sow or other pig within the said city, that they keep them within their enclosure as well by day as by night, so that if any kind of pig be found going about at large without a keeper, that he be heavily amerced by the bailiffs of the city, and also that … the said pigs may be killed by anyone who shall be willing to kill them without being interfered with.[21]

Using the river as a dumping ground for waste and rubbish was an ongoing problem for the city authorities. In February 1467, the Mayor and other officials agreed to provide

> suitable remedies and … remove those things which are injurious to the said river … every one whether he be occupier, owner or

farmer shall heap up over against his dwelling before the [?] day of May now next coming, all the filth in the streets opposite his dwelling to the middle of the street, and then the owner of that dwelling shall be bound to cause to be carried away and removed all the dirt and filth out of the King's Street before the said day … And in the same way … all the wardens of churches shall be charged to the middle of the streets opposite to the churchyards at the expense of the parishioners, and moreover Convents of religious persons shall be called upon to perform the same in due form on their own behalf … and if any one through delay, neglect or malevolent disposition shall not perform the premises … that transgressor shall forfeit forty pence for every offence without any indulgence … Moreover they have ordained that every one dwelling in this City who will buy hay, fuel, heather, straw or hair, or anything to him useful shall not permit the country people to strew or deposit any things, which putrifying may accumulate in the streets of the city under the penalty of 12 pence for every offence … And moreover they have ordained that at the assembly to be held annually in Lent, the Mayor [and other officials] … shall elect and assign two supervisors in every Aldermanry [Ward] for carrying out all the premises, that no excessive putrifaction may take place in future in the King's streets …[22]

'Dirt' was distinguished from 'filth', and filth was any waste matter that was foul-smelling, toxic, and a health hazard, so included human and animal excrement. Thus the city was now getting to grips with keeping the narrow streets clean and free of such matter that either blocked the gutters and cockeys – the main drainage channels – or was carried by rain into the rivers.

In June 1518, further provision for street cleaning was made, with the declaration that

from henceforth shall be had two common carts for the avoiding of the filthy and vile matter for which it is granted to be levied yearly upon the Commons [details of the payments from each Ward follow] … And every person dwelling within the said city shall gather all such filth and vile matter against their own grounds

and lay it upon round heaps ready to the cart weekly, and that the said heaps to be laid away from the channel so it be not ready to be washed into the cockeys etc ...[23]

As the 'filthy and vile matter' was only collected once a week, it must have become very smelly and fly- and rat-infested, especially in the hot summer months; but at least it was an improvement on festering in the streets or rear yards for months at a time.

Street 'filth' remained a problem well into the sixteenth century, and in June 1532, at the City Assembly, the following improvements were introduced:

For as much as the King's River is sore in decay, and like to be in grievous further decay, and the more rather for the weeds growing in the same river be not yearly substantially cut and avoided out and from the same river, and also that the filth continually resorting into the same river by cockeys, gutters and other means be not successively avoided, but evermore suffered to augment and increase more and more, the which in short is like utterly to decay the same river, the which God forbid. For reformation whereof be it at this present time and assembly ordained and enacted that every Justice of Peace within the same city shall find one workman yearly in the said river 4 days, every other alderman to find one man to work in the same river yearly 3 days, every Broder [embroiderer?] of Saint George's Guild 2 days, and every other inhabitant to be charged yearly to the same river and work by the discretion of the Mayor and his bretheren Justices of the Peace or the more part of them. And that every owner of house or ground adjoining to the river from the Mills unto the South tower in Conesford, yearly after the Feast of Pentecost, as oft as need shall require, cut the weeds in the midst of the river and avoid the same weeds out of the same river. Provided that barkers [tanners], dyers, calandrers [cloth processors?] parchment makers, tewers [converting skins into leather], saddlers, brewers, washers of sheep and all such great noyers [polluters] of the same river to be further charged than other persons shall be, and that by the discretion of the Mayor and Justice of Peace as is aforesaid ...[24]

It is clear from this ordinance that it was the leather workers who were the chief offenders in creating pollution and it was also their trade that caused a lot of the odours and waste in the city centre. Part of the process of tanning the leather may have involved the use of dog faeces and human urine – so a very smelly process indeed.

Despite this legislation, in March 1552 the City Assembly had to introduce stricter penalties, because the streets remained 'foul and filthy ... and also the said river decayeth and filleth more and more', i.e. with rubbish, weeds, and waste from local businesses.[25] So it was agreed that certain Aldermen should be empowered 'to arrest and take all such sturdy and disobedient persons as shall sturdily resist, disobey and refuse to do such lawful and necessary things as are thought meet ... [for] making clean of the said river and streets'.

It seems that by the sixteenth century the city thoroughfares were being improved by paving. In September 1559, an Act for the Paving of Streets was introduced at the City Assembly:

Whereas time out of mind there hath been a comely and decent order used within this city for the paving of the streets of the same city, which thing hath not only been a great ease and healthful commodity to the inhabitants of the same but also a goodly beautifying and an occasion that diverse having access to the same city from far and strange places have much commended and praised the same and the Magistrates in the foresight for the maintenance thereof. And for that now of late time through the great greediness and obstinacy grown into diverse men's hearts which neither regard the commodity of health, their own eases, and their neighbours, nor yet the beautifying of the city, have suffered many comely and fair houses adjoining upon the common and high streets in diverse and sundry places within the city to fall in ruin and decay, and some prostrate to the ground in the which good householders and citizens have heretofore dwelt, and also suffer the paving of the street against the same houses or ground to decay and be broken to the great discommodity and annoyance of the neighbours and travellers through or by the same, and to the dis-worship of such as be Magistrate at this present ... Be it

therefore by the consent of Mr. Mayor [and the other city officials] at this present Assembly enacted, that all manner of persons having house, houses, ground, or grounds situate and lying within the walls of the same city, and adjoining upon any common street of the city against which house etc. the street hath heretofore at any time within twenty years now last past been paved with stone, shall from and after the Feast of Saint Michael the Archangel [29 September] next coming, upon reasonable warning given by the Mayor ... cause the same to be repaired and mended again with stone according to the use and custom of the city, within one quarter of a year at the uttermost next after such warning given.[26]

The penalty for non-compliance was for the householder or tenant to pay a fine of sixpence for every yard of ground not paved, or have some of their goods and chattels confiscated.

The dissolution of monasteries and priories during the reign of Henry VIII resulted in changes in the city's appearance, Norwich losing fourteen parish churches during the century. Some were demolished, and some gutted and left to fall into ruin. One, St Mary the Less, in Queen Street, was provided by the Corporation for immigrant weavers from the Netherlands to use as their cloth hall. The period 1538 to 1548 saw not only the closure of monasteries, but also the colleges of secular priests and chantries. The Franciscan and Augustinian buildings in King Street, and the Carmelite building in Cowgate, were soon replaced by secular buildings. The Act abolishing chantries would also have led to the closure of the various hospitals to which they were attached, but the Corporation took them over for use as accommodation for the poor or as isolation units during times of plague.

The Great Hospital, St Giles, was also taken over by the city authorities in 1547, and became known as God's House, providing accommodation for forty old men and women and offering hospital treatment with the employment of a surgeon and other medical specialists. The former charnel house chapel of the priory near the west front of the Cathedral was converted into a boys' grammar school in the reign of Edward VI. Other

areas previously under ecclesiastical control were now greatly diminished, allowing the city authorities to improve them for the public benefit.

The growth of Protestantism during the reigns of Henry VIII and Edward VI also affected city life. About six people were burnt at the Lollards Pit for heresy. They included Thomas Bilney, who preached at Trinity Hall, Cambridge, against the superstitious Catholic worship of saints and relics and was subsequently imprisoned in the Tower of London. Following his release, he continued to promote his views, leading to his imprisonment in Norwich in the dungeon beneath the Guildhall. He refused to recant, and was burnt at the stake at the Lollards Pit in Norwich for heresy in 1531.

In June 1546, Edward Bretten, a shoemaker, appeared in court to be punished

> for that he read openly upon the Bible in Christ's Church [the Cathedral] ... to Alan Gifford ... and to William Grey contrary to an Act made. And the Friday next after Corpus Christi aforesaid [2 July] he examined, confessed the matter, and thereupon, the said Alan Gifford and William Grey upon consideration are dismissed out of prison whereunto they were committed for the same.[27]

An Act of Henry VIII had forbidden the reading of the Bible in English in churches. It seems that in this case the city authorities were tolerant and no punishment was exacted against Bretten and his companions. In any case, the following year Edward VI ascended the throne and Protestantism became the accepted form of religion. The English version of the scriptures, initially permitted by Archbishop Cranmer to be available for every parish church in 1539, was permitted to be read again.

In 1565 the city authorities made arrangements for thirty families of religious refugees from the Netherlands to move to Norwich. They were Protestants escaping from Spanish Catholic persecution. They were a mixture of Walloons who spoke French, and Dutch who spoke Dutch or Flemish. Other refugees had already arrived, and more followed in large numbers so that by 1579 their numbers totalled about 6,000, adding to a native population of about 10,000 – so a very large proportion.

Obviously such large numbers would have a big effect on city life and trade. Those that had been invited were chosen because they could demonstrate new methods in cloth manufacture and teach their skills to local weavers. This didn't quite work out as expected because the 'Strangers', as they were known, initially preferred to keep their skills to themselves, but they did revive the prosperity of the cloth trade and export markets.

There is usually ill-feeling when large groups of foreigners suddenly inhabit a particular area, and this was the case in Norwich. They were seen as business rivals who could put local weavers out of work. In 1570, some of the Norfolk gentry, headed by John Throgmorton, attempted to raise 'a number of men with sound of trumpet and beat of drum' and have the Strangers thrown out on Midsummer's Day. There was little public support for this antagonism, but new regulations, governing what the immigrants should and should not be allowed to do, were introduced at an Assembly in April 1571. They were not permitted to walk in the streets after the curfew bell was rung, or buy skins for processing without permission, and were restricted in their trading activities – shoemakers could only work for or sell their goods to other Strangers – and they were forbidden to bake white bread. Gradually they became more integrated and accepted, because they helped trade prosper, and by the close of the century they were able to become freemen of the city on the same terms as local residents.

Despite these changes, the Strangers tended to remain a minority community, chiefly occupying the industrial area to the north of the city, while their religious beliefs also set them apart. They formed two distinct groups, the Dutch immigrants worshipping in the Blackfriars' Hall, and the French-speaking group preferring the church of St Mary the Less. They also had their own forms of government, and local defence force, and their cloth hall in Blackfriars'.

Beside the entrance to the Castle Museum, there is a plaque which reads:

In 1549 A.D. Robert Kett, yeoman farmer of Wymondham was executed by hanging in this castle after the defeat of the Norfolk

rebellion of which he was the leader. In 1949 A.D. four hundred years later this memorial was placed here by the citizens of Norwich in reparation and honour to a notable and courageous leader in the long struggle of the common people of England to escape from a servile life into the freedom of just conditions.

As stated, Robert Kett was a prosperous yeoman farmer living in Wymondham, about nine miles south of Norwich. In the second week of July 1549, trouble flared up when Kett with a group of local men started pulling down the hedges and fences which had been constructed to enclose what had been common grazing and crop-growing land, but which had been taken over by landowners to create larger grazing pastures for sheep. The cloth trade was highly important to the prosperity of the city, and the sheep's fleece was used for the manufacture of worsted fabric. Men who had previously been employed to till the soil and grow crops were now becoming unemployed because flocks of sheep only needed one shepherd to tend them. The tenants whose ancestors had farmed the land for centuries were driven out of their small-holdings and cottages, and often rendered homeless. They had little means of support or opportunity to appeal, particularly now that Norwich officials were dealing harshly with those who entered the city seeking work but were often forced to beg.

Kett was a charismatic character and soon won support from others who were seeking leadership to voice protest against the unjust situation. An account of the rebellion he led, entitled *The Commoyson in Norfolk, 1549*, was written by Nicholas Sotherton, within about ten years of the occasion of the events.[28] It is thought that he may have been the son of the Nicholas Sotheron who was a Mayor of Norwich in 1539. He shared the same views as the leading officials in the city, condemning the insurgents for their terrorising of the ruling classes and gentry. His account is based on the recollections of eyewitnesses including Augustine Steward, a leading citizen in attempts to suppress the rebellion.

Sotherton records that Robert Kett sympathised with the actions of those who started pulling down the fences and hedges, and

thereto suffered some of [those] with him in company to cast down a certain close of his in Wymondham, therewith encouraged them that such as would not do the like [i.e. other landowners], wished theirs to be done in like case, which so animated the hearts of such of them into whom Rebellion was easily entered, that they proceeded further to do the like, and specially in Flowerdew's close.[29]

Kett then said he would support them in their resistance to enclosures and the rebellion started in earnest,

whereupon of a small company at first not above five or six persons, they increased to servants and vagabonds that they would not be resisted, and the same Robert with them, after they had ended their purpose at Wyndham, came forward to Norwich ward to do the like, and upon Tuesday afternoon being the ninth day were come as far as Eaton Wood within a mile of Norwich, which being heard of by divers evil disposed people in Norwich, there assembled unto them divers vagrant persons of the said City of Norwich, who ... were easily assenting to that Rebellion.[30]

We have already seen that there were many poor people in the city at that time, often harshly treated by the authorities, who had little to lose and perhaps much to gain by joining Kett. In addition, he had already offered to support the initial insurgents from his own funds, which would be welcome news to those who were poor and starving. The numbers were also swelled by 'the mob', those young men already referred to in other riots, who had little to do and were always looking for a bit of sport and excitement. But there were also those who genuinely believed in Kett's cause – honest, hardworking respectable citizens who could understand the problems enclosures were causing and wished to see the laws changed to protect the sufferers. They were also pleading for general social reform, with the prayer 'that all bond men may be made free'.

The insurgents decided to occupy the place on Mousehold Heath called Mount Surrey, originally St Leonard's priory, but later acquired as a residence for Henry Howard, Earl of Surrey.

As Surrey had recently been executed in 1547 by Henry VIII for treason, presumably the place was unoccupied. Kett's followers' camp was centred near a large oak tree that became known as the Oak of Reformation and stood roughly where the water tower is now positioned near Quebec Road.

Kett was a keen supporter of the Protestant Reformation, and so one of the first things he arranged when they were settled at Mount Surrey was to procure 'a Priest to minister there morning and evening prayer in the English tongue, then newly begun to be frequented'. In fact the English version of the Prayer Book had only been authorised for use in churches in June of that year, and there must have been many priests and parishes reluctant to make the change. Sotherton also states that Kett chose

> the best men of life and religion to be their Captains, among whom they chose one, Robert Watson, a preacher in those days of good estimation, and Thomas Codd, Mayor of the City of Norwich, and Thomas Aldrich, of Mangrene [about] two miles from Norwich, a man of good wisdom and honesty and well beloved.[31]

Sotherton states that these three were unwilling to join the conspirators, but were compelled through fear. Also they were awaiting a response from the King's officials in London, and presumably hoping that an army would be marched to Norwich to put a stop to the rebellion.

During this period, many more people came to support Kett's group; Sotherton records 20,000 in the space of three or four weeks, although other sources suggest fewer. Under Kett's direction, they organised the collection of armaments – 'shot, powder, and ammunition', food including corn and cattle, and money. In fact, the Norwich residents were so intimidated by this huge force of men that they willingly brought their cattle and goods, meat, bread and ale in order to prevent any attacks upon their homes, wives and children. Despite this, it seems that many gentlemen in the city were captured and imprisoned, some in the Guildhall dungeons and in the Castle, which was now in the hands of the insurgents. They also compelled the Mayor to provide money from the city coffers, and guarded the gates of the city so that no

gentlemen or other citizens should escape, threatening to set fire to the whole city if their demands for food, money and arms were resisted.

After a period of about five weeks, a herald was sent to Norwich in the King's name. He made a public announcement on 21 July, declaring the king's pardon on all the rebels, requesting them to return quietly to their own homes. Some agreed; but Kett refused, declaring that he had in no way offended the King and so had no need of pardon. He encouraged as many as possible to remain in league with him and continue to pursue their stated aims. Mayor Thomas Codd, Thomas Aldrich and others agreed to the herald's request and returned to the city centre, and released all the gentlemen who had been imprisoned by the rebels in the Guildhall and Castle. They also organised the citizens to resist the rebels, keep a watch out for any attacks and prevent them from gaining access to food or money.

Kett then sent a messenger to the Mayor, stating that unless he 'would suffer them to enjoy the City as to make their provision as they had done before ... they would enter the City by force'. The Mayor retorted that their entry was forbidden, and from henceforth they would be considered outlawed traitors. The city officials then started organising their archers and prepared to do battle with the rebels as they marched down from Mousehold Heath. Kett's men were 'so impudent ... and so desperate' that they gathered up the arrows that fell among them to shoot back. The vagabond boys, even though the arrows were flying thick around them, showed their contempt by dropping their breeches and displaying their bare arses to the attackers – 'which so dismayed the archers that it took their heart from them'.

The rebels also observed that the citizens were lacking sufficient gunpowder for their arms. So, taking advantage of the situation, the same

> ragged boys and desperate vagabonds in great number with halberds, spears, swords, and other weapons, and some with muck forks, pitch forks etc. hastily came running down the hill and took the river most desperately marvellous to the beholders, as so suddenly abashed them that the Gunner feared to shoot.

In fact, he was so frightened at being suddenly surrounded by so many rebels that he fled, and the rest of the city defenders fled with him. The rebels then started flooding into the city, and marched to the very centre, assembling at the Market Cross.

The King's herald departed to bear news of this latest stage of developments to the court in London. Kett and his troops fell upon Mayor Thomas Codd and his chief supporters and carried them off to Mousehold Heath, where they were imprisoned in Surrey Place and fettered with chains to prevent escape. Then messengers were sent off to draw more support from a wider area, but in fact some of the citizens objected to their Mayor being imprisoned. Kett therefore arranged for him to be released and permitted to come and go, under supervision, between the encampment and his own home and the centre of city administration.

After about two weeks, the King arranged for the Lord Marquis of Northampton to be his Lord Lieutenant and head a number of knights and gentlemen with troops to deal with the insurgents. They congregated in the Guildhall, took refreshments and held a council of war about their plan of attack. Soldiers were appointed to guard the city at certain strategic points. The following morning the King's herald was again appointed to issue a pardon to the rebels, but was again largely rebuked with the words, 'They who were loyal to the king had no need of pardon.'

It was reported that despite the presence of the soldiers, some of the rebels had gained entry to the city near the Hospital

> to which place over the White Friars bridge the Herald rode and the said deputy rode another way into Tombland to see what would come of it, and in the plain before the Palace gate of the Bishop, the Lord Lieutenant's soldiers fought with the rebels where was slain above forty persons forthwith, and many of the Lord Lieutenant's men departed sore hurt.

Lord Sheffield was killed, and when the rebels again surged into the city centre, many of the Lord Lieutenant's supporters fled, together with leading citizens and their families, terrified lest the rebels should attack them and fire their houses – which is what

happened. They set fire to properties in Holm Street near the Hospital, and to five of the city gates, including the Bishop's Gates.

> And now began the Rebels again to possess the City and to have
> Aldermen and Constables at their commandments, and in time of
> rain in the night season they encamped in the Cathedral church
> called Christ's Church, in Norwich and had the rule to do what
> them listed, and kept the gates themselves of the city with the
> prisons and other places so that they ruled the whole, and would
> command men by houses to watch their Camp and gates in the
> night, which both many men and their servants then at home were
> fain to do, until God after gave them victory.

Meanwhile, the King now arranged for Bartholomew Even, Lord Warwick, to be the new Lord Lieutenant, supported by the Marquis of Northampton, and an army of 12,000 English troops and 1,200 Swiss mercenaries and 'great store of armour, munition, shot, powder, and ordinance shot'. This army marched to the city on 13 August.

There was an initial battle in the city streets during which 320 people were killed, victims on both sides. Kett's men then retreated to their Mousehold camp, which gave them an advantageous hillside position, and they were able to fire on their assailants using guns seized from Warwick's army. But it was clearly only a matter of time before the superior forces and armaments of the King's men proved victorious, and when the rebels decided to reconnoitre in the area called Dussin's Dale (thought to be near the site of the present-day St Andrew's Hospital, Yarmouth Road), which was less easy to defend, they were speedily surrounded by Warwick's troops and mass slaughter followed.

Of those who survived, about 300 were executed. Kett and his brother William, following imprisonment in the Tower of London, were publicly hanged – Robert from the top of Norwich Castle, and William from the steeple of Wymondham church. Their bodies were left exposed until pecked clean of flesh, as a warning to other potential traitors. But their valiant attempt to create fairer conditions for ordinary men and women was

publicly recognised 400 years later, when the commemorative plaque was erected on the Castle wall.

Norfolk has recently been titled 'Nelson's County'. But shouldn't it rather be 'Kett's County'? After all, Lord Nelson's victories were achieved far away on the high seas, whereas Kett and his followers fought for the common rights of men here in the heart of Norfolk, and died not from military engagement, but from the most savage of public executions.

It could be posed as an A-Level question for history students: 'Nelson or Kett – our true Norfolk hero. Discuss.'

In 1578, Queen Elizabeth announced her intention of touring Norfolk and Suffolk, and the Mayor of Norwich was notified that she would be visiting the city. A contemporary account of the visit is recorded in a pamphlet, 'The Receyving of the Queenes Majestie into hir Highnesse Citie of Norwich'.[32]

She was due to arrive in August, and as the notification came in June, the city officials only had about two months for their preparations. The city had become increasingly shabby in the preceding decades, so the Mayor and city officials had to organise a great deal of work to ensure that all looked smart and welcoming for the Queen's arrival. A large number of carpenters and painters were employed along with other tradesmen to ensure that the principal buildings and streets were in good repair. The Market Cross was provided with a coat of white paint, and the stocks and pillory which stood near the Guildhall were removed from sight. Gravel was laid along the road to St Stephen's Gates, as this was the route the Queen would take when entering the city. The gates themselves were repaired, fitted with a new portcullis, and painted with symbolic emblems, the Queen's coat of arms, the Cross of St George, and the arms of the city. A banner was displayed with the words 'God and the Queen we Serve' to proclaim the citizens' loyalty to their monarch.

In order that no obnoxious smells should offend the royal nose, muck-dumps were removed to a distance from the city centre, and cows were banned from the Market Place, together with all those tradesmen, especially the tanners and leather-workers, who had smelly occupations. In addition to smartening the

appearance of the city, the Mayor had to organise a programme of entertainments, and Thomas Churchyard was appointed as the 'Master of Revels'. He had been a page to Henry Howard, Earl of Surrey, and later mixed in court circles. As he relates in his account of the royal visit, 'I was the fyrste that was called and came to Norwiche aboute that businesse, and remained there three long weekes before the Courte came thether, devising and studying the best I coulde for the Citie,' adding, rather plaintively, 'albeit other gentlemen, as Maister Goldingham, Maister Garter, and others, dyd steppe in after.' He was obviously worried that they might steal the limelight from him.

The Queen arrived on 16 August, and the Mayor, Robert Wood, a wealthy grocer, rode two miles out of Norwich to Harford Bridge to welcome Her Majesty and escort her into the city. She was accompanied by a large train of privy councillors, nobility, and three French ambassadors. He was accompanied by sixty handsome young bachelors, all on horseback and dressed in identical costumes, black satin doublets, black stockings, black taffeta hats with yellow bands, and coats of purple taffeta trimmed with silver lace. A great many tailors must have been employed to get these fine costumes ready in time for the event. Behind them came the Aldermen in scarlet cloaks, former Mayors and Sheriffs, and principal citizens, all on horseback and dressed in their most sumptuous garments to create a dazzling spectacle. Behind them followed a band of 'heavies' to ensure that the 'common people' were prevented from 'disturbing the arraye'.

The Mayor welcomed Her Majesty with the customary speech in Latin, and handed her the customary gift, a silver gilt cup filled with money. Some towns could only afford small amounts of about twenty pounds, but Norwich, the second greatest city in the kingdom, had raised a hundred pounds. All the Assembly cheered as the Mayor finished his speech and presented the city's generous gift. The sword of the city was presented to the Queen, and she presented a silver mace to the Mayor.

The procession now moved towards the city, and en route the first of Thomas Churchyard's entertainments was presented on the Town Close, a part of the City Common. It featured a young man in the costume of King Gurgunt, the legendary founder

of the city, and he was attended by courtiers dressed in robes of black velvet and green and white silk. But unfortunately as Gurgunt stepped forward to speak the first line of his flowery speech in verse – 'Leave of to muse, most gracious Prince of English soile' – the heavens opened and a violent shower of rain caused the royal party to gallop into the city and seek shelter from the downpour.

Fortunately, the rain ceased in the afternoon and the Queen was able to enjoy the pageant held in St Stephen's Street in her honour. It was presented by the 'Artizan Strangers', the Dutch and Walloon clothmakers, and indicates how they, resented at first, had become accepted as an important part of the trading community. The pageant, enacted on a large stage, consisted of a display of seven painted panels depicting seven weavers manufacturing different types of cloth. Eight small girls were assembled on the platform spinning worsted yarn, and another eight knitting worsted yarn stockings, together with a group of weavers displaying samples of the cloths they regularly produced. A 'Prettie Boy richly apparelled' played the role of the 'Commonwealth' and recited some verses mingling praise to the Queen with good wishes for Universal Concord, both in Norwich and throughout all her domains.

The Queen seemed delighted with the entertainment, and spoke to the children who showed her the woven articles they had made. By this time an old virgin, she was particularly attracted to handsome boys and young men, which is why they were strongly featured in the welcoming party and entertainments. One of the highlights of her visit was her introduction to Stephen Lymbert, the young Master of the Grammar School. He greeted her at the door of the Great Hospital on the Wednesday evening, and kneeling before her, recited a Latin oration in her honour. As soon as he had finished, she declared, 'It is the best [speech] that ever I heard; you shall have my hand'. Then she pulled off her glove and permitted the schoolmaster to kiss her fingers, a singular honour. She was clearly attracted to the charming young schoolmaster, and responded flirtatiously.

She and her chief attendants were accommodated for the duration of their visit at the Bishop's Palace, and during the

remainder of her visit enjoyed a hunt in Costessey Park, a masque, a rich banquet at Mount Surrey, and various little entertainments devised by Thomas Churchyard. Unfortunately, the weather remained unsettled for much of the royal visit, and during one of his most elaborate displays on the Thursday there was a thunderstorm of such violence that his actors were literally swept off the stage: 'We were so dashed and washed that it was a greater pastime [for the audience] to see us look like drowned rats than to have the uttermost of the shows rehearsed.'

Before the end of her visit, the Queen was presented with another engraved silver cup, containing £50, by the Dutch weavers, and declared herself well pleased with the way she had been welcomed and entertained in the city.

The chief officials escorted her on the first couple of miles of her return journey, and when the Mayor had delivered his parting speech, the Queen showed her appreciation for all that he and the city had provided by knighting him as Sir Robert Wood and stating, 'I have laid up in my breast such good will, as I shall never forget Norwich.'

There were devastating consequences of the visit, however. Shortly afterwards, there was a widespread outbreak of the bubonic plague. It was rumoured that Elizabeth's courtiers had brought with them the infection, which had been raging in London. However, it didn't manifest itself severely until the following March, 1579, and rapidly reduced the numbers of the poor, who, ill-fed and poorly housed, were always susceptible to disease, living in damp, rat-infested and overcrowded conditions. The plague badly affected trade, because of the deaths of workers and also because fewer visitors or country people, fearing infection, came into the city. In every parish the sexton had the job of nailing on the doors the warning that those inside were infected, adding the words 'Lord have Mercy upon us'. People who had been in contact with the infected had to carry staffs, two feet long and painted white, as a warning to others not to come too near them.

The city officials were able to deliver good and bad news for the sufferers. The good news, proclaimed at the court sessions in July 1579, stated:

Forasmuch as in the time of this great contagion and sickness diverse and sundry poor persons visited with the same sickness are in so great poverty as they are not able of themselves to relieve their necessity; this day therefore Mr. Mayor and Aldermen here present, do agree that every Alderman shall give presently toward relief of the same visited and sick persons. 20 shillings which shall be put into a chest remaining in this [council] chamber for that only purpose.

The bad news followed:

It is agreed by Mr. Mayor and his brethren that every person whose house is visited with sickness of the plague and where any person hath or doth die thereof do not go abroad by the space of six weeks. And that the poor whose houses are or shall be so visited shall be provided for in such manner as they shall have no just cause to go abroad at all. And that none that hath any sores about them do go abroad at all in pain that every offender shall be set in the stocks by the constable or constables of every ward.[33]

It seems rather absurd that the sufferers were not permitted to leave their squalid and infected hovels yet if they disobeyed they would be marched to the stocks, thus increasing the likelihood of infection of their escorts and maybe people in the Market areas as well. Still, it was considerate of the Mayor to try to ensure that the sufferers had all they should need in the way of food and other necessities. These were probably left on the doorstep, the deliverers departing in haste before they too could become tainted with infection.

Other arrangements were also made to prevent the spread of disease. It was decreed:

By the whole consent of this house ... that the Wardens of the Butchers shall give warning as well to our city butchers as to the country butchers that they kill no flesh within the walls of this city upon pain of the penalty of the statute in that case made and provided, during the time of the plague within this city.[34]

It was also decreed to the Ministers of the Dutch and Walloon congregations that their members must ensure greater hygiene in their domestic and work arrangements. It seems that several Norwich citizens had complained that by washing their soiled underclothes, and cleaning their wool fibres in the river, the foreigners could be increasing the chances of contagion. They were instructed:

> Ye have also to take good regard that your necessaries [underwear] be kept dry without wash, for the wash corrupteth and bringeth great infection, and use such cleansing of your houses, your clothes and bodies, and also use such fumes and preservatives as the physicians shall advise you ... and that all dogs within such infected houses to be killed, and none at all to be suffered to wander and stray from house to house ...[35]

In addition, Thomas Usher was appointed to certify weekly to the court the number of deaths which had occurred. He recorded fifty-six deaths in the last week of June, rising to over 200–300 a week in August, and the weekly deaths remaining above 200 until the middle of October.

The population, which had been about 16,000 in 1578, swelled by the Dutch immigrants, dropped by one third. Norwich would be affected by further outbreaks, but was hit more badly by this epidemic than any other provincial town. It should be noted that all the chief citizens who were engaged in the festivities for the Queen's visit were still alive three years after the arrival of the plague. This suggests either that she and her courtiers were not the cause of the epidemic, or that the city officials were such a well-fed and healthy lot they remained immune to infection.

Will Kemp was an actor clown, describing himself as 'Cavaliero Kemp, head Master of Morrice dauncers, high head borough of heighs, and onely tricker of your trill-lilles ... one that hath spent his life in mad jigs and merry jests'. He was a Londoner, and during his career as an actor and comedian spent some time on the Continent in Germany and Denmark with the Earl of Leicester's company of players.

In London he performed with Edward Alleyn's company, known as Lord Strange's men. But in 1593, when the plague was infecting the city, the Rose Theatre where they performed was closed. They therefore toured around the provinces, but many people feared that the players might be bringing the infection with them so in Norwich, for example, in 1594 the city officials asked them not to perform and paid them to go away.

Later on, Kemp joined the Lord Chamberlain's men in London, led by Richard Burbage and William Shakespeare, and remained with them for five years. Kemp left the company in 1599, and then came up with a novel project to perform a Morris dance all the way from London to Norwich. He obviously hadn't been offended by the Mayor of the city paying his previous company to go away, and may indeed have decided to honour Norwich with his presence because the city had paid the actors but received nothing in return.

He organised a bet with his London friends that if he were successful in completing the dance, of about 111 miles, they would triple his wager.

He departed at dawn on the first Monday in Lent from the residence of the Mayor of London, with the intention of finishing at the residence of the Mayor of Norwich. He was accompanied by his servant, William Bee; a drummer, Thomas Slye, to beat the tempo of the dance; and George Sprat, who was there to ensure that Kemp kept to the agreed rules of the wager. His experiences are recounted in the pamphlet he published on his return, entitled 'Kemp's Nine Daies Wonder'.[36] This title was rather misleading because it actually took him nearly four weeks, and he had long periods of rest. But he did complete the whole journey by dancing. He describes what happened as he eventually drew close to the city:

> From Barford Bridge I daunst to Norwich: but coming within sight of the Citty, perceiving so great a multitude and throng of people still crowding more and more about me, mistrusting it would be a let to my determined expedition and pleasurable humour: which I long before conceived to delight this city with ... I was advised, and so tooke ease by that advice, to stay my Morrice a little above

Saint Giles his gate, where I tooke my gelding, and so rid into the Citty, procrastinating my merry Morrice daunce through the Citty till better opportunitie …

He then goes on to describe how, on the Saturday, he returned to the point where he had left off his dancing, and then renewed it again. When he arrived, whirling and twirling at the Market Place, he was delighted to see a group of City Waites, standing upon the Market Cross by command of the Mayor, who performed a piece of music and song to welcome him. Kemp describes them as such good musicians that

few Citties in our Realme have the like, none better, who besides their excellency in wind instruments, their rare cunning on the vyoll, and violin: theyr voices be admirable, everie one of them able to serve in any Cathedrall Church in Christendom for Quiristers.

The City Waites at this time were a group of five musicians who played a variety of instruments at official city functions. Apart from viols and violins they could also perform on trumpets, sackbuts, oboes, recorders, and 'an old Lyzardine'.

Kemp goes on to report an embarrassing incident that occurred:

Passing by the Market place, the presse still increasing by the number of boyes, girles, men and women, thronging more and more before me, to see the end: It was the mischaunce of a homely maide, that belike, was but newly crept into the fashion of long waisted petticoates tyde with pointes & had, as it seemed, but one point tyed before, and cumming unluckily in my way as I was fetching a leape, it fell out that I set my foote on her skirts: the point either breaking or stretching, off fell her petticoate from her waist, but as chance was, though her smock were coarse, it was cleanly: yet the poore wench was so ashamed, the rather for that she could hardly recover her coate againe from unruly boyes, that looking before like one that had the greene sicknesse now had she her cheeks all coloured with scarlet. I was sorry for her, but on I went towards the Mayor's and deceived the people, by leaping

over the churchyard wall at St. John's, getting so into Mr. Mayor's gates a nearer way ...

The 'green sickness' was a form of anaemia affecting young women at the age of puberty and tending to give their complexions a pale and greenish colour. The church was St John Maddermarket, and the Mayor's residence at Charing Cross was close by. The Mayor, Master Weld, presented the dancer with £5 in gold, and appointed him a freeman of the Merchant Adventurers Company, and also granted him a pension of 40 shillings a year for the remainder of his life. So he was well rewarded for his efforts. In return, Kemp handed him the buskins, embroidered with bells, which he had worn on his journey and for many years they were displayed on the walls of the Guildhall.

This is a pleasant theme on which to end an account of the city in the sixteenth century. It was a period which featured much trouble and tragedy, plagues, fires, poverty, and riots, but it ends on the joyful note of the dance.

# 1600–1700

## Puritan & Restoration Norwich
## 'Blown out of the town with a bagpipe'

Sex and the city have ever been quarrelsome bedfellows. Norwich folk just want to have fun, but there's always a Mr Spoil-Sport around, the man who likes to say *no*.

In such a large city, sexual misconduct often occurs and, particularly in the past, was the subject of public condemnation, or punished by the law courts. Before the twentieth century, when contraceptives became more readily available and effective, sex before marriage was frowned upon. This was chiefly to protect a woman's reputation and ensure that children should not be born out of wedlock and become a burden on the parish rates. When a man was identified as the father of a bastard, he was often obliged by the parish to marry the woman against his inclination. So young men, apprentices and servants, with insufficient incomes to support a wife and family, and older men who were unmarried or widowed had to seek alternative sex where they could find it, and enjoy either homosexual relationships or resort to prostitutes. Serving maids and apprentice boys were often sexually abused and found it difficult to resist their master's demands, for which they could be thrown out of work. And women who were widowed, or who, through no fault of their own, were seduced and became pregnant, sometimes had to engage in prostitution if there seemed to be no other means of earning a living.

It was recorded of Norwich in 1681: 'The town swarms with alehouses, every other house is almost one, and every one of them they tell us is also a bawdy house'.[1] Rooms for sexual liaisons were

provided for those who could afford it, but much sexual activity occurred in the streets, in alleyways, or behind walls, for lack of anywhere else to go. A typical example appears in the Mayor's Court books in September 1561. A widow, Alice Lemon 'was taken upon Sunday night last past in the Cockky Lane with one John Gorney in committing the abominable act of whoredom'.[2] Those women convicted of prostitution were publicly humiliated by being paraded about the town, sometimes to the sound of a musical instrument or the beating of a metal basin, and either whipped in the Market Place or ducked in the river. Alice was ducked at Fyebridge. In 1549, Agnes Walkot was expelled from the city:

> Robert Machon became surety before the Mayor [and others] for Agnes Walkot, that she shall remove herself outside the city before the 14th day of July next coming, under the penalty of 40*s*. And under penalty of the same Agnes to be blown out of the town with a bagpipe.[3]

In 1563, Margaret Bundey, condemned as a scold and a bawd, was sentenced to a spell in the stocks with a paper cap on her head, and then plunged into the river on the ducking stool.[4] The men were rarely punished – it was the women who were judged criminals because they were paid for their services. Rape when it could be proved was of course a criminal offence for men, and cases were dealt with twice-yearly at the Court of Assizes.

In the eighteenth century, complaints continued about the public profile of prostitutes in the city streets. A letter written to the *Norwich Mercury* in 1787 emphasises that

> a universal licentiousness [prevailing] on the Sabbath cannot be denied. It is a glaring truth, that our streets are filled with whore-mongers and drunkards on a SUNDAY EVENING, and, I may venture to add, more generally than on any other evening of the week ... churches deserted, places of public entertainment crowded beyond measure ...[5]

Although a correspondent protested a week later that the writer had exaggerated the situation, it seems likely that Sunday would

be the day when many working people did frequent the pubs or sought other forms of entertainment and pleasure, including sex, because it was their only free day, and most of them were paid their week's wages on the preceding Saturday evening.

Theatres were frequented by prostitutes, which could give them a bad reputation. When the Theatre Royal was built in 1758, it was quite small, and so the audiences could be jostled in the crush of arrival and departure. William Wilkins, a Norwich architect, complained that

> a lady must be separated from the Arm of her protector both on entering, and on leaving the lobby ... it really is otherwise impossible that ladies can reach their carriages without danger of spoiling their Dresses, and being squeezed perhaps between Doorkeepers, Porters and prostitutes.[6]

Certain buildings and areas became well known for prostitution, until the city officials intervened and had them 'cleansed'. In the 1960s the pubs in the back streets and 'lanes' of the city had their own particular clientele – in some, local working men; in others, factory women; and elsewhere gypsies and travellers, sailors who had come up the Yare, lorry drivers, rich farmers, or even burglars. There were apparently 'pubs where the most unusually jolly ladies of joy await their gentlemen friends – Norwich has the jolliest harlots of any city I know,' warbled one writer.[7]

More recently in the twentieth century, the Rose Lane and King Street areas were known as the 'red light district' where women in short skirts and kinky boots strolled the streets, and 'kerb crawlers' negotiated a price and picked them up. Throughout the centuries the law has tended to turn a blind eye to such activities, unless those involved are perceived as being at risk, or their activities become the subject of public outrage. Sexual satisfaction is much easier to achieve these days without having to pay for it, but there must still be areas in and around the city where the 'oldest profession' continues to thrive.

Puritanism continued to exert its influence on city life for most of the seventeenth century. Puritan sermons flourished particularly when members of the city council sponsored Puritan preachers

to deliver public sermons from the yard in front of St Andrew's Hall. This much annoyed Bishop Harsnett, who in 1622 ordered parishioners to attend services in the Cathedral.

Richard Corbet, who became Bishop in 1632, also had reservations about the prim disposition of the Puritans, being a man of jovial and frisky character himself. In addition, he felt that the 'Strangers' should stick to their own areas and places of worship. He therefore banned them from holding services in the Bishop's private chapel, a privilege accorded them by his predecessor, Bishop John Parkhurst. Despite his amiability, it was said of Corbet that he was 'something apt to abuse', which seems exemplified in his treatment of the Dutch immigrants.

Corbet was fond of singing and writing verse, one of his pieces having the intriguing title 'Upon Mrs. Mallett, an unhandsome gentlewoman that made love to him'. John Aubrey in *Brief Lives* recorded that Corbet on one occasion before moving to Norwich was with some comrades at the tavern by Abingdon Cross, and heard the local ballad singer complain that he could get no custom. At this, 'the jolly Doctor putts-off his Gowne and putts on the Ballad-singer's leathern jacket, and being a handsome man, and had a rare full voice, he presently vended a great many [ballads] and had a great audience'.[8]

Aubrey records that Corbet had a fond affection for his chaplain, Dr Lushington, who had moved from Oxford to be with him. The pair of them shared a taste for ale and wine:

> The bishop sometimes would take the key of the wine-cellar, and he and his chaplain would go and lock themselves in and be merry. Then first he lays down his Episcopal hat – 'There lies the Bishop'. Then he puts off his gown – 'There lies the Doctor. Then 'twas 'Here's to thee, Corbett' and 'Here's to thee, Lushington'.

And so the pair carried on, until they were too rat-arsed to continue and slumped off to bed. When Corbet died in Norwich in 1635, the last words he murmured were 'Good night, Lushington'.

The Bishop's son, Vincent, was also handsome and amiable, and as eccentric as his father. Aubrey recalled that following his

education at Westminster, one of the best London schools, 'He is run out of all, and goes begging up and down to gentlemen.'

Bishop Corbet is now best remembered for his 'Farewell, Rewards and Fairies', which frequently appears in poetry anthologies. It laments the decline of folklore during the strait-laced Puritan period, and describes how the fairy folk were happier in Roman Catholic times, footing 'rings and roundelays' in Queen Mary's days, but had now ceased to dance altogether:

> By which we note the Fairies
> Were of the old Profession.
> Their songs were 'Ave Mary's'
> Their dances were Procession.
> But now alas, they all are dead
> Or gone beyond the seas;
> Or farther for Religion fled;
> Or else they take their ease.[9]

Did Corbet also surmise that the fairies may have left Norwich, not just because of the Puritans, but because the 'Strangers' had introduced strange foreign ways and religion to the city?

Mathew Wren, Bishop from 1635 to 1638, also objected to the Dutch and Flemish residents retaining their own style of religion, arguing that if they could speak English their foreign churches should be closed and they should be integrated into Anglican worship in their parish churches. This sounds rather like some of the arguments affecting foreign immigrants in Britain today. As a result, some returned to Holland where there was now religious tolerance, but a minority continued to reside in the city, and their church services, in the French language, continued well into the nineteenth century.

In the struggle between King Charles I and Parliament, Norwich was largely in support of the Puritans and Oliver Cromwell. The issue was Charles's weakness as a leader, his resistance of Parliamentary influence and his marriage to the French Catholic Henrietta Maria, all of which eventually triggered the Civil War in 1642. The Norwich citizens raised £240 to finance a company of soldiers to support Cromwell, which became the Eleventh

Troop of the Ironsides, but was popularly known as the 'Maiden Troop' because it was supported by many young women in the city who urged their sweethearts or brothers to fight. There was one feeble Royalist rising to support the King, but this was soon stamped out by the city authorities. The city was not directly involved in the warfare, but many Norwich men saw action on the battlefields before the King's trial and execution in January 1649.

Even before Cromwell came to power, government legislation introduced by a Puritan majority in the House of Commons in 1643, demanding the removal of church images and communion rails, encouraged local supporters to organise an attack on the furnishings of the Cathedral. Under the leadership of the Sheriff, Thomas Toft, who had obtained government licence 'for the utter demolishing, removing and taking away of all monuments of superstition and idolatry', two Aldermen and a mob of supporters entered the building and tore down, smashed, or burnt on bonfires, anything that served as a relic of Catholic worship. Joseph Hall, who had been appointed Bishop only a year earlier in 1642, recorded that

> it is tragical to relate the furious sacrilege committed under the authority of Lindsey, Tofts the Sheriff and Greenwood; what clattering of glasses, what beating down of walls, what tearing down of monuments, what pulling down of seats, and wresting out of irons and brass from the windows and graves; what defacing of arms, what demolishing of curious stonework, that had not any representation in the world but the cost of the founder and skill of the mason; what piping on the destroyed organ pipes; vestments, both copes and surplices, together with the leaden cross, which had been newly sawn down from over the green yard pulpit, and the singing books and service books, were carried to the fire in the public market place; a lewd wretch walking before the train in his cope, trailing in the dirt, with a service book in his hand, imitating in an impious scorn the tune, and usurping the words of the Litany; the ordnance being discharged on the guild day, the Cathedral was filled with musketeers drinking and tobacconing as freely as if it had turned into an alehouse.[10]

It is extraordinary that the Puritans should behave in such an outrageous manner in the chief place of worship in Norwich. But they believed that anything connected with the superstitious elements of Catholicism was hateful to God and must be purged in order for the Christian Church to return to the pure essence of religion as preached in the Scriptures. It seems likely that only a small number of local Protestants would have approved of such extreme behaviour. The Sheriff and Aldermen were more likely supported by the mob element, who had little interest in whether they were smashing Catholic or Protestant items, as long as they could have a bit of fun and earn a sixpence or two by way of reward.

As a result of Bishop Hall's criticism, the church revenues and his private income were confiscated and he was evicted from the Episcopal Palace adjacent to the Cathedral. He was effectively prevented from continuing in his role as Bishop, and went to live in Dolphin House in Heigham Street outside the city walls. In 1648, his private revenues were reinstated, and he was allowed to preach at the parish church of Heigham, and to publish works of religious devotion, becoming one of the most popular writers of his period. In his declining years, he was attended in his sickness by the eminent physician Thomas Browne, who rode over from the city centre to visit him. Following Hall's death in 1656, he was buried in Heigham church. The church, together with Dolphin House, was destroyed by bombing during the Second World War. The house, which had become converted into the Dolphin Inn, was rebuilt in 1960.

It was later proposed that the Cathedral should be used for billeting of troops supporting the Cromwellian cause, and even that the building should be pillaged for building materials that could be sold to benefit the poor. In 1650, the leading officials in Yarmouth had asked Parliament

> to grant us such part of the lead and other useful materials of that vast and altogether useless Cathedral in Norwich, towards the building of a workhouse to employ our almost starved poor, and repair our piers.[11]

Bishop Herbert would have turned in his grave.

The Puritans' emphasis on Sabbath observance and restriction of holidays led to irritation and disillusionment among those who had previously cheered Cromwell on. In 1647/48 local apprentices appealed to the Mayor, John Utting, to permit Christmas and other celebrations to be restored. Utting, however, was detested by the Puritan element as a Royalist sympathiser, and because – despite their protests – he had made no attempt to have offending 'idolatrous images' removed from the churches. They therefore attempted to have him dismissed from office with a complaint to Parliament. In April 1648, a government agent arrived in the city with an order for the Mayor's arrest.

When this news spread through the streets, a large and angry crowd assembled, determined that the arrest should not take place. For them, the Mayor represented a link with the good old days of Royalism before the Puritans took over and introduced a regime in which pageants and processions, street dancing and music, games and sports on Sundays and even Christmas holidays were forbidden. For the Puritans, Christmas remained a Christian festival, worthy of religious observance, but otherwise was to remain a working day like any other. But Norwich folk were disillusioned. The Civil Wars, which had dragged on for more than five years, had resulted in heavy taxes and loss of trade. Many men were away fighting, and there were problems both with the import of yarn for weaving and with exporting the finished cloth products, the overseas trade affected by ships being constantly attacked by privateers.

So an increasing number of people began to view the Royalists as maybe wrong but romantic, while the Roundheads, though perhaps right, were definitely repulsive. Now sizzling into fierier mood, the moderate Anglicans, the impoverished cloth-traders, the out-of-work apprentices, all those who wished to have their traditional jollifications restored, and the usual rag, tag and bobtail of urchins and idle youths, displayed their grievances in explosive action.

Initially they shouted and hurled insults at the government agent, then, it is said, marched to the city gates and had them locked so their Mayor couldn't be bustled out of the city. The following morning they reassembled in greater numbers. Rioting

resumed in the city centre, then a section of the mob broke into the house of Thomas Ashwell (who was responsible for the Mayor's arrest) in Redwell Street near the church of St Michael at Plea, where they stole weapons and helped themselves to his barrels of beer. Later in the afternoon, by now drunk and game for anything, they decided to arm themselves further by breaking into the Committee House in Bethel Street, where the county's supply of arms was kept.

The keeper of the armaments, Samuel Cawston (or Cawthorne), appeared at the gates and did his best to dispel them. Unfortunately, one of his brasher colleagues within the Committee House fired a shot, killing a boy outside in the crowd. By this time the local cavalry forces had been called out and their arrival incensed the mob further. As battle commenced in the streets, a section of the mob stormed the building and, in the process of looting arms, spilt a barrel of gunpowder which accidentally ignited. This caused eighty other barrels to explode, killing forty people, injuring others and causing damage to buildings nearby, including St Peter Mancroft church, and even the windows of St Stephen's church further away were blown out by the blast.

The tragedy was popularly termed the 'Great Blowe'. A troop of soldiers under the command of Colonel Fleetwood marched to the scene and arrested the rioters. At the subsequent trial in December 1648, sixty-six people were implicated in the riots, of which eight were hanged on the Castle Ditches, and the remainder fined and imprisoned.

Thomas Utting, the Mayor, was sentenced to six months in the Fleet Prison in London, presumably on the grounds of inciting violence, and together with the Town Clerk was obliged to pay £1,500 in compensation to the succeeding Mayor and Council for the benefit of the city.[12]

There were mixed feelings in the following year when King Charles was arrested and beheaded. The city officials wrote a letter of congratulations to Cromwell, but some Royalist supporters were hanged in Norwich when they were implicated in a plan to get the King's son restored to the throne. Cromwell took over the governing of the country, and in 1653 assumed the title of Lord Protector, which gave him complete legislative and

executive power in association with Parliament and the Council of State.

Although Cromwell had achieved an important landmark in British democracy, by ensuring that kings and queens could never again assume supreme authority in the government of the country, his rule was unpopular. He failed to achieve a lasting balance of army power against the country's desire for peace and proper representation in government, and it was feared that he might wish to gain the crown himself, had not the army remained hostile to the suggestion. Following Cromwell's death in 1658, the King's son returned from exile abroad, and was proclaimed King Charles II in May 1660. Royalist revulsion at the treatment of Charles I resulted in Cromwell's body being dug up from its tomb in Westminster Abbey and ceremonially executed.

In Norwich there were scenes of great jubilation when the King visited the city in September 1671. By this time he had already legislated for toleration in religious matters, and jollification was restored to the land. Bishop Corbet's fairies could at last feel free to return and frolic in the Cathedral Close.

Thomas Anguish was Mayor of the city in 1611. At the commencement of his role, a terrible tragedy ensued. The historian Francis Blomefield records:

> On the 18th of June it being the Gild Day, a sumptious pageant was prepared at the new mayor's gate on Tombland, and certain fireworks, as had been usual, were fired off in the evening, some of which breaking, frighted the people (who were very numerous) to such a degree, that hurrying away in crowds for fear of hurt, there were no less than 33 persons trodden down and pressed to death, as the register of the parish of St. Simon and Jude declares.[13]

From that date, fireworks were banned at public celebrations.

This disaster must have cast a black cloud over the Mayor's term of office, and it was perhaps by way of recompense to the city that when he died in 1617 he bequeathed a house and other property 'for a hospital or conveniente place for the keepinge,

bringinge up, and teachinge of younge and very poore children … [who] have not friends to help them'.

The 'Children's Hospital' was a charitable institution, an orphanage, where children were provided with accommodation and were educated and taught certain types of work that would enable them to gain employment when they were older. The building was situated in Fishergate. The Assembly Book recording the arrangements states that twelve children, ten boys and two girls, were to be the first residents, selected by the Mayor and Aldermen.

The parishes responsible for the children were to provide them with two sets of clothing, one of linen and one of wool, and eight beds were provided, six for the first residents and two for any additional children who might need to be accommodated. So it was two to a bed, it being the customary practice for children, servants and others to sleep together before the twentieth century when the fashion of separate beds became more widespread. The diet is also described: bread, butter and cheese on four days of the week, and pease and pottage on Sundays, Tuesdays and Thursdays. There was a barrel of beer a week for each child in the winter, and three firkins, each containing about a quarter of a barrel, in the summer months. The food sounds frugal to us today, but many people had to subsist on meagre diets, and the children would be much better nourished at Anguish's Hospital than they could expect at home.

A keeper, Christopher Giles was appointed to run the hospital and Nicholas Shaxton's job was to teach reading and writing. The residents listed in 1620 were actually all boys, aged between seven and ten. Some were the sons of widows who were obviously too poor to provide for their children themselves.

In 1649, another Mayor, Robert Baron, bequeathed £250 to provide a similar hospital for girls, supplemented by a donation of £200 from another benefactor in 1656. The girls were accommodated in St Andrew's Hall until 1664, when accommodation was provided in Golden Dog Lane. Their main occupation was learning to spin wool.

Anguish's institution survived until the late nineteenth century, as a boarding school, and later a day school. The number of

boys had increased to thirty-six by the eighteenth century and they became a familiar sight in the city, wearing their uniform of blue coats and trousers, scarlet and black speckled waistcoats, and red caps. By this time there was also an intake of girls, who wore blue dresses and black poke bonnets that the boys teasingly called 'coalscuttles'.

A pupil in the nineteenth century described the school and accommodation in Fishergate as he remembered it, and it had probably changed little since its establishment in 1620. The building surrounded a quadrangle on three sides, and within the courtyard area was a covered shelter for the pupils, and a flower and vegetable garden for the Master (but out of bounds for the boys). The schoolroom had rows of fixed desks, close together and arranged on either side of an open area, facing the schoolmaster's pulpit-style desk. The desks by the nineteenth century were thickly scoured with the initials and names of generations of schoolboys.

On Sunday mornings the school register was called with all the children assembled in the quadrangle, and then they marched in an orderly manner to attend morning service in the Cathedral. Twice a year there was a founder's day service in St Edmund's church in Fishergate. One included the reading of the will of Thomas Anguish, so the children could appreciate how grateful and obedient they should be. At the other they were tested on their knowledge of the catechism, the elements of the Christian religion, when they might be severely rebuked for not having learned it, or rewarded with a shilling if they had. But in addition to these annual ordeals, there was the pleasure of the Scholars Feasts to look forward to at Christmas and Easter when the rare treat of a meal of roast meat was provided. Except, perhaps, for those who still had not learned their catechism.

The school closed in 1885 when the building was used as a shoe factory. It was demolished in the 1930s, and this was followed by the demolition of the Master's house in the 1960s.[14]

A further charitable institution was Doughty's Hospital, funded by William Doughty, who bequeathed the enormous sum of £6,000 to trustees in 1688, to purchase land for building the institution. It was designed to accommodate twenty-four men and eight women.

The land would provide an income of £250 per annum to sustain the charity and provide the elderly residents with two shillings each a week and an institutional gown. It continued into the nineteenth century, when the inmates received 5s 6d a week, and in 1868 the building was enlarged. In the later years of the century the funds were running out, some of the pensions could not be maintained, and in 1899 it was merged with Cook's Hospital, situated in Rose Lane, which was sold in 1892.[15]

The religious group known as Quakers was founded in the 1650s by George Fox (1624–91) from Leicestershire. They were officially termed the Religious Society of Friends, but gained the nickname 'Quakers' when Fox told an interrogating judge to tremble, or quake, at the name of the Lord.

The group Fox founded turned away from conventional Anglican forms of worship, liturgies and sacraments and preferred to assemble together and let the word of the Lord speak to them and through them as individuals. They adopted a distinctive style of clothing and manners, and refused to swear oaths, or pay tithes to the established Church of England. Because Fox had started by travelling around the country and interrupting religious services to expound his own views, the Quakers quickly attracted alarm and then persecution.

In 1656, nearly 1,000 of Fox's supporters were thrown into prison when they refused to take the Oath of Abjuration. One of their number, William Penn, emigrated with his supporters to America, where he founded Pennsylvania and created a lifestyle via which they could pursue their own ideals unhindered.

A group of Fox's supporters visited Norwich to promote their views in the 1650s. They too attracted antagonism with their criticism of local church services and beliefs. One of the Quakers singled out for punishment was George Whitehead, a schoolteacher, aged only nineteen. In 1654, he stood up in the congregation at St Peter Mancroft church and heckled the preacher. The parishioners, outraged, immediately leapt upon him and dragged him out across the Market Place to the Guildhall. He was interrogated by the Mayor, and thrown into the Castle Gaol, where he was confined for most of the winter, sleeping on the bare floor in a freezing chamber.

But there were others in the city who also desired to see some reforms in religion and were impressed by men like Whitehead who were prepared to speak out and suffer the consequences. In 1655, Whitehead's landlord, John Lawrence, started to become converted to Quaker beliefs, and was summoned to appear before the church leaders at St George's church in Tombland. Whitehead went along to support him, which was probably a mistake because the hostility of the parishioners turned upon him as the one responsible for leading a decent Norwich man astray. Both women and men started jeering and then assaulting him, and once again he was dragged out of a church and off to the Market Place, suffering considerable bruising from being bumped along the paving stones.

But he managed to break free and sped off along St Giles Street. There he stopped at the City Gate, and knocked on the door of the house where Lady Hubbard lived, hoping she might offer him sanctuary. The noise of the mob tearing after him also brought the family chaplain to the door, but he only taunted Whitehead, saying if he was like one of Christ's Apostles he should be able to prove his purity to his attackers. So he was turned away. Fortunately one of Cromwell's armed troopers, currently established in the city, came to his rescue and escorted him back in safety to his lodgings at John Lawrence's house.

The Quaker group had no established building for worship, so held their meetings in each other's homes. In May 1660, while they were assembled in the house of Joseph Whitlock in St Edmund's parish, in the Fishergate area, a gang of men broke in and attacked the group. In a letter written to the Mayor describing what had happened, Joseph Whitlock and his brethren named the chief offenders as

> Christopher Benet, apprentice to Zachariah Mayhew of St. Augustine's; John Sadler of St. Paul's; John Sammon a servant at the Brewhouse without Pockthorp Gates.

The attack consisted of

> smiting, punching, pulling some of us by the arms to haul us out of the Meeting ... pushing us from one another and dragging us

about … dragging some by the hair and spitting in their faces … drawing of blood, throwing of fire … several of them getting on the table and throwing themselves violently down upon the heads of men and women … some of them holding the maid of the house whilst others daubed her face with gore and dung, so that the skin of her face could hardly be seen.[16]

It seems unlikely that these men, probably mainly quite young, were motivated by religious zeal. As in the other mob violence that has been described in previous chapters, they were probably just looking for violent sport. It is, however, possible that they were encouraged to break up the meeting by a Christian minister or city official who resented the Quakers' style of devotion. Not surprisingly, the letter of appeal to the Mayor had no effect. The three ringleaders of the attack were never taken for trial, while the messenger who delivered the letter was temporarily locked up in the Castle Gaol and interrogated, in the hope that he might reveal some particular crime for which he or his fellow Quakers could be accused.

Charles II introduced a policy of toleration for Dissenters, and was personally sympathetic towards the Quakers. But unfortunately, what should have permitted them the freedom to organise their meetings as they pleased had quite a different result. When another minority group, the Fifth Monarchy Men, caused trouble in 1661, the Quakers were also suspected of insurgency and forbidden to hold any further meetings. This was followed by imprisonment when they attempted to ignore the legislation. In Norwich, George Whitehead and about thirty other Quakers were confined in the Castle Gaol in appalling conditions.

Throughout the next two decades, further legislation was introduced penalising the Quakers, initially because they refused to take the Oath of Allegiance to the new king. The Norwich Quakers had their possessions seized because they refused to pay the Church tithes, and were constantly under threat from the rough element in the town, suffering verbal and physical abuse and attacks on their property. The situation became even worse following a plot to murder King Charles and his brother James, when all minority groups were viewed with suspicion, and many

Quakers throughout the country were imprisoned on trumped-up charges. The Norwich Quakers now 'suffered more severe and continuous harassment than they had ever done before'.[17]

However, they had managed to build a Meeting House in Upper Goat Lane in 1679, and eventually, in 1689, the Toleration Act eased their situation. Ten years later in February 1699, the Norwich group established in the Gildencroft beside the burial ground their new Meeting House, which they had purchased for their members some years earlier. By 1700, there were about 500 Quakers in the city.

Much of the Gildencroft chapel was damaged by bombs during the Second World War, but some of it survived and is incorporated within the renovated building that remains today.

Sir Thomas Browne (1605–82) lived through these turbulent times of civil war, religious strife, economic decline, antagonism towards foreign immigrants, and public unrest, but remained generally philosophical and tolerant in his views. He wrote:

> I feel not in myself those common antipathies that I can discover in others; those national repugnances do not touch me, nor do I behold with prejudice the French, Italian, Spaniard or Dutch; but where I find their actions in balance with my countrymen's, I honour, love and embrace them in the same degree.

With the strife in the city, he could see how the mob mentality made things worse:

> If there be any among those common objects of hatred I do contemn and laugh at, it is that great enemy of reason, virtue and religion, the multitude; that numerous piece of monstrosity which, taken asunder, seem men and the reasonable creatures of God, but, confused together, make but one great beast, and a monster more prodigious than Hydra.[18]

Browne is one of the city's most distinguished personalities, and is perhaps better known by locals today for his statue in the Haymarket than for his published writings, such as *Religio*

*Medici* and *Urn Burial*, the books which have made him admired by generations of readers for their style as much as their content. Virginia Woolf's *Orlando* comments on his style:

> Like an incantation rising from all parts of the room, from the night wind and the moonlight, rolled the divine melody of those words which, lest they should outstare this page, we will leave where they lie entombed, not dead, embalmed rather, so fresh is their colour, so sound their breathing – and Orlando, comparing that achievement with those of his ancestors, cried out that they and their deeds were dust and ashes, but this man and his words were immortal.[19]

So one of the greatest writers of the twentieth century salutes one of the greatest writers of the seventeenth century.

Browne was born in London in 1605, educated at Pembroke College, Oxford, travelled on the Continent, and graduated as Doctor of Medicine at Leyden in the Netherlands, before settling in Norwich in 1637. His house from 1649 was adjacent to the Haymarket, later No. 5, Orford Place; the building was demolished in 1842 and a plaque now marks the site. There Browne practised his profession as a doctor, but was not limited to the city, for he travelled throughout the region, visiting all those who sent for him. It is said that he regularly attended the poor and expected no payment in return. His reputation both as a physician and a writer attracted increasing admiration, particularly following the publication of the first authorised edition of his most celebrated work, *Religio Medici* (1643), meditations on his own religious faith and its relation to his profession. When Charles II visited the city in 1671, at a civic banquet in his honour at St Andrew's Hall, Browne was one of the invited guests. Following the meal, in the words of a local poet, Matthew Stephenson:

> Then the King knighted the so famous Browne,
> Whose worth and learning to the world are known.[20]

The touch of the hand of the monarch was recommended by Browne as a cure for tuberculosis, and it is clear that despite

Browne's great intellect and wisdom he still shared many of the superstitious attitudes of his period. He clearly believed in the existence of witchcraft, for at a trial of some poor old women so accused, he was a chief supporter of their conviction and punishment.

The diarist John Evelyn also visited the city in 1671. He had been lodging in Newmarket with Henry Jermain in order to join the circle of Charles II, who was staying there. He records in his diary that on 17 October,

> My Lord Henry Howard coming this night to visit my Lord Chamberlain, and staying a day, would needs have me go with him to Norwich, promising to convey me back, after a day or two; this, as I could not refuse, I was not hard to be persuaded to, having a desire to see that famous scholar and physician, Dr. T. Browne, author of the *Religio Medici* and *Vulgar Errors*, now lately knighted.[21]

Having stayed the night with Lord Henry Howard in the Ducal Palace, his diary continues:

> Next morning, I went to see Sir Thomas Browne (with whom I had some time corresponded by letter, though I had never seen him before); his whole house and garden being a paradise and cabinet of rarities, and that of the best collections, especially medals, books, plants, and natural things.
>
> ... He led me to see all the remarkable places of this ancient city, being one of the largest, and certainly, after London, one of the noblest of England, for its venerable cathedral, number of stately churches, cleaness of the streets, and buildings of flint so exquisitely headed and squared, as I was much astonished at; but he told me they had lost the art of squaring the flints, in which they so much excelled, and of which the churches, best houses, and walls, are built.
>
> The Castle is an antique extent of ground, which now they call Marsfield, and would have been a fitting area to have placed the Ducal Palace in. The suburbs are large, the prospects sweet, with other amenities, not omitting the flower-gardens, in which all the

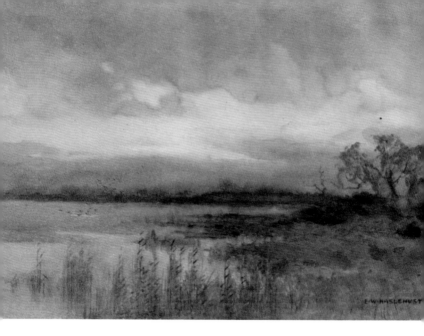

*Above*: 1. Hickling
Broad. In the Prehistoric
period, low-lying
marshlands near Norwich
were flooded during
the winter season. The
Norfolk Broads now
occupy parts of the
region.

*Right*: 2. Bishop's Bridge.
This is the only surviving
medieval bridge in the
city, and was presented to
the city by the priory in
1393.

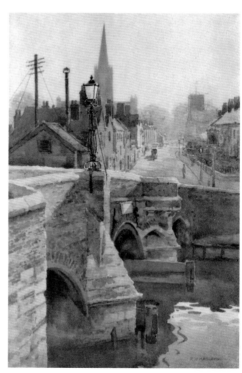

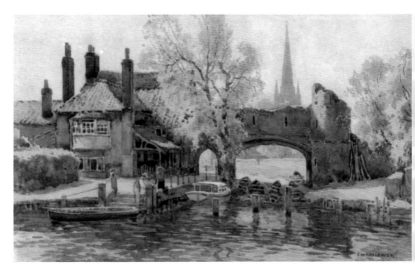

*Above*: 3. Pull's Ferry. The proximity of the river to the Cathedral made it convenient for the transport of building materials in the eleventh century.

*Below left*: 4. The spire viewed from inside the Cathedral Cloisters, which were used as a walkway to connect various different parts of the original monastery.

*Below right*: 5. Market Place and Guildhall. The Guildhall, completed in 1424, features the knapped and galletted flintwork for which Norwich is famous.

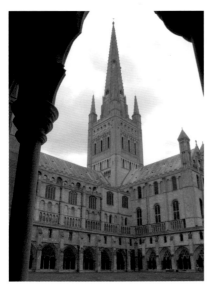

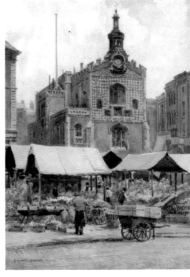

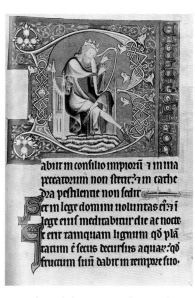

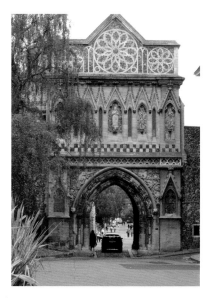

*Above left*: 6. Page from a fourteenth-century psalter presented by Robert de Ormesby for use in the choir of the Priory church. (© Jonathan Reeve, book 97)

*Above right*: 7. Ethelbert Gate, with elaborately flint-decorated gable. St Ethelbert was a king of East Anglia who died in 794.

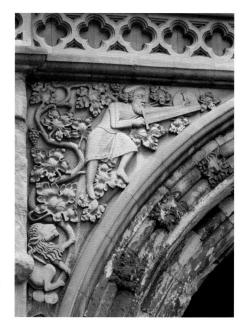

8. The dragon confronts St George, patron saint of Britain, who died during the Diocletian persecutions in Palestine in *c*. 300.

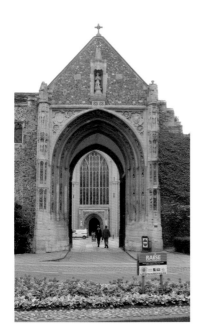

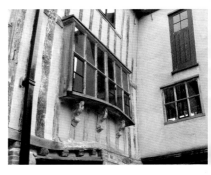

*Above*: 9. Window detail to the rear of Augustine Steward's house in Tombland, now Tombland Antiques.

*Left*: 10. Erpingham Gate, entrance to the west front of the Cathedral, given in 1420 by Sir Thomas Erpingham, who led the English archers to victory at the Battle of Agincourt.

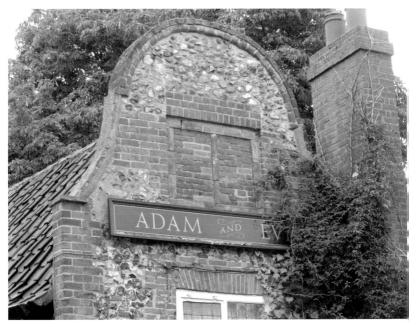

11. Dutch gable end of the Adam & Eve pub, one of the city's oldest pubs, situated near to the river, and to the rear of the cathedral.

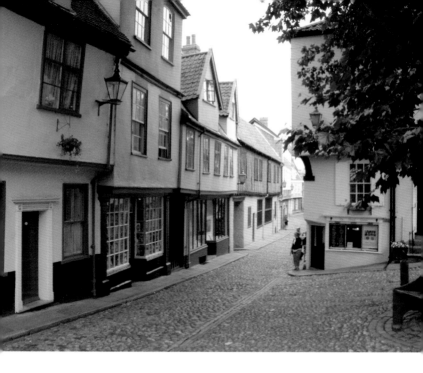

*Above*: 12. Elm Hill was an important commercial thoroughfare during the fifteenth and sixteenth centuries, and was inhabited at different periods by sixteen citizens who became either Mayor or Sheriff.

*Right*: 13. Strangers' Hall. It gained its name because it is thought to have provided accommodation for Protestant Flemish weavers when they fled to Britain in the sixteenth century to escape Spanish persecution in the Netherlands.

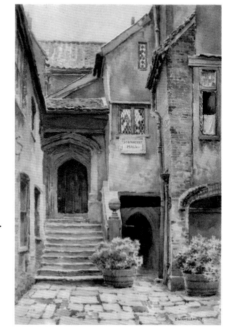

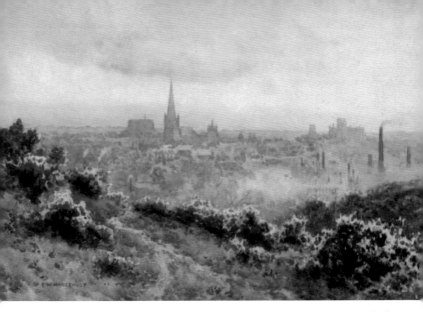

14. Norwich from Mousehold Heath. Kett and his supporters used the Heath as the base for their military operations.

*Above left:* 15. Hanging sign, Elm Hill Craft shop.

*Above right:* 16. Statue of Sir Thomas Browne, in which he is depicted examining a sherd of pottery, relating to his book *Urne Burial.*

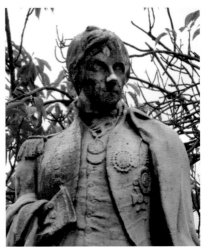

*Above left:* 17. Sundial on St Peter Mancroft church, facing towards the Haymarket.

*Above right:* 18. Detail of the statue of Admiral Horatio Nelson in the Cathedral Close.

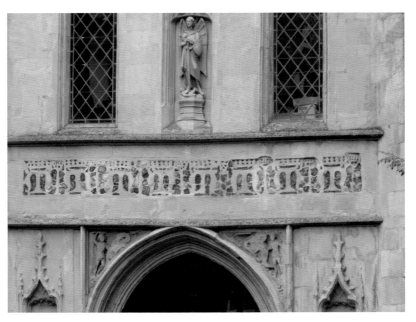

19. St Michael at Plea church, fine medieval flush work, and an image of St Michael above the entrance porch.

*Left:* 20. The Wild Man pub, Bedford Street. It was named after the 'Wild Man', Peter, who was brought to England after being discovered in a forest in Germany, and briefly held in the Norwich Bridewell.

*Below:* 21. The Friends Meeting House, Upper Goat Lane. This was the Quaker building where Elizabeth Fry attended meetings during her childhood.

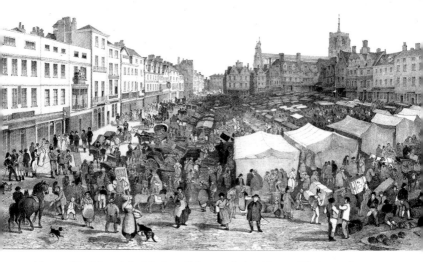

*Above*: 22. Norwich Market, lithograph by Henry Ninham, from a drawing by John Sell Cotman, *c*. 1809. The original watercolour is in Tate Britain, London. (Courtesy of Norwich Castle Museum/Norfolk Museums Service)

*Right*: 23. Wombwell's Travelling Menagerie. One of the processional wagons, *c*. 1880, Outney Road, Bungay. (Bungay Museum collection)

*Below*: 24. Back of the New Mills, Norwich. Oil painting by John Crome. (Courtesy of Norwich Castle Museum/ Norfolk Museums Service)

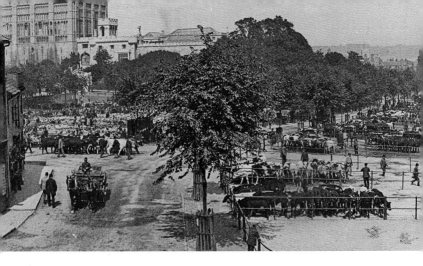

*Above*: 25. The Cattle Market in the Castle Ditches, which enhanced the prosperity of the city in the late nineteenth and early twentieth centuries. (From *Norwich Through Time* by Frank Meeres)

*Left*: 26. Door of the Monastery of St Mary & St Dunstan, Elm Hill, founded by Father Ignatius in 1864.

*Below*: 27. Royal Arcade. Designed by George Skipper in 1899, it was described as 'a fragment of the Arabian Nights dropped into the heart of the old City'.

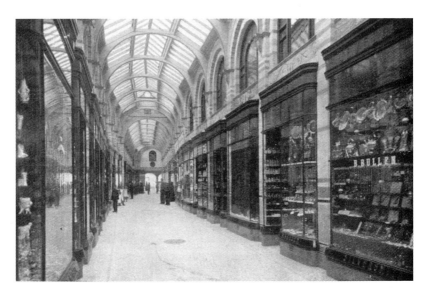

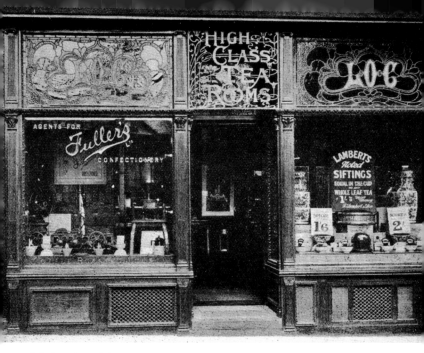

28. Lamberts Tea-rooms.

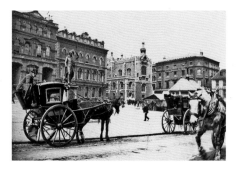

29. Cabs waiting in the Market Place on a Sunday with most of the stalls cleared away. The statue of Lord Wellington in the background was later moved to Cathedral Close. (From *Norwich Through Time* by Frank Meeres)

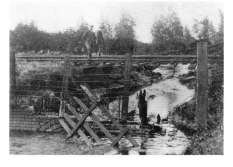

30. Damage on the outskirts of the city caused by the disastrous floods of 1912. (© W. B. Bartlett)

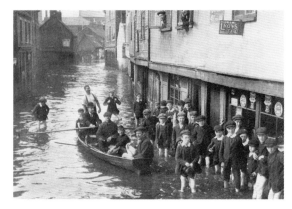

31. During the 1912 floods, three people were killed, and 3,650 houses were badly affected by flood water.
(© W. B. Bartlett)

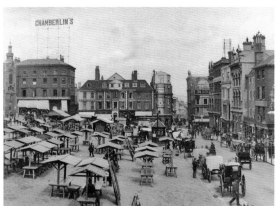

32. The Market area was established in the Norman period, and the stalls became permanent fixtures in 1938. They have recently been re-designed and enhanced.
(From *Norwich Through Time* by Frank Meeres)

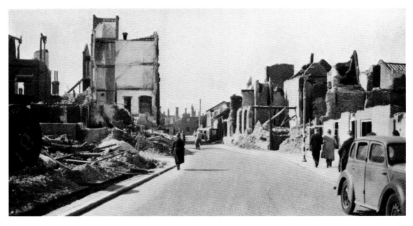

33. Westwick Street was one of the areas devastated by bomb damage during the Second World War. Coleman's factory was destroyed, as well as shops and houses.

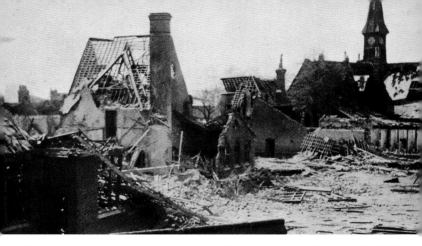

34. St Augustine's school was destroyed during an air-raid in April, 1942. (From *Norwich Through Time* by Frank Meeres)

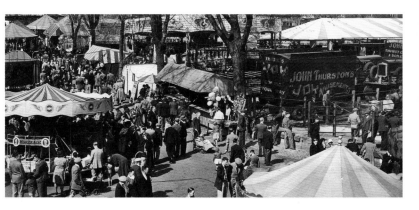

*Above:* 35. Fairs were traditionally held in Tombland in the medieval period, but the one depicted here was a Fun-Fair in the twentieth century. (From *Norwich Through Time* by Frank Meeres)

*Right:* 36. St John Maddermarket parish pump, a main source of water for parishioners until the early twentieth century.

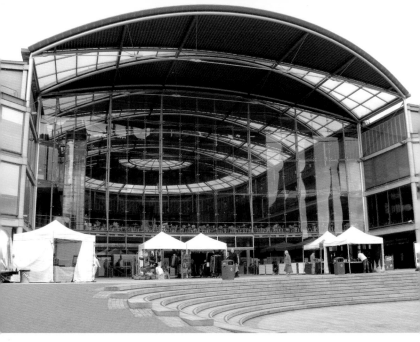

37. The Forum, Millennium Plain, designed by Sir Michael Hopkins. It opened in 2001 to replace the Library, which was destroyed by fire in 1994.

*Above left*: 38. The Norwich Union clock in Surrey Street.

*Above right*: 39. Bronze heraldic lion on City Hall steps. The lions were designed by Alfred Hardiman, and one of them was exhibited at the British Empire Exhibition in 1936.

*Right*: 40. Detail of one of the bronze doors, featuring local trades, at the entrance to City Hall.

*Below*: 41. Upper Goat Lane. Much of the lane is sprayed or painted with graffiti, including this brightly coloured window.

*Next page*: 42. Artist's impression of Norwich in the early Norman period, by Ivan Lapper: Norwich Castle information plinth near he entrance door. (Norfolk Museums Service)

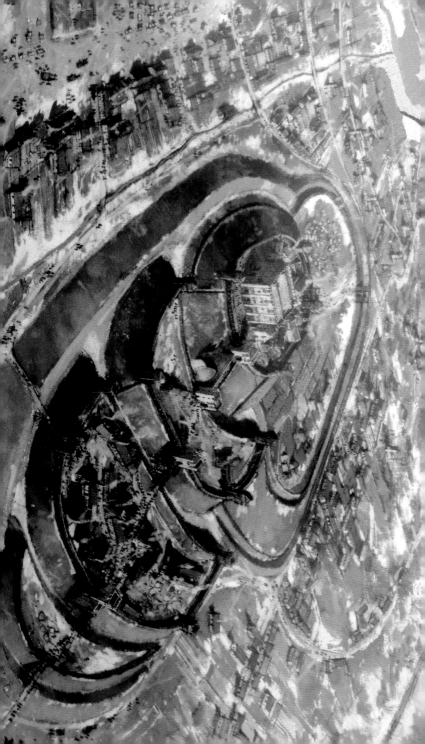

inhabitants excel. The fabric of stuffs brings a vast trade to this populous town.[22]

With regard to the Ducal Palace which Evelyn mentions, this was situated in what is now Duke Street, and was the largest private house in the city. It was partially demolished by the Duke of Norfolk in 1711, one wing being acquired by the Guardians of the Poor as a workhouse. Parts of the site remained ruinous, and in 1739 three children were killed when a crumbling wall collapsed on top of them. In the 1960s the site was converted into a car park.[23]

It seems likely that Browne conversed with Evelyn about his book *Urn Burial*, published in 1658 and inspired by the excavation of a pre-historic burial site at Great Walsingham. Evelyn's thoughts were evidently dwelling upon the theme of mortality, for he comments that during their walk:

> I observed that most of the church-yards (though some of them large enough), were filled up with earth, or rather the congestion of dead bodies one upon another, for want of earth, even to the very top of the walls, and some above the walls, so as the churches seemed to be built in pits.[24]

It was obviously very unhealthy for so many bodies to be crammed into such cramped spaces, for their putrefaction could poison the air during hot, dry weather; and rainwater running from the churchyards into the gutters, wells, river, and perhaps drinking water, could lead to outbreaks of disease. In addition, bodies buried too close to the surface without coffins might easily be dug up by foraging stray dogs and pigs.

Browne was buried in the church of St Peter Mancroft, near his dwelling place, and where he regularly worshipped. There is a memorial to him in the sanctuary, in which he is described as 'a man very pious, whole, learned, and famed throughout the world'. The interior of the building was very different in his period from how it looks today, for Cromwell's men destroyed its furnishings, ornaments and pictures in 1643–44. In addition, during the rioting between the Royalists and Puritans in 1648,

the 'Great Blowe' blew out all the windows, which were then damaged again during a severe storm in 1661.

Browne's statue in the Haymarket, by Henry Pegram, R.A., erected in 1905, is the finest of all the statues in a city not rich in open-air works of art. It was designed to celebrate the tercentenary of his birth, and he is depicted in a relaxed pose, gazing contemplatively at a sherd of pottery, a reference to his book *Urn Burial*. His serene and self-absorbed pose is in marked contrast to the hustle and bustle of the crowds of shoppers and tourists milling around his feet. Pigeons sport about his head and shoulders, while children run and jump on the steps near his plinth. At one time there was a small fountain and pool nearby, and on Saturday afternoons students delighted in filling it with washing-up liquid and watching the rainbow coloured bubbles float around him: a dazzling display that would have amused the great philosopher himself.

He has survived two world wars, been adorned with various monstrous headgears, daubed with graffiti, and on one occasion even provided with a small house to inhabit by an imaginative student at Norwich School of Art. More recently, his site has been honoured with a sculptural display of marble and stone objects relating to his writings, but also conveniently doubling up as picnic chairs and tables. The modern city has taken the great man to its heart, and he remains one of its most appealing attractions.

William Schellinks was an artist, a painter, draughtsman and etcher, who was born in Amsterdam in 1623. In July 1661 he travelled with a merchant ship owner, Jacques Thierry, and the latter's young son from Amsterdam to England. He was engaged in making topographical drawings for the Van der Hem *Atlas*, and described in a journal the places they visited. On 11 October 1662, they rode into Norwich, where they stayed at the King's Head, opposite the Market Cross. He writes:

> Norwich in Norfolk is a famous old town, pleasantly situated on the slope of a hill along the river which protects its lower side, and elsewhere surrounded by strong walls with towers and twelve

gates. The town is three miles in circumference, is very populous and prosperous and has beautiful churches, houses and streets ...[25]

It is interesting that Schellinks comments on the prosperity of the city as it had suffered economically as a result of the Civil Wars and trade recessions. But the town had been very prosperous in previous centuries and a visitor would note the fine buildings, Cathedral, Castle, Guildhall and churches, the activity of the cloth merchants, the diversity of stalls in the Market and other signs of wealth, and therefore would be less likely to observe any signs of recession.

Schellinks goes on to comment on the handsome Market Cross and Market House, and the cloisters of the Cathedral, adding that they are judged to be the most beautiful in the whole of England. In the docks on his arrival he noted that regular ferry boats sailed daily from Norwich to Yarmouth, passengers paying the modest fare of twelve pence, and he compared them favourably to the similar Breukelen boats in Holland.

In the afternoon following their arrival, he and his companions walked around the centre and saw the local militia exercising and drilling in the square. Then they walked up to the Castle and were surprised when prisoners who were locked in the gaol suddenly called out to them through the narrow windows 'very loudly for alms'. Next they visited the Cathedral, and although the cloisters had been praised, Schellinks comments that otherwise 'there is nothing special to be seen'. But he was amused by an effigy of a skeleton near one of the doors, with the following inscription:

All you that do this place pass by
Remember death for you must dye
As you are now even so was I
And as I am so shall you by.

Thomas Gooding, here to staye
Wayting for God's judgement daye.

Gooding had requested that he should be buried in the wall in an upright position, so he would be ready for the Resurrection

when it occurred. One hopes he is not still waiting, or he might have preferred to have been buried lying down like most sensible people.

On the following day they walked out through the 'Bear Street Gate' (Ber Street) and up the hill to enjoy a panoramic view over the surrounding countryside. Later, they noted some interesting features on Monastery Hill, a maze cut neatly in the ground and grass, and near it the ruins of the chapel, which, they were perhaps informed by a passer-by, was rumoured to contain hidden treasure buried there by a cripple some years previously.

Schellinks and his companions were of course keen to hear about the large number of their countrymen living in the city. Upon their arrival, they had visited a Mr Vinck, who was eighty years old, of Flemish descent, and had been born in Norwich and had a prosperous hosiery business with a large shop. He no doubt told them about other Dutch and Flemish immigrants, and Schellinks adds that a large number of Dutch craftsmen who were still there had taught the local people those cloth-weaving techniques for which the city was famous.

Like John Evelyn, he admired the churches so beautifully decorated with their closely fitting and smoothly knapped flints, but concluded with an unflattering description of the Norfolk landscape:

> Much of the surrounding countryside is a swampy bog on which lots of geese are raised, and the higher ground is sandy and full of rabbits.

This he would have observed as he and his companions set off on horseback for the next stage of their travels.

# 1700–1750

## Georgian Norwich Begins
## 'We are here at a miserable passe with this horrid sot we have got for our Dean'

For much of the eighteenth century, Norwich was at a peak of prosperity, influential in the region, serving as an important provincial capital. The prosperity was mainly due to the expansion of the worsted cloth manufacture, for export sales were developing rapidly and were shipped to Spain, Portugal, Holland and Germany. The Norwich fabrics were light, well-finished, attractive in design and comparatively cheap because the average wage of weavers was considerably lower than in Exeter, the other main British exporter. By 1750, the city was producing a wide range of cloths, both fine and coarse fabrics, with high standards of dyeing, and was particularly noted for its shawls, some with fine hand embroidery and others with elaborate woven patterns. These were being shipped to the North American colonies, and the East India Company shipped them to India and China.

The Woolcombers Guild held an annual feast and procession on St Blaise's Day, in February, as he was their patron saint. Bishop of Sebaste in Armenia in the fourth century, he had suffered a Christian martyrdom by being torn to shreds with iron wool-combs – so not a very cheery figurehead for the young apprentice lads in the trade. Perhaps they were warned that they might share the same fate if they misbehaved. Their processions were eagerly awaited events, and the following occasion was reported in the local newspaper on 9 February 1734:

Last Monday the Wool Combers of this City held their annual Feast called Bishop Blaze when they made the greatest Appearance ever seen before: They had several fine Flags, on which they wrote LIBERTY and PROPERTY on one side, and PROSPERITY TO THE WOOLLEN MANUFACTURE on the other: Two Boys wore Crowns of Wool, beautifully wrought on which were fastened Favours with Mr. Alderman's picture on them; and there were 14 other Boys in Wool Caps of various Colours who wore Favours on their shoulders with the words LIBERTY and PROPERTY on them.[1]

'Favours' were ribbons or cockades usually worn in hats or lapels as part of livery costume. The boys, as representatives of the Woolcombers Guild, probably wore a ceremonial livery for their Feast Day. This was a convivial occasion, but later in the century there was strife between the Journeymen Woolcombers and their employers, as the local press recorded in 1752:

A difference having arisen between the Journeymen Woolcombers and their Masters at Norwich, about Wages: the Journeymen have retired from the City to a Heath about three miles off, where they have created Booths for themselves, and about three hundred of them live without committing any irregularities.[2]

It seems that, apart from low wages, the Woolcombers were also enraged because a man had recently been employed without serving his apprenticeship, and it was claimed he was also a thief.[3]

A second report appeared in August of the same year:

At a full Court of Mayoralty held the 22nd Day of August 1752: whereas it has been represented to this Court that the Journeymen Woolcombers (who have lately turned themselves out of work), have, by their agents, sent into different parts of the kingdom, industriously propagated a Report that no Journeyman Woolcomber can at present work with safety in this City but will be liable to receive personal Insults from the other Journeymen: This is to certify that there are severall Woolcombers (more than a hundred) now at work in this city who go about their Business

freely and unmolested; and that others who may chuse to come
and work here, shall be protected in their Persons and property as
fully and effectually as other Workmen in this City or elsewhere
can be by Law.[4]

So no sympathy for the protesters, and now they were also
being threatened that other Woolcombers would be welcome
to come along and replace those on strike. Saint Blaise didn't
seem to be giving them much support! Fortunately they were
supported by purse clubs, which were to help guild members
in need. Eventually the protest subsided and they returned, still
disgruntled, to work.

Parson James Woodforde, who had moved from Somerset
to become Rector at Weston Longville near Norwich in 1776,
witnessed a magnificent procession of the Woolcombers when
visiting the city on 24 March 1783. He describes how the city
centre was packed with spectators, not just in the streets but
gazing out of windows and from the rooftops. The procession
proceeded through every part of the city and did not finish until
four o'clock in the afternoon:

> It far exceeded every Idea I could have of it. Hercules, Jason and
> Bishop Blaise were exceedingly well kept up and very superbly
> dressed. All the Combers were in white ruffled Shirts with Cross-
> Belts of Wool of divers colours – with Mitred Caps on their heads
> – the Shepherds and Shepherdesses were little Boys and Girls on
> horseback, very handsomely and with great propriety dressed.
> Orations spoke in most of the principal streets. I never saw a
> Procession so grand and well conducted.[5]

This special procession was organised to acknowledge the end of
the War of Independence in the American Colonies, which had
lasted for six years, and although England had been defeated,
the peace must have seemed sufficient cause for celebration.
The classical heroes which had attracted James Woodforde's
eye included twenty Argonauts, with Hercules, and Jason in
a phaeton drawn by four horses, following the golden fleece
carried on a grand palanquin, an appropriate feature for a

Woolcombers' parade. All these figures were accompanied by musicians, including four trumpeters, drums and fifes and the band of the local militia.

Despite increased general prosperity in the city, the market for various commodities did fluctuate from time to time. Towards the end of the century the wars with France during the Napoleonic regime resulted in the foreign markets becoming increasingly inaccessible. The work forces suffered from the decline in their wages, as well as bread being at famine prices as the war was prolonged. The manufacturers, however, had accumulated fortunes from the wool, leather and other trades and built many of the fine Georgian houses which can be seen in the city side streets. Those who could afford it employed the eminent city architect Thomas Ivory. He was carpenter for the Great Hospital in 1751 and also designed some of the city's most elegant buildings, including the Assembly Rooms, the Octagon Chapel for the Dissenters, and the large block of terraced houses in Surrey Street.

The 'Nether-Row', the lowest street of the Market, which had originally been apportioned for the use of rural traders, was from the seventeenth century transformed into a promenade area for the wealthier citizens. Many prosperous merchants had houses and inns along this row, with some of the best shops. All the former stalls, barrows and baskets were cleared away, and the street's appearance was enhanced with wide new paving. It became known as Gentlemen's Walk.

The leather trade continued to be an important industry and grew more prosperous in this period. The local cattle grazed on the surrounding marshes were supplied as meat for the butchers' stalls, their hides to the tanners, and the leather was used for boots, shoes, harnesses and other commodities. Brewing also prospered and it was said that Norwich had the best barley for producing malt in the world. Much was consumed locally, at a time when all ages and classes had beer as their staple beverage, and it was also marketed in London.

The increasing number of beast sales in the Market Place had resulted in the area becoming too congested, so the city officials provided a new livestock market for cattle near the Castle, known as the Castle Ditches. In 1738 the area was made more spacious

when the ditches were levelled out. In 1812, Davey Place was constructed as a pedestrian thoroughfare that linked the livestock area with Gentlemen's Walk and the main provision market.

Affairs at the Cathedral continued to have their ups and downs, good characters and bad. Dr Humphrey Prideaux was appointed prebendary in 1686, and found upon his arrival that the Cathedral was poorly administered due to the lax character of Dean Fairfax. Initially Prideaux had to divide his time between Norwich and Saham Toney, where he was Rector. In a letter written in 1693, he reports:

> I am now at Norwich, where the Dean behaves himselfe more like a beast than ever, and is so obstinate and perverse in his own humours, which are indeed intolerable, that there is no endureing of him.[6]

A month later he is writing, 'We are here at a miserable passé with this horrid sot we have got for our Dean. He cannot sleep at night till dosed with drink.' And apparently the Dean regularly involved his manservant in his drunken behaviour. In addition, Prideaux complained that the Dean seldom attended church, never took Holy Communion, and rarely opened a book, adding,

> Goe to him when you will, you will find him walking about his roome with a pipe in his mouth and a bottle of claret and a bottle of strong beer ... upon the table, and every turn he takes a glass of one or the other of them.[7]

In June 1702, following the death of Fairfax, Prideaux succeeded him as Dean. He was then able to take action against one of the prebendiaries, John Stukeley, who had been behaving indecently, and to whom Dean Fairfax had obviously turned a blind eye despite the disrepute it must have brought upon the Cathedral clergy. Prideaux wrote to his patron at Nottingham on 4 September 1702:

> As I owe my Deanery to you I pray you to protect me in the just discharge of my duties. I have lately been forced to expel

one of the minor canons of this church, and enclose my sentence against him. The crime of which he is charged has been proved by many witnesses to have been committed for seven years past, but notwithstanding its abominable nature, he finds here many abettors, including Mr. Davy the Recorder of Norwich 'a hot-headed weak man', and because they think they can have no redress from the Bishop ... they are now contriving to bring it by way of petition before the Queen and Council. To bring so filthy a cause before her Majesty is a great affront; but I thought well to mention the matter to you and ask for your favour.

As a result, Prideaux was able to dismiss John Stukeley, one of the minor canons of the Cathedral, and the Calendar State Papers for 1702 state:

Stukeley was charged with having long committed acts of indecency in the presence of women; that the Dean has consulted with the Archdeacon of Norfolk and one of the prebendaries and other learned persons. Judges the crime proved, and that owing to the long practice of it, it is a case for expulsion. Declares Stukeley expelled accordingly.[8]

In a period in which it has been written that 'Among the cathedral clergy there is hardly to be found a single name in the whole course of the eighteenth century distinguished in any way whatever',[9] Prideaux has been praised as 'a scholar of large and varied reading and a man of great energy of character'. He was well known as an authority on Oriental religion, but his *Life of Mahomet*, written in 1697, is described as

not of much historical use, being remarkable for rather coarse and very unnecessary abuse of the Prophet, and wholly destitute even of that minimum of sympathy without which no one can usefully write the biography of another.[9]

Indeed, Prideaux shows very little sympathy for anybody in his letters, recording in one, with regard to the citizens of Norwich, 'I take care to have nothing at any time to doe with them except in my

profession'. He was equally harsh and un-Christian in his comments on condemned prisoners in the Castle Gaol, describing some of them as discharged by 'an over-kind jury', and said of others who could not be charged because they were infected with an outbreak of smallpox in the prison: 'It would have been a very bloody assizes, had all had sentence of death that deserved it'. He added, when the seven condemned were swinging on the gallows, 'They were seven desperate sturdy villains and we are well rid of them.'[10]

The Castle had been used as a prison since it ceased to be of military significance from about 1300. The keep housed a variety of criminals, debtors, burglars, horse-thieves, highwaymen, prisoners of war and murderers. From the Georgian period criminals were publicly hanged outside the walls, just beyond the Castle bridge, and these executions attracted huge crowds of spectators. Hubbard Lingley was the last person to be publicly hanged for murder in Norwich in 1867.

One convicted criminal imprisoned there in the Georgian period was John Prior, and a local newspaper of 1750 records the following:

Country News: Norwich, December 1st: On Sunday last, John Prior of Oxnead near Buxton in the county of Norfolk was committed to the Castle, for wilfully murdering his own Child, an infant under two Years of Age. The manner in which he did it, was perhaps the most barbarous that ever was heard of, and is as follows: His Wife being at a Publick House in the Town, he went for her to come home, but she told him she would not come yet; and his Answer was, that if she did not go directly, it would be the worse for her; accordingly he went home without her and found the Child asleep on the Bed, gave it several blows on the Head and threw it upon the floor; but still finding Life in the Infant, took it by the heels and dash'd the Head against the Wall.'

This newspaper report is followed by another in the following year 1751:

On Thursday last died in the Castle of Norwich, John Prior, late of Oxnead in the County of Norfolk, who was committed there, in

December last, for the murder of his own Child, an infant under
two years of age.

The newspaper provides no cause of death. No suspicious
or unusual circumstances are reported, so presumably it
was not suicide or murder by one of Prior's fellow prisoners.
As it is unlikely that he was elderly when committed, he
couldn't have died of old age, so perhaps remorse and inner
turmoil and the unhealthy conditions in the gaol hastened his
decline.[11]

In 1753 the prisoners in the Castle managed to escape:

Last Tuesday about five o'clock in the Evening the Prisoners in the
Castle of Norwich made their Escape by the following stratagem:
as the Governor's Son and one of the Turnkeys were going to ward
them up, they suddenly seized them, and ty'd them Neck and Heels
together; and (having before agreed to lock up such Prisoners as
did not chuse to go with them) they set two of the most desperate
amongst them to stand guard over the keepers till they should go
and call at the Grate to be let out: And as soon as the other Turnkey
unlocked the Door they gave him two or three Blows, which laid
him senseless; and then made the best of their Way, sixteen in all;
but four were retaken the same Night in Norwich not having got
their irons off; two of which were Clarke and Rose the Smugglers
who broke out about two Months since.[12]

Another interesting criminal case was reported in the newspapers
in 1764:

Norwich, Dec. 29: On Sunday last was committed to our Castle,
by William Smyth Esq; James Knights of Tivetshall St. Margaret's,
labourer; being charged by Daniel Randall of the same place,
Alehouse-keeper, with breaking into his house at Tivetshall
aforesaid on the 8th inst. In the Night time and feloniously taking
thereout one pair of Spice-Drawers wherein were contained about
£60 in cash, ten gold rings, and Bills and Notes to the amount of
£20 more, his Property: several Persons have been taken up on
Suspicion of this Robbery. The above Knights is an old offender

and has been several Times in the Castle for House-breaking; and his own Daughter was ordered for Transportation about two Years ago at Chelmsford for the same offence.

After securing him on Suspicion of committing the above Robbery, a search was made for a long while in every place, and coming to search in the Thatch of his House he said 'For God's Sake don't pull the Thatch of my house down'; but they persisting, found forty-three pound ten shillings in Cash, supposed to be part of the said Money, and the ten gold rings. There will be several Indictments against him. In his House were found a great quantity of Provision, great numbers of sheep-skins, with different Marks on them; several Carpenter's Tools, Geese, and Turkeys Heads, in great numbers; and one whole Goose just killed was found in his bed. Before the War ended, he was ordered to be taken by the Constables to be sent for a Soldier, or to Sea; and when the Constables were got some little Distance with him from his House, his Wife (being unwilling to part from so good and industrious a Husband) followed him with a Case-knife, which she had concealed, and cut him so desperately in one of his legs, to the Bone, that it prevented his going.[13]

Sometimes criminals were better off in prison than suffering rough justice from the public, as the following newspaper item illustrates:

June 5th, 1784: It appears from the confession of Sarah Hazell committed to the Castle last week with her husband John Hazell, for the murder of her daughter-in-law, that she murdered the child herself, and that her husband carried it, wrapped up in a cloth, about five furlongs and then threw it into the river.

On the release of John Hazell from prison on June 12th, he was surrounded by the mob, who after treating him in a cruel manner, carried him down to Fye Bridge, where they tied a rope about his body, and threw him over the bridge into the river, but the peace officers being sent for, he was taken out of their hands. The mob afterwards pursued him to Bishop's Gate, where they again forced him across the river, and he was obliged to take refuge in a neighbouring house.[14]

Although the Castle Gaol was a nasty place to be confined in, the prisoners did from time to time receive gifts from the public, which seems rather odd considering how tough the legal system of crime and punishment was in the period. Perhaps it was generally perceived that not all prisoners were necessarily heartless thugs but had committed crimes either through ignorance or through desperation in the need to provide for their families. The newspapers of the period occasionally record items such as the following on 5 January 1760:

> We, the poor Prisoners in the City Gaol, humbly beg leave to return our sincere and hearty thanks to our unknown Benefactors for the following Gifts, viz. for five shillings on the Thanksgiving-Day; for half a guinea on Christmas Eve, for a very good and large Beef-Pye on Christmas Day, for 40 and 48 3*d* loaves last week, which the Governor carefully distributed amongst us. Also to the Gentlemen at the Coffee-House for 6 stone of Beef and a shilling to each of us.[15]

These gifts were usually offered in the Christmas and New Year period.

The Governor could obviously refuse them, as inappropriate, or if he was dishonest retain them for himself and his family, so it seems that he was a kindly individual. It was probably he who penned the letter on the inmates' behalf. A polite and grateful response might elicit more such generous gifts in the future.

By the middle of the eighteenth century, the prison was becoming overcrowded and unsanitary. It was inspected by the prison reformer John Howard in 1777, when he noted the appalling conditions. As a result, a new prison block was designed in and around the keep in 1792 by the celebrated architect Sir John Soane. It soon proved to be too small for the increasing number of prisoners, so a new gaol was built where prisoners were housed in separate cells in blocks radiating from the gaoler's accommodation in the centre. From this position, he and the prison officers could keep a close eye on the cells and the exercise yard.

In the following century, prison accommodation was moved outside the city centre to Mousehold Heath in 1883, and the

Castle prison block was converted for museum displays by architect Edward Boardman.

Whereas in previous centuries the bubonic plague had been the cause of many deaths in the city, by the seventeenth and eighteenth centuries smallpox was the most acutely contagious disease. Accounts of it appear in the letters of two sisters, Barbara and Elizabeth Postlethwaite, whose family home was at Denton Rectory in Norfolk. When Barbara married the Reverend Samuel Kerrich in 1732 and went to live at Dersingham, the sisters kept in touch by writing letters, and much of their correspondence has survived. Barbara wrote from Dersingham on 24 April 1744:

> Mrs. Gregson is just come home from seeing her friends at Norwich and Attleborough, and brought such dismal accounts of sickness everywhere that have disconcerted all our schemes. She says at Norwich in particular there is a very bad fever and measles besides the smallpox, and that so bad that she left Mr. Gregson at Attleborough and only went to Norwich herself, he having never had the smallpox, and in the country towns she passed through, people airing themselves that looked very fresh got up of the smallpox, and in one place no less than three feather beds laid in a yard close by the roadside where it was known the smallpox had very lately been, that she says she has been in continual fear. We observed the bill of mortality either last week or the week before was increased 26 in one week at Norwich. It is very sickly hereabouts too, at Lynn there is an exceeding bad fever and very mortal. When you see my cousin Johnson you will be able to give us a true, and I hope a better account from Norwich. Everybody here discourage us very much.[16]

'Cousin Johnson' was a poor relation of the sisters who had been assisted financially by the Postlethwaite family to establish a small business close by St Peter's church near the White Swan in Norwich in 1735. She is referred to in a letter written by Barbara earlier in 1741:

> Dersingham, 24th September, 1741:
> … My cousin Johnson was very brisk when we were at Norwich, talking of their late election they have had for Sheriff, and teasing me

to send the gown and shift. I told her I would not, but she said she would come to the coachman and see what he had got for her when he came back. However there was nothing worth her going for. I sent only a shift and apron because she would go for something. Her daughter said she was sure my goodness was such that I would send them. She talk like a player and look a masquerade, for she have shaved her forehead at top. I suppose she had a large widow's peak, you never saw anything look so blue and frightful in your life, except you had seen Tom Andrews with a fringed mob on. She was very well dressed else, with a clean blue and white cross-barred gown and clean apron. She dined with us, and the Dr. gave her half-a-crown, she took eleven shillings for my coat.

A 'player' was the contemporary term for an actor, and presumably Cousin Johnson had shaved her forehead because it was fashionable in the city at the time. John Calver and William Crowe were elected Sheriffs for 1741, and were sworn into office on Michaelmas Day. The reference to the delivery of the clothes illustrates how goods had to be conveyed by coach at the time, to a coaching inn or office, and, as Cousin Johnson was too poor to hire a servant, she had to collect the items herself.

By 1750, inoculation for smallpox was initiated, but the disease was still current. Elizabeth wrote to her sister from Denton on 12 April 1750:

Dear Sister,

I shall be glad to hear in your next that you are quite out of danger from the smallpox, and I hope it do to abate here though they still inoculate. Yesterday both Mrs. Howman and Miss Berney came out of the smallpox, they think it will prove a good sort. When I talk with Mrs. Catherall about going away she was so civil to tell me as the smallpox was in the city, she was sensible I couldn't be at any uncertainty as to the time of going, and therefore should not expect my going at a quarter's warning, but to go when I thought it safest and best.

Elizabeth Catherall was the landlady of Chapelfield House in Norwich, and later Elizabeth had lodgings with her. She describes

her journey to take up lodgings in the city in a letter of 12 August 1750, written from Chapelfield House:

> Dear Sister,
>
> ... I performed my journey to Norwich much better than I could expect, but was very weary and my spirits sunk, but thank God did not cough which I very much expected, and thought it impossible for me to move so far without, which made me dread the journey. For had I thought I should have come off so well, I should not, I believe, have taken a room at Chapel Field House, but have rested myself at a tavern or somewhere, but as I have, must stay this winter, for I must pay for half a year if I do not, and that I can't afford to do ...

She writes again on 24 August, after she had time to settle in, but was not finding her accommodation entirely convenient:

> Dear Sister,
>
> I would have wrote last week, but the carrier stay so little a while in town, and Miss Baker of Hedenham just then called upon me, that prevented me. She and her sister were in town all the assize week ... I was a good deal disturbed the two assembly nights with the music and dancing, but it was an amusement to me to see the company, and made some amend for the disturbance it gave me ...

She wrote again on 28 September:

> I never told you in what manner I live, I am a sort of housekeeper. When I first came I went to the cook's shop, but now I begin to keep fires, I cook my own victuals. I have bought a little tin boiler and little dripping pan, for I roast sometimes, but I am forced to do that upon a string. You would laugh to see my little cookeries, for a little serve my maid and myself.

Elizabeth, having lived comfortably at Denton, was now in straitened circumstances following the death of her brother, for whom she had been acting as housekeeper, and who had

died intestate on 10 May 1750. Those who could afford it often purchased food from local cooks' shops, of which there would have been many in the city, but this seems to have been proving too expensive, so Elizabeth was cooking in her lodgings.

It is fascinating to have so detailed an account of a woman of genteel birth and prosperous background having to adjust to living on a smaller income. It was a common fate for many females until the twentieth century, when it at last became possible for women to pursue careers of their own choice.

# 1750–1800

## The End of Georgian Norwich
## 'Ran away from his Master ... James Hewes, a small chimney-sweeping lad'

Towards the end of the eighteenth century, increasing traffic of wheeled vehicles, coaches, carriages, and carts necessitated improvements to the roads in and out of the city. They were repaired by the Turnpike Trustees, who obtained funding from the tolls they charged. By the turn of the century, all the city gates were removed because they hampered the flow of traffic, and old bridges were rebuilt, or new ones created. The result of the removal of the city gates meant that the old defensive walls were also no longer needed, and new buildings were erected around them. Today, there are only sections of the walls left, notably in the area around the top of St Stephen's Street and near the Chapelfield Gardens.

In the absence of sufficient men to serve as soldiers, especially when recruits were needed for overseas service – for example, during the Seven Years' War, 1756–63 (when Britain was allied with Prussia against France, Austria and Russia) – various ploys were used to enlist them. This often involved 'press gangs' encouraging, forcing, bribing or tricking men to agree. Those convicted of crime could also be offered the option of either punishment or enlisting, as was the case reported in the local newspaper in 1756.

Norwich, May 1: At the Sessions this week for the County of Norfolk, one Mills made his appearance in the Pound, who was brought from Aylsham Bridewell, having been some Time past in

that part of the Country shewing Slight of Hand Tricks and eating Fire. His appearance was genteel with a laced Hat, and Ruffles. He was sentenced to be whipt next Market-Day at Walsham, and kept to hard Labour for one Month, otherwise to serve his Majesty, which last he gladly accepted. The Justices sent for an officer who inlisted him in Court and gave him two Guineas and a Crown.[1]

Well, that seems like a pleasant escape from a nasty fate, but army and navy life was harsh, with severe discipline and punishment and of course the high risk of death when involved in military action – which was one reason why men had to be conscripted by force or persuasion.

The local newspaper in 1755 provides an example of recruiting officers at work:

Norwich, April 5: On Saturday an Officer of the Navy came to this City to inlist Seamen for his Majesty's Service, and great numbers have already inlisted as Volunteers; all of whom are intitled to, and will receive his Majesty's Bounty: and, as a further Encouragement, the Magistrates of this City have given Orders to supply such as were in Want with Shirts, Shoes and Stockings.[2]

This report illustrates how desperately poor some of the Norwich residents were – not even possessing decent basic clothing. Unemployed men would have jumped at the chance of enlisting with the promise of pay and free clothing, but for the married men it often meant that their wives and family were left to fend for themselves until their husbands' return, which might not be for several years, or perhaps never, as both sea voyages and a seaman's life – with its harsh treatment, poor food and dangerous conditions – were hazardous.

'His Majesty's Bounty' was a sum of cash given to recruits on enlistment. The city officials were keen to see the poor who might need parish relief taken away for naval service, which was why they were prepared to offer clothing as an additional incentive.

Riots and disturbances occurred frequently throughout the Georgian period, another indication of the poverty and social deprivation that prevailed. At the time of writing, August 2011,

rioting, looting, and property burning is occurring in various London boroughs, and has just spread to Birmingham as well. The causes are probably similar: dissatisfaction with current social conditions, pockets of inner-city deprivation, and many young men growing up with little education or training and worsening prospects of employment. It seems clear that in London today, just as in Norwich in the eighteenth century, valid reasons for protest are often aggravated by mobs of mainly young men who have little interest in the cause, but are looking for sport which may also lead on to fighting, stealing and attacks on property.

In Norwich, riots occurred when George I was crowned king in August 1714, the mob deciding to join those who wished to protest about the legitimate claims to the throne of the Young Pretender. In 1716, on May Day, when a new Mayor was elected, 'there was such rude and riotous behaviour by the Rabble of the freemen, as the like was never known, which caused by fighting many bloody noses, and by throwing of stones and brickbats, many broken heads'. In 1740, there were riots caused by a shortage of grain for bread, following poor harvests, and in the same year a five-day riot because the price of fish, usually another staple food of the poor, had risen sharply.

Food shortages also caused the most violent of all the Norwich riots. In September 1766, a crowd assembled in the Market Place and attacked the provision stalls. They also marched into bakeries and breweries, causing havoc, and partly demolished the White Horse tavern in the Haymarket. The rioting continued for nearly a week, until 2 October, but was finally subdued by the authorities without the need for military intervention. A local reporter commented that this was 'an example which I hope other places will endeavour to imitate'.

However, there was still considerable unrest, and on 25 October a local newspaper printed the following public notice issued on 21 October:

Whereas it has been humbly represented to the King, that on Wednesday the 15th day of this instant October, about seven or eight in the morning, an anonymous threatening incendiary letter

was found under the Threshold of the Shop-Door of James Poole,
of the City of Norwich, Esq; directed as hereunder, and containing
the words and letters following, viz:

For Mr Pool Grocher (i.e. grocer) in Norwich.

Mr. Pooll,

   This is to Latt you to know and the rest of you Justes of the Pase
that if Bakers and Butchers and market people if they do not sall
thar Commovits at a reasnabell rate as they do at other Markets
thare will be such Raysen as never was known for your vinegar
hoses and your Tallow Chandler and fine House will be set on
fire all on one Night for we are detarmed we will have our Minds
as wall as you have your minds and all you grand Rogues for to
suffer the Bakers to tain the flower as deare as to was before but
tis to Late you all know that we will Rise 9 hundred Men and no
boyes for we will clare all before us and if we donot a now we
will rais twise 9 hundred.[3]

This letter was written by somebody who could read and write
but suggests that he had received little education, probably like
most of his supporters. He affirms that among the insurgents
there will be 'no boys', wishing to make the point that these were
men with a serious mission who did not wish to be associated
with any ragamuffin urchins in it for laughs.

   The Norwich magistrates offered a reward of £100 for
information leading to the discovery and conviction of the
person who penned the letter. It is not recorded whether the
culprit was ever discovered but on 6 December a trial took place
of those arrested during the 'late Riots and Outrages'. The jury
consisted of sixty of the principal manufacturers and tradesmen
of the town, and the trial lasted for four days. It seems totally
unjust that men with starving families and children should be
convicted and punished for rioting because they were suffering
from lack of food, but it was a period in which any form of
crime or rebellion affecting property was harshly treated. Eight
men received sentence of death, although on 20 December a
respite was issued for six of the eight. Two men were eventually

executed, and others were transported or imprisoned. The local newspaper reported the following on 17 January 1767:

> On Saturday last, John Hall, aged 46, and David Long, aged 56, for being concerned in the late Riots in this City, were executed pursuant to their sentence. They behaved very penitently, and expressed great Contrition for their past misconduct, and earnestly recommended to the Populace a due observance of the Sabbath, and Attendance upon Divine Worship; the Neglect of which had been the principal means of their coming to an untimely End. After they had hung the usual time, their Bodies were cut down and carried back in a Cart to the Gaol, where they were deposited in Coffins, and delivered to their friends, in order for Interment.[4]

It is very sad to learn that they 'expressed great Contrition' when all they were aiming to do was obtain food for themselves and their families. Nor are their words about the necessity of attending Sunday worship very credible, for many families were so poor that their ragged and dirty condition would cause embarrassment in a place of worship principally attended by the middle-class and affluent. Still, at least the victims were permitted a decent burial by their own families. It was not the end of the matter though, as poor harvests and the high price of grain for bread resulted in other food riots throughout Norfolk in 1772.

There was also rioting and mob violence associated with the Dissenting ministers, their congregations, and places of worship. The Methodists gained some support in the city following visits by John and Charles Wesley in 1754, but another Methodist preacher, James Wheatley, who arrived earlier in 1751, was attacked with his supporters by a mob – said to number about 9,000 to 10,000 – when they held an open-air meeting at the Tabernacle in February 1752. First, the mob drowned out the voice of the preacher with drums, clapboards, and other instruments, and then started accosting the congregation: it was recorded in a contemporary diary that 'Mr. Wheatley could not get away, he was shamefully handled, his hat and wig lost, his head broken in several places, his clothes rent, and himself all over mire and

dirt.' Eventually he managed to escape to a house nearby, and the Mayor sent his officers to protect him from further violence.[5]

The Baptist community was similarly targeted. A newspaper reported in 1752:

> By Letters from Norwich, we have the following Account of the Rioting there on Sunday last: They broke open Mr. Lawson's door, one got up on a chair and made a mock-preaching with a Bible, then broke the windows and rioted about the streets all day long; they not only disturbed the Baptist Congregation, but abused the People very much as they came from the Independent Meeting. The Mayor and Sword Bearer came and read the Proclamation, nevertheless the Mob behaved very rude before them crying out 'Church and King, down with the Meetings, down with the Meetings'.
>
> No Bills being found against them at the Sessions they are grown more outrageous, bold and desperate than ever. On Monday night they gathered in St. Austen's, and went to the House of one James Cannam with Fire Pans and Tongs, Pitchforks and Quarter-staves; after they had burst open the door, they flung a man they found in the house into the Necessary with his head foremost, then carried him to a pump and pumped upon him, till he escaped from them with much difficulty.
>
> The City is filled with a panic fear, especially the Low-Party; the Mob are now many thousands: abundance of Papists are among them; if any are put in Prison, they soon get Bail and riot more than ever. This Mob has now been supported near Three Months.[6]

The 'Low Party' were those Anglicans who preferred Protestant simplicity in religious matters, as opposed to High Church, which favoured greater exaltation of the clergy and ritual. The riots may also have been provoked by new government anti-Catholic legislation. The 'Independent Meeting' referred to presumably means the Old Meeting House in Colegate, one of the oldest Nonconformist churches in the country. It was built in 1693 by William Bridge, a Congregationalist, who had fled to Holland to avoid persecution for his religious beliefs but returned to Norwich in 1642. It is believed that the church was built in a courtyard

so that the men of the congregation could defend the building from rioters in the front while women and children slipped out at the back: the wisdom of this advance planning became more apparent as mob violence against Dissenters continued through the eighteenth century.

Also in Colegate is the Octagon Chapel, designed by Thomas Ivory and one of his masterworks. It was built in 1756 to replace an earlier Presbyterian meeting house, and was variously described by John Wesley as 'perhaps the most elegant one in Norfolk'; but he added, 'How can it be thought that the old coarse Gospel should find admission here?' Anglicans referred to it as 'the Devil's cucumber frame' – but this was just sour grapes. In the later eighteenth and early nineteenth centuries it was the church of the Unitarians, including the prominent and wealthy Martineau family, and John and Amelia Opie, of whom more in the next chapter.

The Opies, and other members of the Octagon congregation, including William Taylor, the son of an eminent Norwich manufacturer, were keen supporters of the French Revolution when it broke out in 1789. Other supporters included John and Susannah Taylor, and it was said that Susannah danced a jig with Dr Parr, headmaster of the Norwich School, round the tree of liberty at a great Whig dinner to celebrate the fall of the Bastille.[7]

Many working-class men also supported the French Revolution and established their own Radical Clubs, numbering as many as forty, with about 2,000 members. This reaffirms the level of deprivation in the city and the enthusiasm for toppling a regime in which the rich abused the poor. When John Thelwall, a popular lecturer on Radicalism, was invited to speak in the city in 1797, a party of dragoons stormed into the lecture room and trashed it. Presumably they were acting on the orders of some authority, but nobody claimed responsibility. Radicalism tended to die out as the violence of the Revolution increased. During the resulting Napoleonic Wars, many of the wounded sailors who fought in the Battle of Camperdown in 1797 were brought from Yarmouth harbour to the new Norfolk & Norwich Hospital for treatment.[8]

Quantrell's Gardens was the popular place for recreation in the Georgian period. It was just beyond St Stephen's Gate, south of Queen's Road. One of the attractions in 1790 was inspired by the French uprising. The local newspaper reported:

> Those who never beheld that monument of tyranny and cruelty the BASTILLE in Paris, must be completely gratified in Mr. Quantrell's Gardens with the exact representation of that horrid prison and the gate of St. Anthony copied in a style, which Vauxhall would not blush to admit within its confines, and executed by Mr. Ninham of this city.[9]

The 'Vauxhall' was the popular pleasure gardens patronised by the gentry in London. Parson James Woodforde, on a trip to Norwich on 1 June 1785, was fortunate to see the amazing spectacle of a balloon ascent from Quantrell's Gardens, very much the talk of the city at the time.[10]

He describes how he was walking on Bracondale Hill at about three o'clock in the afternoon when there arose a violent thunderstorm with lightning and heavy rain, which lasted about an hour. Immediately afterwards he saw the balloon, piloted by James Dekker in a boat annexed to it, ascend from Quantrell's Gardens and travel in a south-easterly direction – it almost passed above his head. His companions – his niece Nancy and Mr and Mrs Custance, who were visiting Norwich with him – were in Mackay's Public Gardens at the time, and they also saw the balloon very plainly, together with a vast crowd of people who had assembled in the vicinity. Woodforde adds:

> It was rather unfortunate that the weather proved so unfavourable – but added greatly to the courage of Dekker that he ascended so soon after the tempest. It also bursted twice before he ascended in it, upon the filling it, if it had not, a girl about fourteen was to have went with him in it – but after so much Gas had been let out – it would not carry both ...[11]

A contemporary newspaper records the first attempt at the balloon ascent, from Quantrell's Gardens on 13 May of the same year:

Mr. Dekker and his ROYAL BALLOON from London, with its elegant GONDOLA or BOAT, on which stands a beautiful Chinese Temple, richly embellished and decorated in a Style of unparalleled Elegance, is now to be seen every day, from Eight o'clock in the morning to Eight in the Evening, at Quantrell's Gardens, Norwich – Ladies, Gentlemen, etc. One Shilling each, Working People, Children and Servants, sixpence each …

Mr. Dekker will be accompanied by a YOUNG LADY from London … Books are now opened, and tickets (for the day of Ascension) at Ten Shillings and Sixpence for the front seats, and Five Shillings for the second seats, may be had at the Banks of Messrs. Gurney, Kerrison and Hudson and Co.[12]

Woodforde was fortunate to be able to see the balloon ascent for free: five shillings and ten shillings were very large amounts of money in the Georgian period, so only the wealthy could afford to pay for seats to view the spectacle of the ascent at close quarters.

Following the event that Woodforde witnessed, there was a second ascent on 23 June, the delay caused by the weather conditions. On this occasion the balloon was in the air three-quarters of an hour, and it then landed at Topcroft, about twelve miles from the city. 'Several Gentlemen had pursued the Balloon on Horseback from Norwich and came up with it within a quarter of an hour of its descent …'[13]

The contemporary newspapers provide scraps of information about Norwich characters who would otherwise be almost entirely forgotten, and are now resurrected only by the intrepid local historian. For example, a report on 30 May 1752 tells us that:

On Wednesday last died one, Nobbs a Weaver in the Castle Dykes, who hired his Room by the week; and on Thursday as his Landlord was taking down his loom in order to sell it, to buy him a Coffin, and to bury him, he found, concealed in a Hole in the Wall, where one of the Posts of the Loom stood against it, Sixty Guineas in a Leather Bag.[14]

Sixty guineas was a fortune in the eighteenth century. Nobbs was presumably hoarding it for when he could no longer work, and to provide for his own funeral expenses.

And then there is the prolific Peter Flower, who no doubt died exhausted by his labours:

> Dec. 20th, 1760: On Sunday last died, aged 75, Peter Flower, a journeyman butcher, in the parish of St. John Sepulchre, in this city. By three wives he has had born and baptised thirty-eight children; twenty by his first, six by his second, and twelve by his widow who now survives him.[15]

Local newspapers also shed light on Georgian funeral customs:

> January, 1766: On Sunday night, Chilvers, a lamp-lighter was interred at St. John's Timberfield. The Corpse was preceded by 21 Lamp-lighters in black cloaks, each with a lamp fixed to a pole … the senior Lamp-light, as Chief Mourner, followed by 20 others and then 70 persons belonging to a Purse of which he was a member at the Duke's Head whence the procession started.[16]

The church is now known as St John, Timberhill. What a weird and scary sight it must have been to see this procession of men in black cloaks, on a dark night, their features only lit by the flickering beam of their lanterns. Chilvers was obviously a member of a Purse Club which paid money into a fund so members would have their funeral expenses covered when the time came (unlike Nobbs the Weaver). The procession started at the Duke's Head and no doubt finished there when the lamp-lighters returned to raise a glass to their dear, departed comrade. Today, a funeral on a Sunday would be unusual, but in the pre-twentieth century, it was the only day of the week when working men could attend.

The 'necessary' or outdoor 'privy', usually just a hole in the ground, was the normal toilet facility for most people until the twentieth century. The 'privy' – short for 'private' – often was not very private at all, and there are tales of boys creeping up behind whoever happened to be sitting on the hole in the ground and

tickling their exposed rears with stinging nettles. The facility could often prove hazardous for small children for other reasons:

> March 1790: On Thursday last, a fine boy, about five years of age, fell through the seat of the necessary belonging to Mr. Mapes, in the Haymarket, the reservoir to which is not less than 40 feet deep: in this shocking situation he remained from a quarter past ten till three o'clock in the afternoon, before he was discovered by his cries. A person immediately went down to his relief, and when he had raised him halfway up, the bucket in which the child was, striking against a timber that had not been perceived, he was again precipitated to the bottom head forward. The second attempt to save him proved, however, successful, and, miraculous as it may appear, the infant is now in apparently perfect health. The humanity of a number of individuals on this occasion, spoke loudly for the goodness of their hearts. We hope this accident will make others cautious in guarding such dangerous places.[17]

The newspapers continued to report stories of runaway servants and apprentices. For example, in 1783:

> Ran away from his Master, Nicholas Frary, James Hewes, a small Chimney-sweeping lad, about four feet high, and between ten and eleven years of age ... the said boy was bound out apprentice by the Court of Guardians at Norwich. Any person who will take care of him and send him to his said Master shall be satisfied for their trouble: and whoever harbours him after this Publick Notice must expect what the Law directs in such cases.[18]

Small boys were frequently taken on as chimney-sweeps' apprentices because the job involved getting the lads to climb up inside the chimneys to ensure they were properly swept. It must have been a frightening task for a young boy when first forced to do it. If he complained, he would be bullied or beaten, which is probably why James Hewes ran away. It would be pleasant to think that a kind family took him in, but the offer of a reward, or punishment if the boy was harboured, makes it likely that he was returned to his master.

An unusual character, Dr Fortunatus Benvenuti, appeared in the news when he was arrested in 1767:

> To detect Impostures of any kind is deserving the Thanks of the Public and is in no instance of greater utility than to expose and suppress that Species of it, which under pretence of extraordinary Skill in medicine, commit merciless Depredations on the credulous and necessitous.
>
> A Foreigner, who calls himself Dr. Fortunatus Benvenuti, has for several Months past strolled about this Kingdom sumptuously dressed, in a handsome Chariot, with two servants in Livery; after having been permitted with Impunity to continue many weeks at Leicester, Birmingham, York, Liverpool, and other Places, he lately infested this City, to the additional Distress of many diseased and indigent persons.
>
> On Monday he was summoned before the Mayor and two other Justices of the Peace ... he was called upon for his Authority for Travelling in England, he said he had the King's Letter, which appeared to be a Foot Licence from the Commissioners of Hawkers and Pedlars; upon the whole Examination he appeared to be destitute of Knowledge, Medicines, and Instruments to perform the wonderful Cures he pretended to effect, except an apparatus for Couching, and tolerable acquaintance with the Anatomical Structure of the Eye ... the Magistrates finding himself, a woman who passes for his wife, and the Servants were vagabonds according to the Vagrancy Act, acquainted them that unless they quitted the City that afternoon they should be committed to the House of Correction for six months: accordingly, to the Relief of the Poor (whom he pretended to cure Gratis, although each paid a Shilling to the servant before they were admitted to an Audience with the Doctor) and much to the credit of the Magistrates who exerted themselves in their Favour, they decamped immediately.[19]

The writer of the article seems pleased to point out that whereas other cities had permitted this imposture to continue unchecked, Norwich acted wisely and swiftly in exposing the quack and his embezzlement of the poor and simple. Doctor Fortunatus was allowed to depart without punishment, but would he then

continue his tricks elsewhere, or did the city officials send word of warning to other towns in the region? The truth is that none wished to incur the expense of a trial or imprisonment unnecessarily.

Street fires occurred from time to time – but none as bad as in the seventeenth century now that most properties were tiled instead of thatched. In 1746 a fire occurred in the Shire House on Castle Hill, destroying it, and in 1751 a more serious fire broke out in Bridewell Alley. The local press reported on 26 October:

> Last Tuesday Morning about two o'clock, a Fire broke out in a Warehouse belonging to Mr. Britiss, a Household Broker in Bridewell Alley in St. Andrew's Parish which proved the most terrible, before it was extinguished, that has been known in the City for many years. The Flames in a very short time extended to the City Bridewell and entirely consumed the same with several Houses adjoining. Notwithstanding the great Care that was taken by several Gentlemen of Fashion, who attended and encouraged the Populace that were diligent in working at the Engines and carrying Buckets of water, it was six o'clock before the Fire was got under. A genteel collection has been made in every Parish in this city, to contribute towards the Relief of the poor Sufferers and those persons who distinguished themselves by their Industry in extinguishing the Flames.[20]

It seems that the 'Gentlemen of Fashion' did not wish to soil or singe their lace ruffles and satin breeches, so just stood aside and cheered on the workers. And was the 'genteel collection' of money partly used to compensate Marmaduke, who scuffed one of his silver shoe buckles, and Clarence, whose embroidered waistcoat got splashed with muddy water?

The custom of annually presenting twenty-four herring pies to the King continued in the Georgian period. It was reported in the local newspaper in 1761:

> On Wednesday, according to annual custom, were presented to, and most graciously received by his Majesty, twenty-four herring-pyes from the Corporation of Norwich by which they hold their Charter.[21]

This tradition dated back to an early period, and in the city records of 1354 there is a detailed record of the procedures:

> Concerning the delivery of 24 Herring Pies parcel of the fee farm of the City of Norwich:
>
> Powder for the Lord King's pies – Half a pound of ginger, half lb. of pepper, a quarter of cinnamon, 1 oz. of cloves, 1 oz. of long pepper, half oz. of grains of Paradise, half oz. of galingale.
>
> And let it be known that the Lord King shall receive of the citizens of Norwich six score herrings in 24 pies, that is to say 5 herrings in each pie. And Hugh Curson of Carleton shall carry the said pies to the Lord King. And he shall have 4d from the said citizens for the carriage of the said pies, and one pie.
>
> Be it remembered that the Lord King shall receive annually of the Bailiffs of the City of Norwich one hundred of the first fresh herrings coming to the city in 24 pies ... And be it known that Hugh de Curson is bound for his lands and tenements to carry the said pies to the Lord King. And the said Hugh, or the carrier in his name, shall receive at the court of the Lord King as below written, that is to say, 6 loaves, 6 dishes from the kitchen, 1 gallon of wine, 1 gallon of beer, 2 trusses of hay, 1 bushel of oats, 1 pricket of wax and 6 tallow candles.[22]

With regard to the ingredients of the pies, 'grains of Paradise' were Guinea grains, and galingale was a kind of ginger. Hugh de Curson held estates at East Carleton, a village about four miles outside Norwich, and his role as official pie-carrier was connected with the tenure of those lands.

It seems that the pies were always welcome, and, if not always eaten by the royal family, were probably enjoyed at the table of the courtiers or chief officials. But in 1629, a complaint was made concerning both the quality and quantity:

> To Alexander Anguish, Mayor, John Thacker and William Gostlin, Sheriffs:
>
> After our hearty commendation, we have thought it fit to let you understand, that upon the deliver here at court of the herring-pyes, which we lately received from you, we find diverse

just exceptions to be taken against the goodness of them, which we must require you to answer and take such order that the same may be amended for the future tyme as you would avoid further trouble: the exceptions we take are these, viz:

First, you do not send them according to your tenure, of the first new herrings that are taken.

Secondly, you do not cause them to be well baked in good and strong pastye, as they ought to be, that they may endure the carriage better.

Thirdly, whereas you should by your tenure, bake in these pasties, six-score herrings at the least, being the great hundredth, which doth require five to be put into every pye at the least, we find but fower herrings to be in diverse of them;

Fourthly, the number of pyes which you sent at this time, wee finde to be fewer then have been sent heretofore, and diverse of them also much broken.

And lastly, we understand, the bringer off them was constrained to make three several journeys to you before he could have them, whereas it seemeth he is bound to come but once.

To every of which our exceptions, we must pray your particular answer for our better satisfaction, that we may have no cause to question it further, and so we bid you heartily farewell.

Your loving friends,
Pembroke. John Savile
Rich. Manley
Hampton Court the 4th of Oct. 1629.[23]

The words 'loving friends' must have been written with a degree of sarcastic indignation. That there were so many reasons for complaint is difficult to understand. The fact that the carrier was obliged to call three times before he could collect the pies suggests that the officials had failed to order them in advance and then had them baked in a hurry, leading to deficiencies in contents, numbers, and quality of fish and pastry. But it is more likely that the reason was political. The monarch at the time was Charles I, already in conflict with his Parliament, and those Norwich officials who favoured the Puritan cause may have felt that the King was no longer deserving of their very finest pies.

However, the Mayor muttered grudging excuses, and there were no further complaints. The long-standing custom of the delivery of the royal pies continued, and only finally ceased in 1816.

The Norfolk & Norwich Hospital was founded in 1771, and was the first hospital in Norfolk that provided medical treatment for all classes. The doctors who attended gave their services free of charge, although if casualties were admitted and found able to pay, they were charged a shilling a day to cover food and other costs. The hospital was primitive according to modern-day standards, with no piped water or drains, no trained nurses, and with only one resident doctor, although four unpaid physicians and four surgeons attended as required. But it provided an improved level of care for a wider section of the community and one patient extolled its virtues in a letter published in the local newspaper in 1781:

TO: The worthy Chairman and Gentlemen of the Weekly Committee of the Norfolk & Norwich Hospital:

Gentlemen,

I am so obliged to you for your kind treatment and happy Cure I have received at this Hospital, that I am at a Loss to express myself, on an Occasion so very beneficial to me. To this excellent Charity I am indebted, under Divine Permission, for being restor'd from Lameness to Vigour, and from Pain to Ease, and am enabled to return to the usual Offices of Life, with a healed Limb, and a serene Bosom, freed from those gloomy Anxieties which present Affliction and Apprehension of future continually excite.

In a leisure Hour during my Residence here, whilst I was reflecting upon the high Value of the Benefit received here, the annexed lines offered themselves to my Thoughts, and humbly hope you will excuse my Freedom in presenting them to your Perusal, though very conscious they have no other Merit than that of being the genuine Tribute of a grateful Heart.

I am, with greatest Respect, Gentlemen,

Your obliged and humble Servant,

Walter Heywood.

Norfolk and Norwich Hospital.

Awake, my Muse! And tune thy humble Lay,
The pleasing Call of Gratitude obey,
Collect thy Powers, each meaner Theme despise,
And, at her Altar, let the incense rise.
Born by the Subject on Poetic wing,
In praise of Norfolk's Hospital I sing,
Where God-like Charity with cheering Rays
Her sweet Beneficence o'er all displays ...[24]

Exploring the lanes and alleys that radiate from the city centre is a fascinating adventure, now enhanced by the blue plaques installed by Norwich HEART (Heritage Economic and Regeneration Trust) as part of its programme to provide more information about the city for visitors.[25]

In Bedford Street is the Wild Man pub. The blue plaque on the wall outside records that it was named after a feral child who was accommodated briefly in Norwich Bridewell in 1751. Known only as 'Peter', he was first discovered in 1724 in some woods near Hamelin in Germany, about twenty-five miles from Hanover, where he was observed walking on his hands and feet, climbing trees like a squirrel, and feeding on grass and moss.

It was decided to accommodate him in the house of correction at Zell, and there he was shown to George I of England, who was visiting Hanover at the time. It was judged that he had been born in about 1715, although nothing could be discovered of his parentage, and that he must have been abandoned in the woods as a small child and left there to fend for himself.

The King arranged for him to be brought to England in 1726, where he was exhibited as a freak. Queen Caroline attempted to have him educated, but even encouragement to help him to speak proved unsuccessful.

Following the Queen's death, the King provided accommodation for Peter with a farmer, Thomas Fenn, at Berkhamsted in Hertfordshire, where he was occupied in manual labour, although in need of constant supervision. Each spring he tended to wander away from the farm, and in 1751 was apprehended as a vagrant in Norfolk. He was conveyed to Norwich Bridewell, near to where the Wild Man pub is now situated. It was suspected that

he might be a Spanish spy, and of course he could not explain anything about himself. It was during his confinement there in October that the serious fire occurred, mentioned above.

After about six weeks, the keeper of the Bridewell saw an advertisement requesting information concerning Peter's whereabouts. Contact was made with the farmer and Peter was returned. Thereafter he wore a brass collar inscribed 'Peter the Wild Boy, Broadway Farm, Berkhamsted' so that if he wandered again he could be returned to his home. He lived to a good age, about seventy, dying in 1785, and was buried at Northchurch in Hertfordshire. The city of Norwich must have seemed a strange and noisy place to him, and he must have been relieved to return to the quieter and more familiar region of the Broadway farm again.

The White Swan Playhouse was the principal venue for theatrical performances in the early part of the eighteenth century. It was situated on the site of the present-day Forum. The Norwich Company of Comedians regularly acted there, and one of their performances is mentioned in the *Norwich Mercury* in 1727. A newspaper advertisement of 1761 reports that 'Mathews and Co. from Sadlers Wells' were there with 'Pantomimical Dance', with seats costing 2*s* 6*d*, 2*s* or 1*s* 6*d* in the upper gallery. It was superseded by a purpose-built theatre, designed by the eminent city architect Thomas Ivory in 1758 and built next to his much admired Assembly House. This was very prestigious for the city, for it was only the second purpose-built theatre in the country.

The committee books recording the meetings of the management group provide fascinating details about the Georgian performances and actors. One particular couple who constantly caused problems were Mr and Mrs James Chalmers. Mrs Chalmers was described as 'a good comedienne' who had performed at Covent Garden in 1754, and joined the Norwich Company in 1756. James Chalmers was 'esteemed a good Harlequin' and an engraved portrait of him in the character of Midas depicts 'a stumpy little man with coarse face'. They are mentioned as a performing couple in the minutes of the Theatre Royal in 1769.

However, James Chalmers was soon in trouble in 1770 when it was ordered that he would be prosecuted 'for a breach of his Articles', i.e. the employment contract that all the performers had to sign. He then seems to have been found guilty and sacked. In January 1771, the minutes record, 'Mr. Chalmer's fresh application was referred to the Proprietors and rejected', but in February a change of heart had occurred:

> Some of the Proprietors now present apprehending it to be the Opinion of the Proprietors at the last General Meeting that the prosecution against Mr. Chalmers should not be further proceeded on, unless he should plead to the Declaration filed against Him, the Proprietors now present direct that Notice be given Him there shall not be further proceedings had thereon if he particularly requests the same by giving his Note for Five Guineas towards the charges incurred, but if he should plead to the Declaration, then Mr. Dewing is desired to proceed and carry the Prosecution on with Vigour & Mr. Dewing is desired to make out his Account of the charges incurred which the treasurer is desired to discharge.[26]

Then in April:

> Ordered that Mr. Griffith give Notice to Mr. Chalmers that he is not to be permitted to go behind the Scenes for the future.

It seems that Chalmers was in the habit of continuing to frequent the theatre to see his wife, and she now took umbrage, for the minutes also record:

> Ordered that Mr. Griffith give Notice to Mrs. Chalmers that if she refuses to take such parts as are allotted to her by the Managers that her Salary will from henceforth be discontinued …

Perhaps she felt she wasn't being given sufficiently important roles because the managers were having trouble with her husband. But, as he was without work, she was obliged to take what she was offered or the pair of them would become totally destitute.

Then in December, Mr Chalmers was finally re-employed:

> Upon repeated application of Mr. Chalmers to the Proprietors, it is agreed that he shall be received as a Performer at his former Salary, so long as he shall behave himself to the Satisfaction of the Proprietors, there being deducted out of his salary the weekly sum of five shillings & 3*d* until the sum of Five Guineas for which he has given his note to the Proprietors be discharged.

Did the managers take him back because he was a fine actor and so a credit to the company? Or just because they were short of male performers at the time? Or because his persistent nagging – and no doubt, that of his wife – was getting on their nerves and compromise seemed the easiest solution? The minutes reveal nothing. But the couple continued to cause trouble, for the next mention is in March 1773, when it was ordered 'That Mr. Chalmers be immediately discharged'. Having behaved himself, more or less, throughout 1772, whatever he had now done must have been pretty serious to result in instant dismissal. Once again there are no details, and our imaginations continue to boggle.

James Chalmers is mentioned no more in the minutes, but Mrs Chalmers continued to perform. Yet she cannot have pleased her employers, for in May 1775 it was agreed that her salary should be reduced to one guinea a week. It is worth noting that a guinea a week was a large income at the time and indicates that good performers could expect high salaries. Then, in May of the following year, she was discharged. There were various other people who were discharged, so perhaps the theatre was going through a sticky financial patch. This was not quite the end of Mrs Chalmers's career in the city, for in May 1781, six years later, the minutes report:

> On account of the general Failure of Business in the Summer Circuit, it is ordered that the Sum of Twenty pounds a piece which has been yearly in the Circuit allowed to Mrs. Chalmers & Mrs. Pearson be reduced to Ten Pounds each.

With this large reduction in salary, and her husband no longer employed at the theatre, the couple decided that Norwich no longer had much to offer them. They moved to Ireland and are

recorded as appearing in theatres at Dublin, Kilkenny, Waterford, Limerick and Cork. In Belfast in 1787, Mr Chalmers created his own speciality act of leaping through a hogshead of blazing fire. Following his wife's death, he travelled to the United States, and appeared on the New York stage. Upon his return to England, he performed in Edinburgh in 1804, playing leading roles, chiefly in comedies. The last that is heard of him is in 1810, reported in the *Norfolk Annals,* that Mr Chalmers:

> [C]omedian of considerable merit and formerly of the Norwich Co. found speechless upon a doorstep of a house in Worcester ... and died in the Infirmary.

So ended the life of one who was an acclaimed performer but who had caused so many problems for the Theatre Royal managers.

On 30 July 1784, the theatre provided a performance cashing in on the popularity of the new hot-air balloons and Mr Dekker's recent ascents in the city:

> By desire of Major Money – 'Hamlet', and 'The British Balloon, or a Mogul Tale', in the course of the first act, the cobbler, his wife and the doctor, will make their descent from the Gallery in an air-balloon, after an Aerial Excursion from Hyde Park Corner to the Dominions of the Great Mogul.[27]

Although the theatre was much admired and frequented, there were criticisms too. The local newspaper published a letter in 1782 which praised the plays and performances but had harsh words for the musicians, referring to the faults of the band:

> Their manner of coming into the orchestra on the conclusion of the acts is very reprehensible ... they jostle together without the least order and not only distract the audience by their instruments, but are equally or almost as vociferous as the actors. Again, what occasion is there for our ears to be constantly saluted by a bell from Mr. Prompter, to notice the conclusion of the act ... Another heavy grievance is the fulsome view of a number of scene-shifters and other persons who are constantly standing in front of the

boxes. The Manager should lay his commands on them to stand
further back ...[28]

Georgian stage performances were often criticised for immorality,
and a letter to this effect criticised some of the Norwich
performances:

> It is said that some very indecent pieces, and pernicious in their
> tendencies are preparing for the ensuing benefits – the present
> design is to caution, if possible, every performer from intruding
> any such on an insulted public as they value the encouragement
> or fear the resentment of an injured audience.
>
> Every family is not conversant with plays, and a father may
> unwarily introduce his daughter, or a husband his wife, to scenes
> utterly subversive of chastity, modesty, and virtue – and shall it be
> said that such performances are not only suffered, but desired, by
> those who ought to set an example of propriety, and, as it were,
> form the taste and manners of the vulgar? – forbid it, good Heaven
> ... let them not countenance obscenity, give a sanction to vice
> and, as it were, plant the very seeds of corruption in the breasts
> of their young families, as they value the morals, nay the soul of
> the rising generation.
>
> [Signed] CATO.[29]

At the foot of the letter was a 'note by the printer':

> We believe we may venture to assure the author of the above letter,
> that every objectionable passage and even every word that might
> possibly offend, will be omitted in the representation of all plays
> intended to be exhibited at the approaching benefits.

A new theatre replaced the building in 1826, but was demolished
by a fire in 1934 and rebuilt in the following year. The building
has recently been modernised and enhanced with more extensive
restaurant and booking office space.

# 1800–1900

## Norwich in the Victorian Age
## 'The very stones in the street were dear to me'

In September 1825, Mr Marten, together with his family, paid a first-time visit to Norwich. His tour is recorded in a diary (his forename isn't mentioned) and provides fresh impressions of the city as experienced by a visitor.[1] With his wife, daughter and a servant, he departed on the steam packet *Hero* from London docks, bound for Norfolk, and they reached the port of Great Yarmouth a day or so later. They stayed in Yarmouth and visited Gorleston, and then on Saturday, 10 September, took another steam vessel to Norwich. On arrival they booked in at the Norfolk Hotel, and on the following day, Sunday, attended morning service at the St Mary's Baptist chapel.

They were obviously a devout family, for in the evening they attended another service at the Princes Street chapel.

Then, on Monday morning, they visited the Cathedral, where they attended Matins at 9.45. Marten describes the service as 'the same as in other Cathedrals' which suggests that he was an Anglican, but also that he had a taste for visiting a variety of different places of worship. He continues:

There were scarcely a dozen persons beside the ecclesiastics who officiated. The building is in fair preservation considering that it has been [in use] since the year 1096. The interior is very clean and from the magnitude and architecture presents to the eye a solemn grandeur. The Courts & inclosure and ancient houses around it are also kept in that order & have that still and quiet aspect & that appearance

of retirement & comfort which is usually found around Country Cathedrals.

We then walked about the large city & came by St. Giles Church into Heigham, and called on Mr. Grout who permitted us to go through his important Silk Manufactory. The works are in several floors and the winding twisting bobbinings are by machinery moved by a beautiful 20 horsepower Engine. These operations are watched and conducted by more than seventy females some so young as 7 to 8 years of age. These are on foot from seven in the morning till eight in the evening watching the threads, repairing the broken & seeing that all go on well – occasionally supplying oil where wanted to prevent evil from friction. Only that they have half an hour to breakfast & an hour for Dinner. And these little girls earn some 5 shillings, some 5/ 6d a week.

Marten's description makes it clear that the workers endured a very long, arduous and tedious working day, but were quite well rewarded for their labours: 5 shillings a week was a good income in the early nineteenth century.

Yet from the age of seven or eight, when they should have been enjoying a degree of freedom and education, it was appalling servitude for the children, endured only because the income paid for food, clothing and accommodation, and kept families free of parish charity or the horrors of the workhouse.

Marten continues:

We were then shewn the winding into warp – the subsequent Beaming – & the reeds for the weaving & were informed that a yard wide crape has in that breadth 2560 single twisted threads of silk. We then saw one of the female superintendents at her crape loom, and afterwards the turners shop where nine men were employed in preparing Bobbins etc. for the factory here & the much larger which Mr. Grout is now erecting at Yarmouth. The silk used here is principally from Bengal but part was the white silk from China.

Seeing a loom going in a private house as we passed we asked the woman who was weaving Norwich crape & learned that she could by close application weave eleven yards each day but we omitted to ask her earnings by that work.

We strolled thence to the confines of the town northward till we came to the fields & found the population lively – the small sharp stones with which the streets are paved very annoying – and churches so abounding that the eye could scarcely fail to see two or three whichever way it turned. Many of these are flint faced and some of them with squared flints very carefully cut & nicely laid – We counted eleven steeples from our chamber window.

In the evening we wandered through the Eastward & Southward parts of the city & saw many very large & elegant houses. Being asked by two Italian Image lads to buy an image of Walter Scott [the popular Scottish novelist] – a bust of natural size which was offered for a shilling – I conversed with them in their own tongue which appeared to gratify them. I learned that they were natives of Florence – had walked in five days from London – had brought their goods on their heads & had sold all but a Walter Scott – a Shakespeare – a Milton – & a Lord Byron. As I could not buy, I presented them with a few pence for which they expressed their thanks very pleasantly.

On the following day, 13 September, the Marten family obtained permission to gain a panoramic view of the city from the turrets of the Castle. However, as it was a very windy morning they were advised that it would be difficult, so they instead walked around the Castle Mound, which provided a good view over the surrounding buildings as far as the distant hills.

Here we counted 23 steeples of the 36 churches which the Map of Norwich states to be in it – and prolonged our stay because of the pleasure we enjoyed. There was however some alloy in seeing the Bars and fastnesses for the securing of future County offenders – the Castle – the mound & the fosse round it, belonging not to the city but to the County …

The city is now building a new Gaol near St. Giles & a wing of it is expected to be inhabited towards the close of the year. We were admitted to go over the whole building. The Governor's House is in the centre and from the several windows he can at all times inspect every part of the prison. The Chapel is in the Governor's house. His pew is opposite & very close to the Pulpit

which is entered from the winding stair case. The Felons are in Pews even with this Governor whose eye may be constantly on them – and the Turnkeys guard the two entrances during the whole of divine service – the Debtors are on the floor of the Chapel and thus everyone can see & hear the Preacher. We were shewn the cells for the Felons who are confined at night separately – but they have a Day-Room & they have the privilege of the open air in a yard allotted to them. Condemned Felons left for execution have other & still stronger lonesome cells which they are not permitted to leave until the hour when they are taken to the platform over the entrance gate to surrender their forfeited lives to the violated justice of their Country.

The principal Streets of Norwich are with flat pavements for the foot passengers – but the greater number are paved with smaller pebbles and flints uneasy to the foot and on which one unused cannot walk either steadily or comfortably. We were not accosted in any of our walks even by a single mendicant – Everybody seemed busy and we were told by a Gentleman, a resident, that no complaints were heard and that the manufacturers and general business of the place were in thriving condition. Houses of the third and fourth rate & some even beneath these were building to a great extension of Norwich, a circumstance which marks many other cities beside this.

Our stay in Norwich has been pleasant – and the Norfolk Hotel intitled to praise for the goodness of its provisions – the neatness of its accommodation: & the attention of its conductors & servants. We were also perfectly satisfied with the reasonableness of its charges.

We left the Hotel at 20 minutes before 4 o'clock in the stage for Cromer ...

So the visitors' comments were complimentary, and it is amusing to note that the flint stones which were so much admired on the walls of the churches caused so much discomfort to the feet. The Marten family must have been used to walking on cobble stones, with which many streets in other places were still paved, but it seems that the Norwich cobbles were much smaller and sharper.

The comments about everybody in the city seeming busily occupied were echoed by other visitors. At the beginning of the nineteenth century, the population had risen to 37,000, although more northern manufacturing cities such as Manchester, Birmingham and Leeds were now greater than Norwich. But it still remained an important industrial city, and its chief occupation – as Mr Marten observed – was weaving, both in factories and in workers' own homes. The other chief industries were leather-working and brewing. The city remained an important commercial centre for the rural areas, with many country folk coming in to trade and buy in the markets. Towards the end of the century, the population had more than doubled, but Norwich was then exceeded in size by fifteen other cities.

Mr Marten records how the city was growing, with new houses being built in the suburbs. Villas and terraced houses spread in the Vauxhall Street and Heigham areas, occupied by the better-paid workers. Railway transport helped to make the city more accessible and prosperous when the first station at Thorpe was built in 1844; and new housing, and hotels, developed in that area as well. The Prince of Wales Road, spacious and tree lined, reminiscent of avenues in Paris, was constructed to provide an imposing approach to the railway station from the city centre. With its wide pavements and handsome Victorian buildings, it remains an attractive thoroughfare today, but has been somewhat marred by nightclubs, fast-food takeaways and discos attracting young people, but also by noise, drunkenness, fighting and vomit on Friday and Saturday nights. Such venues are a popular ingredient of city life but seem out of place in this stately old street. Why not move them all down to the funky new Riverside area, closer to Thorpe station?

For the early part of the Victorian period, the city remained an unhealthy place to live. Many households had to collect their water from the polluted river, and there were no sewers, but only the cesspits into which the night-soil carts tipped the household waste collected from outdoor privies. Several of the streets occupied by the poor – King Street, Magdalen Street and Ber Street – were slum areas where large families lived in overcrowded conditions, and diseases such as cholera, diphtheria and typhoid

were endemic. There were over 500 deaths from smallpox in 1819, and another epidemic in 1872. In 1832, 128 people died of cholera, and there was another outbreak in 1893.

However, there was some improvement in terms of medical care and treatment, and better hospital provision, particularly at the Norfolk & Norwich. In 1849 a special children's hospital was built with donations raised by Jenny Lind, the celebrated Swedish singer. It was originally in Pottergate, but later moved to more spacious premises in Unthank Road in 1898. Other improvements included pumped water gradually being made available to more houses, and a Board of Health established to initiate improvements in health and cleanliness standards. A large cemetery was established in Earlham Road in 1855 after a government health inspector noted that the city churchyards were overcrowded with burials, causing health hazards. In 1877 a programme of slum clearance was also commenced.

If you stroll from Tombland and the Cathedral area, along Wensum Street and over Fye Bridge, you will find yourself in Magdalen Street. Here you will encounter another side of the city, an area which in the Victorian period had been smart, with fine houses and prosperous businesses, but now suffers because the main shopping area for the city is firmly seated in the centre. Despite signs of neglect, boarded-up buildings and graffiti, it retains a zestful character, with a variety of individual shops as well as pubs and eating places, and is best enjoyed on a Saturday when more people are about and it exhibits a Camden Town air of sprightliness.

Along the street, you will discover the alleyway leading into Gurney Court, with a blue plaque commemorating two famous Norwich personalities, Elizabeth Fry and Harriet Martineau. Nearby in Colegate are the Octagon Chapel and the Old Meeting House, places of worship for Dissenters, which had a strong influence on the lives and future careers of these two female reformers.

Elizabeth Fry (1780–1845) was born in Gurney Court. Her father, John Gurney, was a prosperous banker and wool-stapler, and also a prominent member of the Quaker Society of Friends. As a boy, he had bright red hair, and one day, as he was walking

through the city centre, a group of lads followed him, pointing to his red locks, and jeering, 'Look at him – he's got a bonfire on top of his head!' John was so disgusted that he went straight to a barber's shop, had his head shaved, and went home in a wig.[2]

Later, he married Catherine Bell in 1773, who obviously didn't object to carrot-tops, or bonfire heads, and they moved into Gurney Court, which had been the home of the Gurney family for two generations.

The couple had eleven children, and so, following Elizabeth's birth in 1780, they rented Earlham Hall, a spacious house with large grounds on the outskirts of the city. The children were of course brought up in the Quaker religion, but the girls in particular resented the plain costumes and pious lifestyle they were expected to adopt. So they rebelled a little, and were soon frowned upon by sterner members at the Friends Meeting House in Upper Goat Lane for wearing fashionable attire – in particular, scarlet cloaks, which shone out brazenly among the Quakers' subdued shades of grey and black. The girls resented Sunday worship so intensely that Elizabeth – or 'Betsy' as she was known in the family – referred to it as 'DIS' in her diaries, a codeword for 'Disgusting'. It is recorded that either she or one of her sisters wrote, after another tedious experience,

> Oh, how I long to get a broom and BANG all the old Quakers who do look so triumphant and disagreeable ... I spent FOUR hours at Meeting. I never, never wish to see that nasty hole again.[3]

Unexpectedly, unlike her sisters, Elizabeth underwent a profound religious conversion. While still a teenager, she was at the Meeting House in 1798 when a visiting American Quaker, William Savery, preached an emotional and powerful sermon. She was so overcome that she burst into tears and recorded in her diary: 'Today I felt that there is a God. I have longed for virtue. I hope to be truly virtuous.' This was the major turning point in her life. Her sisters were not impressed. Rachael Gurney wrote in her own diary:

> I feel extremely uncomfortable about Betsy's Quakerism, which, I saw, to my sorrow, increasing everyday. She no longer joined in

our pleasant dances and singing ... she dressed as plain as she could.[4]

But Elizabeth's conversion was complete and thereafter she aimed to live a life dedicated to religious piety and charitable work.

When she was nineteen, and still living at Earlham, she attracted the romantic attention of Joseph Fry, an old school friend of one of her brothers. An amusing account of his courtship tactics is related. Elizabeth proved shy and uncertain in her response to him, but:

Mr. Fry had no intention of exposing himself to the possibility of a refusal. He bought a very handsome gold watch and chain, and laid it down upon a white seat in the garden at Earlham. 'If Betsy takes up that watch', he said, 'it is a sign that she accepts me: if she does not take it up by a particular hour, it will show that I must leave Earlham'.

The six sisters concealed themselves in six laurel bushes in different parts of the grounds to watch. One can imagine their intense curiosity and anxiety. At last the tall, graceful Betsy, her flaxen hair now hidden under a Quaker cap, shyly emerged upon the gravel walk. She seemed scarcely conscious of her surroundings as if 'on the wings of prayer, she was being wafted into the unseen'. But she reached the garden seat, and there, in the sunshine, lay the glittering new watch. The sight of it recalled her to earth. She could not, could not, take it, and fled swiftly back to the house. But the six sisters remained in their laurel bushes. They felt sure she would revoke, and they did not watch in vain. An hour elapsed, in which her father urged her, and in which conscience seemed to drag her forwards. Once again did the anxious sisters see Betsy emerge from the house, with more faltering steps this time, but still inwardly praying, and slowly, tremblingly, they saw her take up the watch, and the deed was done.

She never afterwards regretted it, though it was a bitter pang to her when she collected her eighty-six children in the garden of Earlham and bade them farewell, and though she wrote in her journal as a bride – 'I cried heartily on leaving Norwich; the very stones in the street were dear to me'.[5]

Lest the reader should foolishly assume that Elizabeth was the mother of a very large family before Joseph wooed and won her, it must be hastily pointed out that the eighty-six children were pupils from poor homes whom she had educated and generally cared for. 'Betsy's Imps', they were called by Mr Gurney, and he didn't object to her taking over part of the large house for their schooling.

Following her marriage, Elizabeth moved to London, where she became dedicated to prison reform. She visited Newgate Prison for women in 1813 and found the conditions for both women and their children so appalling that she was determined to make whatever improvements could be achieved. She also fought for reform of asylums and founded hostels for the homeless as well as charitable societies. An American minister visiting England recalled:

> Two days ago I saw the greatest curiosity in London, aye, and in England too, compared to which Westminster Abbey, the Tower, Somerset House, the British Museum, nay Parliament itself, sink into utter insignificance. I have seen Elizabeth Fry in Newgate, and I have witnessed there the most miraculous effect of true Christianity upon the most depraved of human beings.[6]

It seems clear that her life, dedicated to charitable works, developed from her early interest in the ragged children of Norwich and the school she created at Earlham Hall for 'Betsy's Imps'.

The Martineau family moved into Gurney Court after the Gurney family had vacated it. Thomas Martineau was a wealthy cloth manufacturer, a descendant of Gaston Martineau, a Huguenot, or French Protestant, who had settled in Norwich in the late seventeenth century following Catholic persecution. Harriet Martineau was born in Gurney Court in 1802, and later the family moved across the road to another large and imposing house, No. 24, which also bears a commemorative plaque.

Harriet described her childhood in the house in her autobiography:

> My passion for justice was cruelly crossed from the earliest time I can remember, by the imposition of passive obedience and silence

on servants and trades-people, who met with a rather old-fashioned treatment in our house. We children were enough in the kitchen to know how the maids avenged themselves for scoldings in the parlour, before the family and visitors, to which they must not reply; and for being forbidden to wear white gowns, silk gowns, or anything but what strict housewives approved.

One of my chief miseries was being sent with insulting messages to the maids – e.g. to 'bid them not to be so like cart-horses overhead', and the like. On the one hand, it was a fearful sin to alter a message and, on the other, it was impossible to give such a one as that: so I used to linger and delay to the last moment, and then deliver something civil, with all imaginable sheepishness, so that the maids used to look at one another and laugh.[7]

The family worshipped at the Octagon Chapel, in Colegate, the church for the Unitarian community that became the centre of both their religious and social life. Harriet's younger brother James was educated at the Norwich King Edward VI School, but detested its culture of bullying and savage punishments. He was later transferred to the more enlightened Carpenter's School in Bristol, where he flourished, and later became a Unitarian minister at the Octagon.

Harriet is the most acclaimed member of the family. Quite apart from her mother's domineering way of dealing with the servants, Harriet had a difficult childhood. She suffered a number of health problems, including digestive disorders, and grew up with only a limited sense of taste and smell, and was increasingly deaf. She later recalled her anxieties about having to attend Sunday worship in the Octagon Chapel with her stern mother and family:

My moral discernment was almost wholly obscured by fear and mortification. Another misery at Chapel was that I could not attend to the service, nor refrain from indulging in the most absurd vain-glorious dreams, which I was ashamed of, all the while. The Octagon Chapel at Norwich has some curious windows in the roof; not skylights, but letting in light indirectly. I used to sit staring

up at those windows, and looking for angels to come to me and take me to heaven, in sight of all the congregation – the end of the world being sure to happen while we were at Chapel. I was thinking of this, and of the hymns, the whole of the time, it now seems to me. It was very shocking to me that I could not pray at Chapel. I believe that I never did in my life. I prayed abundantly when I was alone; but it was impossible for me to do it in any other way; and the hypocrisy of appearing to do so was a long and sore trouble to me.[8]

Many children have experienced similar wandering thoughts and emotions during long religious services which they could not fully understand or be a part of; but it was worse for a sensitive and intelligent child like Harriet, because her parents were so profoundly pious, and her mother unlikely to be either understanding or forgiving.

As her deafness continued to increase, by the time she was a mature woman she had to rely on an ear-trumpet, which became 'an enduring and sometimes daunting feature in the recollections of her friends and acquaintances'.[9] She was also known as an incessant and noisy talker, and Sydney Smith, the essayist and wit, described a nightmare dream in which he was chained to a rock and being talked to death by Harriet Martineau and the historian Thomas Macaulay.[10]

Her life developed further problems. Her favourite brother, Thomas, died of tuberculosis in 1824, and her father's manufacturing business, specialising in army cloth, declined at the end of the Napoleonic Wars. He died in 1816, a year after the Battle of Waterloo. The cloth business collapsed completely in 1829, and Harriet decided that she must earn an income to support herself and her mother. She started writing moral tales for children, and later more serious works, such as *Illustrations of Political Economy* in 1834.

She then moved to London and developed a reputation as both the leading female writer of her day, and as a social reformer and champion of the underprivileged. Looking back on her childhood, and the problems of her life in Magdalen Street, she decided that:

> My ideal of an innocent and happy life was a house of my own
> among poor improvable neighbours, with young servants whom
> I might train and attach to myself.[11]

In other words, quite the opposite of her mother's example. But
it is curious that, despite her good intentions, she clearly shared
the same impulse to impose her will, and be a 'control freak' as
it is termed today. She fulfilled her ambition when she created
her own household in the Lake District, and also, finally casting
off her mother's grim shadow, became an agnostic.

The novelist and poet Amelia Opie (1769–1853) (née Alderson)
was a friend of the Martineau family, and she and her husband
John Opie, the portrait painter, were part of a group of intellectuals
whose lives centred around the Octagon Chapel. The Opies lived
in the house at the junction of Castle Meadow and what is now
called Opie Street. It bears a blue plaque commemorating their
residence, and on the roof of a shop in Opie Street is a rather
weird white statue of Amelia shrouded in a cloak. Quite spooky
if you happen to spot it in the half-shadow late at night.

Amelia, the daughter of a local doctor, had been baptised at the
Octagon, and later also attended services at the Friends Meeting
House. One member of the congregation recalled seeing her enter
there

> with her head thrown back, and her bearing that of one who knew
> she was a personage of importance in that sedate assembly, pass to
> a seat of honour below the minister's gallery, and compose herself
> to her devotions.[12]

Amelia wrote *Father and Daughter* (1801), *Poems* (1802), and
*Adeline Mowbray* (1804), a novel on a theme derived from a
story by Mary Wollstonecraft. She also wrote a memoir of her
husband after his death in 1807. The following letter provides
some idea of her life when she was a widow.

> Norwich, 29th June, 1821.
>    When a letter was brought me from Mr. Taylor's I took it up,
> examined the direction, looked at it again & exclaimed 'Well! to

be sure this is the hand of my old friend Mr. Dyer!' & when on opening it I found that I was right, right glad was I to see your respected name once more at the bottom of a letter to me!

No, my good friend, no – I shall not revisit London (except business may carry me thither for two or three days), not for many years I trust – as my dear father, hitherto so young for his years & so independent of me, is now old & ailing for the first time at seventy eight & dependent on me for amusement in a great measure. I therefore shall never leave home again, unless he accompanies me, which is very unlikely – & I do not even drink tea out – except which is a rare occurrence, that he goes with me – However – Time flies very fast – my morning hours are my own & I rise very early – nor does he want me till he comes in from his rounds – for he still visits his patients & except that he is very thin, & occasionally feeble & is always suffering more or less from that painful disorder Hypochondria, he is much the same as ever he was, & retains his appetite & his healthy complexion. Therefore I have much to be thankful for, & a quiet life agrees both with my body & my mind.

This is quite enough of Self –

Your lines, I had the pleasure of receiving before – & I could beat you for obscuring their beauty to me in old English though they read very Spencerish – but I had rather they had been Dyer-ish – Pray, my dear – let your next dream be in Modern English.

Depend on it, 'good man & true', that I will never be long in London again without announcing myself to you ...[13]

The letter draws to a close with a few lines commenting on how pretty Clifford's Inn was looking when she visited in the previous year; Amelia then ends with an affectionate farewell.

Her correspondent was the poet and essayist George Dyer (1755–1841), who lived at Clifford's Inn, London, from 1792 until his death, and who was a friend of the more celebrated essayist Charles Lamb.

A contemporary of James Martineau at the Norwich School in Cathedral Close was George Borrow (1803–81). Borrow was a very different character from Martineau, but they shared a hatred of their Norwich school, where Borrow was a pupil from 1816

for a three-year period. He had already experienced a taste for travel, which was to be his life-long passion. A later headmaster at the school, Dr Augustus Jessop, noted that

> Borrow's two years of the Grammar School were not happy ones. Borrow, as we have shown, was not of the stuff of which happy schoolboys are made. He had been a wanderer – Scotland, Ireland, and many parts of England had assisted in a fragmentary education; he was now thirteen years of age, and already a vagabond at heart![14]

Jessop was writing of a period when a distinguished former pupil of the school, Sir James Brooke, was paying a visit to meet fellow scholars in 1858. At that time, Borrow was living in Great Yarmouth, only a short distance away, but Jessop recalled that he did not appear among the welcoming group, and added:

> My belief is that he never was popular among them, that he never attained a high place in the school, and he was a 'free-boy'. In those days there were a certain number of day boys at Norwich School, who were selected by members of the Corporation and who paid no tuition fees; they had to submit to a certain amount of snubbing at the hands of the boarders, who for the most part were the sons of the country gentry. Of course, such a proud boy as George Borrow would resent this, and it seems to have rankled with him all through his life …
>
> To talk of Borrow as a 'scholar' is absurd. 'A picker-up of learning's crumbs' he was, but he was absolutely without any of the training or the instincts of a scholar. He had had little education till he came to Norwich, and was at the Grammar School little more than two years. It is pretty certain that he knew no Greek when he entered there, and he never seems to have acquired more than the elements of that language.[15]

These comments by Jessop seem both absurd and snobbish. There is no reason to suppose that Borrow resented being a 'free-boy', for there would have been several others in the same position who could have formed a friendly clique together. Borrow was a

free spirit, disliking everything that the confinement and tedium of the school system represented, and, once having escaped, eager to dust the school-chalk off his boots for ever.

He had also suffered through being a pupil when the headmaster was Edward Valpy, who served from 1811 to 1829. Valpy has been described as 'probably the best master who ever adorned the school', a man of considerable scholarship who also enormously increased the number of pupils in a very short time.[16]

But Valpy was remembered by some of the boys not as a considerable scholar, but as a considerable flogger. A former pupil, the Reverend Dr John Cox, recorded that Valpy's temper was violent, and his manners 'bearish', and believed this was the reason why he could not persuade 'clergymen or gentlemen' to remain in his employment. His temper was wreaked on his pupils, who were frequently and unreasonably flogged and forced to endure a torrent of odious personal abuse. Cox himself was so brutally beaten after omitting a word in reciting the Greek irregular verbs that his father had him immediately removed from the school.[17]

Borrow was also a victim of Valpy's wrath. James Martineau recalled an occasion when he was ordered to hoist the boy onto his back to receive a flogging: 'not that there was anything exceptional, or capable of leaving scars in the infliction: Mr. Valpy was not given to excess of that kind.' So contrary views are expressed, but it is unlikely that Borrow ever forgot or forgave either the punishment or the indignity of having been hoisted on another boy's back for a thrashing.

James Brooke, another free spirit like Borrow, also resented being flogged. When he finally ran away from the school in 1819, he delivered his parting shot by hiding Valpy's cane under the floorboards of the schoolroom. Brooke, mentioned above, subsequently had a distinguished career as an army officer, became the first Raja of Sarawak, and was appointed a KCB by Queen Victoria.

The school had gained a reputation for savage flogging over a long period of time. In 1651, when little Jacob Astley's parents decided to send him there, his grandfather wrote, 'Full littell thincke you how his bumbe will suffer for they are all churlish

masters there.' He offered his suggestion for easing the caning pain: 'he should lay a cowld ston to a warme bumbe'. The boy seemed to have suffered no lasting damage, as he grew up to become Sir Jacob Astley, Bt, became an MP and built the fine mansion of Melton Constable Hall.[18]

Borrow's unhappy time pent up in school, when he longed to be off and away with the gypsies, may have coloured his recollections of the city. In one of his books, a translation of Klinger's *Faustus*, he adds a description of the residents of Frankfurt in this manner:

> They found the people of the place modelled after so unsightly a pattern, with such ugly figures and flat features, that the devil owned he had never seen them equalled, except by the inhabitants of an English town called Norwich, when dressed in their Sunday's best.

His translation of Faustus created upset in the city in other ways. Borrow, having been away on one of his travels, returned to Norwich in 1825, and stayed with his mother in the house in Willow Lane, where he penned a letter to the printers of the book:

> As your bill will become payable in a few days, I am willing to take thirty copies of Faustus instead of the money. The book has been burnt in both the libraries here, and, as it has been talked about, I may perhaps be able to dispose of some in the course of a year or so.[19]

The *Literary Gazette*, dated 16 July 1825, described it as a work

> to which no respectable publisher ought to have allowed his name to be put. The political allusions, and metaphysics which have made it popular among a low class in Germany, do not sufficiently season its lewd scenes and coarse descriptions for British palates. We have occasionally publications for the fireside – these are only fit for the fire.[20]

Borrow may have had some unhappy memories, but in *Lavengro* it is affection for Norwich that is uppermost. He describes it as

> A fine old city, truly ... view it from whatever side you will; but it shows best from the east, where the ground, bold and elevated, overlooks the fair and fertile valley in which it stands. Gazing from those heights, the eye beholds a scene which cannot fail to awaken, even in the least sensitive bosom, feelings of pleasure and admiration.

And he concludes:

> Now, who can wonder that the children of that fine old city are proud of her, and offer up prayers for her prosperity? I, myself, who was not born within her walls, offer up prayers for her prosperity, that want may never visit her cottages, vice her palaces, and that the abomination of idolatry may never pollute her temples.

It was during his school days that he developed a fascination for languages, and rapidly became familiar with a dozen of them. They included Romany, which he picked up from the gypsies on Mousehold Heath. He had met Ambrose Smith, a gypsy *gryengro* or horse-dealer, on the Horse Market on the outskirts of the Castle Mound, and remained fascinated by the gypsy way of life, its language and culture. Smith reappears with the more picturesque name of 'Jasper Petulengro' in his writings.[21]

After being articled to a solicitor in Norwich, 1819 to 1824, he travelled, mainly on foot, for seven years, through England, France, Germany, Russia and the Orient, often alone but also from time to time with groups of gypsies, picking up new languages and dialects all the time. The results of his travels were the two books for which he is today best remembered: *Lavengro* (1851) and *The Romany Rye* (1857).

The 'Walking Lord of Gypsy Lore' was commemorated by special celebrations in July 1913. A public dinner was held at the Maid's Head along with a reception at St Andrew's Hall, which appropriately featured a lively band of gypsy musicians. People who admired his books travelled to the city from all over

the world to participate in the events, and the Lord Mayor, A. M. Samuel, gifted Borrow's family home in Willow Lane for use as a commemorative museum. Unfortunately, due to the cost of maintaining it, the museum was closed in 1948. All that survives to record Borrow's home is a stone plaque on a modern brick building, Borrow Court, in Cow Lane at the foot of Willow Lane. It has a head-and-shoulders portrait of the author, but provides no information about the site of the house.

John Bilby (1801–39) had a very different experience of life in the city, for he was a tradesman. He wrote an account of his life and career in an autobiography, supplemented with diary notes.[22] He was born in Yarmouth, and the family moved to Norwich about a year later, in 1802. After two changes of address, they rented a house in St Saviour's parish, where John remained until the time of his marriage. His father died when he was seven, so his mother had a struggle caring for John and her other three children, until she remarried in 1811.

John records that soon after his mother's remarriage, when he was ten:

> I was engaged as Errand boy to Mr. Willement, master weaver of St. George's. Lived with Mr. Willement for 12 months, then for a short time at Mr. [Houth's?] an Appraiser of London Street in Norwich, left Mr. [Houth?], to go and live with Mr. Leeds a brush-maker of St. Andrew's – at this shop I was two years when my master was made a Bankrupt of, and I left. I was also with Mr. Ling a tailor in St. Michael at Plea until I was bound out Apprentice to Mr. Mason, tailor and hair-dresser of King Street in Norwich.

Like other young men, John tried a number of jobs before he settled down to train as a hairdresser, the career that he pursued for the remainder of his life. In 1821, when he was qualified and experienced, he had the opportunity of running a barber's shop himself:

> I agreed to conduct the Business for Mr. Lofty, the Hair Dresser of St. Giles, Norwich, 3rd Feb. 1821, he being at the time very ill and not able to attend to it himself …

He didn't remain there very long. He had joined a group called the Musical Sons of Good Humours, singers and musicians, and then got a new job provided by Samuel True, the treasurer of the group. True provided the young man with a hairdresser's parlour in his own house, which was freshly painted and equipped for business, and John commenced his trade there on 9 March 1822. The diary gives the impression that he was a bright and breezy chap who made friends easily, and so had quickly prospered in his chosen career.

In his spare time he continued performing with the Musical Sons of Good Humours, and received a Star Medal for serving as secretary to the Lodge. A short while later he was elected president. He was also honoured to be selected by the Norwich Company of Comedians to perform at the Theatre Royal in a special show celebrating the coronation of George IV. He took the part of a Knight of the Garter, and the performance took place some time after the coronation, in 1822. The *Norfolk Chronicle* reported:

> In consequence of extensive preparations, the opening of the Theatre is necessarily postponed until Thursday, 31st January when will be represented the CORONATION of His Majesty George IV, as performed at the Theatre Royal, Drury Lane. The dresses and regalia and every other decoration are copied from the models of the Theatre Royal, Drury Lane, by permission of the Proprietor. The whole of the Company with numerous Additional Aid both Vocal and Instrumental will be employed to give every possible effect to this splendid ceremony.

Bilby formed part of the 'Additional Aid', and was mighty proud to appear in such a splendid production. During this period he had been courting a young woman, 'Miss Payne', to whom he had taken a fancy when he was eighteen. They enjoyed a pleasure cruise together on the *Nelson* steam packet to Yarmouth, and maybe she had permitted him the favour of grasping her ungloved hand before they parted. Now that he was more financially established, he could take the plunge and get married. So in that same eventful year of 1822, he writes in his journal:

> I was married to Miss Payne on the 25th of November, 1822 by
> the Rev. Whittingham at St. Saviour's Parish Church – spent the
> day very comfortably and had a large supper party in the evening
> at Mr. Payne's house in St. Paul's parish ...

We learn very little about 'Miss Payne' from the journal, not
even her Christian name, so perhaps they just addressed each
other as 'Mr Bilby' and 'Miss Payne' before marriage, and 'Mr'
and 'Mrs' Bilby thereafter, just as Jane Austen's characters refer
to each other by titles.

But John does make mention of his wife again a year later:

> My wife was delivered of a fine boy on the 11th of June, 1823, at
> a quarter before eleven at night. The boy was named John Bilby
> [well, there's a surprise] on the 15th. Mrs Bilby came downstairs
> on the 22nd, this was the 11th day after her being delivered of
> a son.

This suggests the birth had been a difficult one.

John was given a job by his new father-in-law, but then obtained
a new shop in St James's parish on New Year's Day 1824, taking
on the clientele of another hairdresser who had retired. He writes
that he had 'a good run of trade by the March following'.

In April 1824, he was selected by lot to serve in the militia as a
private for five years, presumably standard practice at the time for
getting more men to enlist. He was obviously reluctant to do it,

> but I found a young man who was willing to serve for me – for
> a sum of money – this sum I paid him and he was sworn in on
> the 20th of the same month – his name was Daniel Orford of St.
> Martin's parish.

In 1827 the family moved from St James's to St Paul's parish, and
John was appointed an Overseer for the Poor, an appointment
which continued for several years afterwards. The winter of 1837
was a particularly cold one, and John, together with other parish
officials, helped raise a subscription of several hundred pounds to
provide the poor with food and coals, which he personally helped

to deliver from house to house. There was thick snow in the streets, and John writes: 'Five officers from the Horse Barracks in this city amused the public by driving through the streets in a large sledge.'

The following winter was equally severe, for he records in the January: 'Mr. Berry, Mr. Dring and myself relieved 2000 poor persons in St. Paul's parish with bread and coals.'

This is virtually the last we learn of the virtuous and vigorous Mr Bilby. His diary comes to an end, and a following page, written in a less neat hand, records:

> Mr. John Bilby died on Sunday the 15th of July at half-past 8 o'clock in the morning, after a long illness which he bore with Christian fortitude, aged 37 years, in 1839, and he was interred in St. Giles' churchyard on the 18th. His funeral was attended by his wife and three children, his two brothers, and his sister, Peter, William, and Charlotte, and Mr. Payne also, his bearers were as follows: Mr. Fox, Mr. Hart, Mr. Whiting, Mr. Poll, Mr. Alborough, Mr. Right.

The cause of death is not given and it must have been something particularly virulent, for he was still a comparatively young man. He had suffered a long illness, so perhaps he had picked up an infection from one of the poor people to whom he had been handing out supplies in 1838. This, combined with the bitterly cold weather, could have led to his untimely demise. Let's hope that the Musical Sons of Good Humours provided some rousing harmonies at the funeral.

After all this talk of schooldays, thrashings, and funerals, let's get a breath of fresh air by wandering around the Chapelfield Gardens, which can be approached from the city centre along Theatre Street. Although the gardens are bedevilled by the constant roar of traffic, the green lawns and flower-bordered paths create a pleasant atmosphere where people can enjoy a picnic lunch and relax with a book or a newspaper, and where children can romp and play.

The gardens were originally a field attached to the medieval College of St Mary in the Fields, a residence for secular priests.

It was roughly on the site where the Theatre Royal now stands. Later, after the city walls were built in the fourteenth century, the field was used as a military training ground for archers before they went off to fight in the Battle of Agincourt. In 1580, the local yeomanry also trained there in preparation for the anticipated invasion by the Spanish Armada.

By the mid-eighteenth century, the fields had been converted into public gardens for the benefit of local residents. They were surrounded by railings, and planted with trees and shrubs, with broad walks where leisure activities could be enjoyed in fine weather.

A poetic description of the transformed pleasure gardens, written by 'B.H.' appeared in the *Norwich Mercury* on 24 June 1749:

> When Sol darts forth his strongest Ray,
> And Monarch of the cloudless Day,
> Pours forth his sultry Heats,
> When Beaux and Belles from Town and Court,
> Fatigued with Pleasure's Rounds, resort
> To Country, cool retreats;
>
> To Chapel Field the Norwich Fair
> Retire to breathe untainted Air,
> Amidst the breezy Bowers,
> Where Young and Old, the Grave and Gay
> Assembled, join to pass away
> The cheerful, vacant hours.
>
> The Tradesmen here forgets Fatigues,
> The Rake resigns the dear Intrigues,
> Which all his Soul possessed;
> Here mourning Lovers cease to sigh,
> Whilst social Joy glads every Eye,
> And sooths each pensive Breast ...[23]

In 1794 part of the area was transformed into a reservoir and flooded by a waterworks company. It was in use until 1852, and used as a skating rink during the winter when the water froze.

However, by the nineteenth century the gardens were chiefly frequented by idle and dissolute boys, and washerwomen who used the bushes to spread out their washing to dry. So in 1866, after the reservoir was no longer needed, the area was transformed into a neat park again, with flowerbeds, fountains, seats, and a children's playground. An elegant pavilion of Japanese design was commissioned from Thomas Jeckyll, and used as a bandstand. There were four entrance gates to the park, and the unkempt and unruly were no longer permitted to misbehave there. The gates were locked at night, and the park keeper rang his bell at dusk to warn the public that the park was about to close.

The site has remained an attractive public garden ever since, used for both leisure activities and special entertainments. The pavilion was taken down in 1949, and there is now a neat bandstand in the centre. The area used to be strongly flavoured by the aroma of chocolate wafting from the nearby Rowntree Mackintosh factory, but now it has closed, and the scents of perfumed flowers and freshly mown grass remain untainted.[24]

In the nineteenth century, a variety of leisure activities were on offer in the city. Apart from the Theatre Royal, the Adelphi Theatre in the Ranelagh Gardens offered full-blooded dramas, and the Vaudeville in St Giles Street had an ice-skating rink, a music hall, and performing dogs. The Free Library opened in St Andrew's in 1857, and the Subscription Library in Guildhall Hill offered a choice of 50,000 books (it is now a restaurant). Sports could be enjoyed on Mousehold Heath, and a swimming pool was opened soon after 1875, near the river at Heigham. There were also many pubs providing both drink and entertainment, a recorded total of 655 different-sized establishments in 1878, ranging from small one-room beer-houses to large old coaching inns.

A visiting attraction was Wombwell's Mammoth Menagerie. In 1821, the following advertisement appeared in the Norwich local press.[25] It refers to King's Lynn, but the animals exhibited in Norwich would have been much the same.

MR. GEORGE WOMBWELL begs leave to announce to his numerous friends and the public that he intends EXHIBITING the whole of his IMMENSE MENAGERIE AT LYNN ... where

amateurs and connoisseurs will have an opportunity of viewing at one glance almost every rare and valuable Quadruped, Bird and Reptile that ever were imported into this Kingdom …

It would be impossible to give an adequate account of this interesting Collection in any advertisement, as it would cover a newspaper or fill a volume. The 'Change or the Tower [i.e. the major London attractions that displayed collections of beasts], if compared with this Collection would be found as a mere shadow; for there are no less than Nine Lions … besides three beautiful Silver Lions, Tigers, Leopards, Panthers, Striped and Spotted Hyenas, Ocelot or Tiger in Miniature, the Civit and Musk Cat, real Jackalls, Ant Eaters, Cotimundis, Cavies, and Ogoties. An immense large ANIMAL brought from the frozen regions near the North Pole; he is perfectly white and his limbs are as large as those of an elephant …

The list also includes a zebra, camel, elephant, sea-cow, rattlesnake, kangaroos, porcupines, monkeys and apes, boa-constrictors, serpents, crocodiles and a great variety of smaller animals and birds. Cavies were guinea pigs, but it is not known what Cotimundis and Ogoties were. The large animal brought from the North Pole was presumably a polar bear.

One of the attractions of the event at a later date was an invitation for those who were brave enough to enter the Lions' Den. Those who attempted it (and survived) were presented with a signed certificate, illustrated with a picture of a man's head in the lion's jaws, and inscribed with the person's name as 'a memento of the Valour displayed by Entering a Den of African Lions accompanied by Madame Salva, the renowned Lion Huntress'. This was an opportunity for young men to show off their bravery to their girlfriends. In Bungay in Suffolk, in 1887, William 'Tit' Raven, aged twenty-nine, accepted the challenge and survived the ordeal, but died not long afterwards, no doubt from delayed shock.[26]

It is terrible to think of all these creatures having been captured and transported to Britain, confined in captivity and trundled all over the region in horse-drawn wagons to be gawped at and maybe teased by crowds of people. Fortunately today there are

laws to restrict the import of animals and ensure that those permitted are humanely treated. But in the early nineteenth century, animal welfare organisations barely existed, and for the public, menageries were a unique opportunity to see all kinds of strange and exotic creatures from overseas, which they could otherwise never hope to see, except in the engraved plates of books of foreign travel. Wombwell's menageries continued to tour all over the country and were still visiting Norwich in the early twentieth century.

Frederick Rolfe was one of many visitors to the city with no opportunity to enjoy any entertainments or sightseeing. For he was one of those from the Norfolk region convicted of crime and detained in the Castle Gaol. He was sentenced for snaring rabbits on Pentney Common, West Norfolk, in 1882.

At the time he was aged twenty, but in his autobiography *I Walked by Night*, although not stating his age, he claims that he was only a lad, adding, 'Dear Reader, it was hard lines to send a Boy to Prison for killing a rabbit.' As a result, his account of prison life has been used by other writers to emphasise how inhumanely children were treated in the Victorian period. He also states that the sentence was a 'Month's hard Labour', but in fact the Grimston Petty Sessions records state that his sentence was a fine of 10 shillings plus 13 shillings in costs, but as he could not pay it, he was sent to Norwich Castle Gaol for fourteen days. It therefore seems that Fred was fabricating the story to win sympathy from his readers.[27] There is information relating to Fred's imprisonment in the 'Crime and Punishment' section of the Castle Museum.

Fred recorded his experiences in his handwritten memoirs. The published autobiography retains his original spelling.

> I was taken to Norwich by train, handecuffed to a Police man. Wen I got to Norwich I was led along through the streets the same way like a real dangerous fellow. There were no Cabs then for prisners, and evry one could have a good stare at me as I went by. No doubt some people said 'He have done some thing bad' and some may have said 'Poor kid' – be that as it may, I know it seamed a long road to me through the streets, but at last we arrived at the Castle

Entrance. A door swong open and a Turnkey led us inside. I shall never forget what I felt when I first saw that gloomy Place, and I was just fit to cry, but held back my tears some how.

Well the Turnkey told me to turn out my Pockets which I did. There was not much in them, but I rember in one was a little cake my Mother had put in there for me, he wanted to know why I had not eaten it befor, but I was too frightened to answer him. The next thing I had to do was to strip off my clothes, and be looked over to se if I had any marks or scars on my boddy. Then they rote down the colour of my eyes and hair, and weight and age.

Wen I was done with all that I was pushed out into a cold passage naket as I was Born, to wait till the Bath was ready. I had to go through with that, and then he brought me shirt and socks, and a sute of clothes covered all over with the broad Arrow, and a number to wear on my Jacket. I forget now what it was, but I used to know well enough.

Then I was put in my cell. The Cell was about ten feet long by six broad, and had a stone floor, and a board for a bed wich the Turnkey shewed me how to put down and make. He brought me a loaf of bread about the size of a good Apple and a can of water, and told me that that was my tea. The bread was brown and hard, made up of maze meal and wheat meal mixed, but it did not matter to me what it was like – I did not want a bite that night as I was fairly done. I kept on thinken of Mother and home, and the trubble I had been and got myself into, just like some had always said I would, and yet tryen all the time to keep up my spirits. I was glad when the Turnkey told me to undress and to put my cloes outside and then to get to bed.

I will try and tell what it was like as it was a queer sort of bed. There was the bed bord with a raised wooden pillow, but no mattress for the bord. For the rest of the things in the cell there was a stool to sit on, and a small table built in the wall to get your meals on. There was a wash bowl and a water Jug, and another utincile. I was given a wooden spoon to eat with, but no knife or fork is wanted there.

You had a Bible and prair Book, and a himn book, and some times the Parson would come along and leave some little track. He would some times come and se you, to tell you the enormity

of your crime, and warn you that it wold lead you to even worse things, if you did not behave better in futur. I used to hate the sight of him, it may have been rong of me but I felt like that.

Now to tell you what the work was, for they made me tread the Weel, and pick okum, which was hard old tarry rope, not that that killed me by a long way, but it was then I made a vow that I wold be as bad as they had painted me.

You were called up at six in the morning, got dressed, made your bed up, and with a pail of water had to scrub the floor and table and make everything bright and clean for the day. Breakfast at seven thirty to eight o'clock, then half an hour in Chappel – and was suprisen to hear how the Prisners sang the himns. Nine o'clock we were marched off to the Weel room. Then there were numbers posted up from one to twelve. The Warder in charge would shout out what numbers he wanted to work on the Weel, and those men wold stamp it round for fifteen minutes and then come off for five minutes. It was like walking up steps and never geting any higher, but very hard work and we was kept at it from nine till twelve.

Then came diner, wich was one pint and a half of stirabout, composed of one pintg of oatmeal, and half a pint of maze meal put in the oven and baked. We were put on the Weel again from one o'clock till four of the afternoon, then we were set to pick okum till eight, wen we went to bed ...

On the whole I was fairly lucky and did not have to hard a time. The Turnkey Warder was getten old and about to retire, and he pitted me for my age, and would pass my task if it was not finished, only telling me to try and pick more next time. I think I was the youngest Prissner there at that time. I might explain that a Prissner get eight marks a day if he have done his work well and behaved him self. He also got one penny for evry twelve marks earned, provided it did not exceed ten shilling. As I have said the way a man was punished was by taken some of his marks away from him.

Refractory prissners were locked in dark Cells, and given bread and water for as many days as the Governor had given them.

There is a lot of difference now in the Prissons. Some kind and Human Gentleman visseted the Old Castle and said that it was not fit for Human Beins to be shut up there, so it was Condemd,

and a new one built, much better and the Prissners Rutine made much easier. Prisners now are treated like human Beins, in the old days they were treated more like Wild animiles. Of corse there was a lot of difference in the Warders. Some were verry ready to get a man punished, others would over look lots of things. But they like the Prisners were looked after pretty sharp by the Head Warders, and others put over them.

Well I finished my month, and as I looked a bit fagged out I was given a small loaf of bread to help me along home with. I did not touch it but took that loaf home and hung it up in the house wen I got there. It hung there a long time and some hard memries hung with it.

When I got home every one looked at me as if I had done some terrible crime, or I thought they did posibly. If I had had some one to have shewn me a little kindness then or pitty, it might have been a turning point in my life, as I had been through a hard time for a lad like me. But there was none to do that except my old Mother ...

It is a long time since those days but many is the time I have walked through the Beautifful rooms of Norwich Castle, now that it is a Museum and thought of the weeks I spent there in Prisson, and of all the misery and sufferen that have been endured inside the Walls of that Historick Building.[28]

There is a poignant letter written by another criminal from the new prison that succeeded the Castle Gaol, on Mousehold Heath. The inmate was W. F. Mitchell and the letter is written on official prison notepaper, bearing the rules and regulations for the writing and receiving of correspondence.[29] The rules state:

The permission to write and receive letters is given to prisoners for the purpose of enabling them to keep up a connection with their respectable friends and not that they may be kept informed of public events.

All letters are read by the Prison authorities. They must be legibly written and not crossed. Any which are of an objectionable tendency either to or from Prisoners or containing slang or improper expressions will be suppressed.

The letter is dated by the prison authorities, 29 January 1897:

My Dear Farther And Mother,

Just a few line to you hopen you are quite Well and i hope my dear Wife and dear little son his quite Well by this time kiss him for me dear mother i hope you will forgive me for what i done to them dear mother after i found out what i done to my dear wife i was frighten and running away i fell on my little son whit the knife in my hand dear mother will you write back and let me know how annia his and the little one give my kind love to hear and i hope she will forgive me for what i done to hear dear mother i want you to come and see me when you come to Norwich let me know if you will let me know when you write to me dear mother ask annia to keep my Shirt for me dear mother i will pay you what i owe you if God spear me to come out hear give my kind regard to the parson of Claxton chapple tell him i shought like to see him if he was to come and see me dear mother give my kind love James and his his wife if you see him ask him to ask mother to write to me tell her i sorry for what i done dear mother i set and wish i was with farther on Sunday at chapple dear mother Write back to me and let me know how little annia his kiss hear for me so good by this time one and all God bless you all i cant Write no more this time i do not feel much like Writting

W. F. Mitchell
Mousehold Prisson
Norwich

The conversion of the Castle Gaol into a museum and art gallery, which Fred Rolfe referred to, was the work of local architect Edward Boardman in 1894. Today, the 'Norwich School' galleries are the best place to view many beautiful images of aspects of the city in the eighteenth and nineteenth centuries. They include paintings by the city's two greatest artists: John Crome and John Sell Cotman.

John Crome (1768–1821) was the son of a weaver, and was baptised at St George Tombland church. Like many other lads

from poor backgrounds, at the age of twelve or thirteen he went to stand in the Maddermarket waiting to be offered work as a servant or assistant to a tradesman. He was taken on as an errand boy, but later in 1783 became apprenticed to a house and coach painter, Francis Whisler, in Bethel Street. During this period he became friendly with Robert Ladbrooke, another aspiring artist and apprenticed to an engraver. The pair became fellow painters and life-long friends, marrying a pair of sisters. Crome's talent as a self-taught artist was soon recognised and he gained employment as a drawing master to William Sparshall, a Quaker wine merchant. Through this connection he was later employed in 1798 as the drawing master for the Gurney girls at Earlham Hall, and enjoyed the treat of accompanying them on a sketching tour in the Lake District.

He was a personable young man, and a wealthy gentleman, Thomas Harvey of Catton, who had a private collection of fine paintings, allowed Crome to copy them. He developed his early style by studying the techniques of the great Dutch landscape artists, such as Hobbema, and also the Suffolk artist Thomas Gainsborough, who had himself been influenced by Dutch painters. There is a story that some of Crome's earliest paintings were done with hairs from the tail of his cat, because he was too poor to afford to buy brushes.

His career was primarily devoted to painting scenes in and around Norwich, attracting attention for his individuality of style. In 1803 he was one of the founder members of the Norwich Society of Artists. In 1806 he had two paintings exhibited at the Royal Academy. He became the president of the Norwich Society in 1808, when he was aged forty.

He became the drawing master at Norwich Grammar School, where his eldest son, John Berney Crome, was head boy in 1813, later to become a distinguished artist himself. Another pupil, Richard Noverre Bacon, remembered him as 'my mirth loving, kind and earnest teacher'. He loved meeting up with his friends and pupils in the local pubs, regularly frequenting the Rifleman Tavern in Cross Lane, the Black Bull in Magdalen Street, and the Hole in the Wall near Exchange Street, where the Society of Painters held their meetings.

George Borrow describes him in *Lavengro* as

the little dark man with the brown coat and the top-boots, whose
name will one day be considered the chief ornament of the old
town, and whose works will at no distant period rank among the
proudest pictures of England – and England against the world!

Borrow's prophecy was correct. Today, Crome is considered one
of the finest of British landscape artists, and his superb *Mousehold
Heath*, *c.* 1820, was purchased for the Tate Gallery in 1863. He
died in 1821, and was buried in St George church, Colegate,
where there is a memorial to him in the south aisle chapel with
a medallion portrait by John Bell.

John Sell Cotman (1782–1842), Crome's younger contemporary,
achieved less acclaim in his lifetime, but today is recognised
as one of the most outstanding of English watercolourists.
Whereas Crome remained firmly Norwich-based, apart from
a tour through Belgium and France in 1814, Cotman moved
around, spending a large part of his career in London, several
years in Great Yarmouth, and periods in Wales, Yorkshire and
Normandy.

He was born in 1782 in the parish of St Mary Coslany, the son
of Edmund Cotman, hairdresser and later haberdasher. He was a
pupil at the Norwich School in 1793, where his skill as an artist
was soon recognised. The headmaster, Dr Forster, disliked cats
intensely. One day when he entered the classroom he found a large
black cat sitting on his desk. Approaching closer, he realised that
it was a painted silhouette cut out of cardboard. He held it up,
and, gazing keenly at one of the pupils, said quietly, 'I know only
one boy who could have drawn this.' Then, smiling to himself, he
placed the drawing carefully in his desk. Recognising Cotman's
skill, he deemed that no punishment should be inflicted.

Cotman was superstitious, and later kept a black cat for luck. It
didn't help much. Eager to acquire professional skills as an artist,
he did not remain long in the city but moved to London at the
age of sixteen. There he worked as an assistant to Ackermann, a
publisher of engraved prints. He studied drawing at the evening
classes of Dr Thomas Monro, and in 1800 had two drawings

exhibited in the Royal Academy. His increasing abilities were soon recognised, for in the same year he was awarded the prestigious large silver palette by the Society of Arts.

After a few months of sketching tours in Wales, and a formative period living in Yorkshire when he produced some of his finest watercolours, he returned to Norwich in 1806 and established a School of Drawing in Wymer Street (now St Andrew's Street). He also began exhibiting with the Norwich Society of Artists, and was elected as vice-president in 1810.

In 1812 he moved to Great Yarmouth, where he undertook commissions for the wealthy banker Dawson Turner and became drawing master to his family. The major commission was to produce drawings of the architectural antiquities of Normandy, and three tours in France between 1817 and 1820 resulted in the publication of two volumes of etchings of *Architectural Antiquities of Normandy* in 1822. During this same period he also published books of etchings of architectural antiquities of Norfolk, and the sepulchral brasses of Norfolk and Suffolk.

By this time, Cotman had married, and needed the support of Dawson Turner and the income from the etchings to support his wife and family of five children. But given that he was an ambitious and creative artist, it was not the sort of work he wished to focus on, and he later lamented that his talent had been wasted in pedestrian work when his skills wished to soar free. His surviving letters to Dawson Turner in the Norfolk Record Office often reflect his gloom and despair, although at the same time expressing appreciation for all the moral and financial support that Turner had offered him.

In 1823 he returned to Norwich and opened a new School of Drawing at a large and handsome house in St Martin at Palace Plain, near the Cathedral. This can be seen now as a retrograde step: the house was too expensive for his modest income, and the drudgery of teaching pupils who were often uninterested and inept was a drain on his easily deflated spirits.

Thereafter, most of his income continued to be derived from his role as a tutor. His sons assisted him in this work as they matured, but they too were prone to lack of confidence and depression. Cotman did achieve some modest successes. He became an

associate of the Old Watercolour Society in 1825, and later in 1833 was elected president of the Norwich Society of Artists, but it was disbanded during the same year.

Doubtful of the chance of ever achieving fame and fortune in Norwich, Cotman was elated when he was appointed to the role of drawing master at King's College School in London. He felt that the capital would be a stimulus to his artistic impulses and would offer far more opportunities for appreciation, exhibitions and sales than Norwich could provide. He moved with his family to take up the appointment in 1834, and thereafter lived in Bloomsbury for the remainder of his life.

His last visit to Norfolk was in 1841, when he recorded in a letter that King's College had given him a fortnight's holiday – but 'I shall stretch it to three weeks or nearly so, for Edmund can do my duty … till I return to meet my extra duties in the upper department'. Miles Edmund was his eldest son, and assistant drawing master at the college. As John's biographer, Sydney D. Kitson, notes:

> His fortnight's leave, which might be 'stretched to three weeks or nearly so', extended itself eventually to nearly two months. During this time the elderly truant enjoyed himself with a boyish delight such as he had not experienced for many years. In Norwich itself his fellow-citizens, formerly so critical of his eccentricities, now hailed him as a great London artist and the Professor of Drawing at King's College.[30]

During his autumn holiday, he travelled around the Norfolk countryside, making drawings in black and white chalk on grey paper, some of them including elaborate colour notes as memoranda for intended paintings. He stayed with his son John Joseph, who had remained behind in Norwich, living in lodgings in Heigham Terrace. He wrote to Dawson Turner on 17 October:

> I came into this County, really and truly for my health … with my feelings deadened to Art & Pictures – Judge for yourself my happiness in finding your Flints capable of once more creating a blaze in my heart.[31]

It suggests that perhaps Cotman would have been happier and more successful if he had remained in Norwich instead of being at Dawson Turner's beck and call in Yarmouth and then taking on the onerous responsibilities of the career of drawing master in London. Like Crome, he might have become honoured as a loyal son of the city. Kitson records:

> The end of the holiday came on November 18, a holiday which had been prolonged from week to week since Cotman could not tear himself away from scenes which were now doubly dear to him because of his early associations and for their own distinctive loveliness. He was due to leave Norwich by night mail, and after his return to London he wrote to Dawson Turner telling him how he had spent his last day in Norfolk:
> 'I galloped over Mousehold Heath on that day, for my time was short, through a heavy hail-storm, to dine with my Father – but was obliged to stop and sketch a magnificent scene on the top of the hill leading down to Col. Harvey's house, of trees and gravel pit. But Norfolk is full of such scenes. Oh! Rare and beautiful Norfolk.'[32]

The elegiac group of sketches he made throughout his holiday convey his intense poetic response to his native region, and must be rated among some of his finest works.

It was his artistic swansong. He died the following year, on 24 July 1842, profoundly disillusioned by his lack of success, and tenderly concerned for the welfare of his family. He had been ignored to such an extent that, when he died, not a single obituary was published, not even in the local Norwich newspapers, and it was many years before his reputation soared to the position it has attained today. In July 1942, exactly a hundred years after Cotman's death, the *Burlington Magazine* devoted its entire issue to the artist, and by the mid-twentieth century he was becoming widely considered as the equal of Turner, or even his superior.

The difference between Crome and Cotman was that Crome was a Norwich boy, who knew his place: and his place gave him security and support. Cotman had early in his career departed from Norwich and been taken up by posh friends, and thereafter

believed that he must aspire to the life of a gentleman. His period with Dawson Turner in Yarmouth, and his elegant house in St Martin at Palace Plain, and his extravagant expenditure on books, antiques and paintings, was all living beyond his means. Coupled with a lack of recognition, and no support from a community such as Crome enjoyed, he saw his career puddle into decline, his fate to 'skulk through life as a drawing master and pattern drawer to young ladies'.[33]

But throughout all these vicissitudes, and his various changes of artistic style, he remained a great artist and one of the most inspiring sons of the city, empowering us with a new vision of the streets and countryside around us.

Today, there is a plaque on his house in Palace Plain, and his enduring memorial is the comprehensive collection of his oil paintings, etchings, drawings and watercolours in the Castle Museum, a selection permanently on display. But perhaps now is the time to consider some new way of honouring one of the country's – nay, the world's – finest artists. A statue, an imaginative and sensitive one, not an 'old fogey' type like Wellington in Cathedral Close. Or some more original form of memorial by contemporary artists in the grounds of the Castle, or in the Cathedral Close, for he was a pupil at the Norwich School, and painted a superb watercolour of St Luke's Chapel (now in the Castle Museum). He needs a presence in the open air, beneath the East Anglian skies that he depicted so skilfully, and in the setting of buildings, trees and flints that created such a blaze in his heart. 'Oh, rare and beautiful Norfolk.'

Various new religious groups developed in the Victorian period. Quaint cobbled Elm Hill became home to a new city monastery. It was named the Priory of St Mary and Saint Dunstan. Organised on Benedictine rules, it was established in February 1864 by Joseph Lyne, who was only twenty-seven years old. He adopted the title of Father Ignatius and the fraternity consisted of ten chosen companions. A chapel was established in a courtyard to the rear of Elm Hill, and the opening ceremony was held there, during which Father Ignatius preached an eloquent sermon, condemning the deficiency of church services in the city, and the vice and immorality that prevailed. He and his brethren

would work towards spiritual reform to save Norwich people's souls.[34]

Unfortunately, the eccentric appearance of the monks, going barefoot in cold wintry weather, and malicious gossip circulating about their intentions, attracted the attention of the mob element in the area. Groups of idle apprentices, young mechanics and street urchins gathered at the gate of the monastery, jeering, hooting and shouting insults, causing great annoyance to the surrounding inhabitants. This rowdy behaviour increased in volume when the monks arranged a processional walk to St Gregory's church on Easter Sunday.

There were also problems within the monastery. Although fervently devout and an inspiring preacher, Father Ignatius was impractical where domestic arrangements and finances were concerned. So these aspects of the communal life tended to be neglected when he was absent on preaching tours, and also winning support from local people who were permitted to attend services, and sessions of prayer and teaching, as 'the Third Order'.

Another problem was that his moral standards were unflinching, so discipline for his supporters was harsh. On one occasion he returned to the monastery to discover that while he had been absent, some members of the Third Order had attended a dance at St Andrew's Hall. Father Ignatius was both disappointed and furious that they could have dared to flout his example concerning the sins of the flesh. He organised a medieval-style penance in which the guilty women involved had to lie prostrate in ashes on the chapel floor, while the men were publicly whipped on the altar steps.

This severe and humiliating punishment alienated several of his supporters and of course was quickly gossiped about in the neighbourhood. Ignatius was already the subject of increasing hostility because parents claimed that he was poaching their adolescent and older children away from their own parish churches.

While he was absent on another occasion the monks appointed a new abbot to replace him, in June 1865. But Ignatius acted swiftly in having the interloper dismissed upon his return. These internal and external problems were exacerbated when various

tradesmen claimed that their bills were unpaid, and started to get nasty. In addition, the monastery premises were only leased to the brethren, and in view of the increasing financial problems the owner, the Vicar of Claydon, claimed the property back.

Ignatius tried desperately to avert this decision. But eventually bailiffs were sent in, and he was manhandled and evicted by force. What had been a brave venture, inspired by good intentions and winning a fair degree of respect and support among sections of the public, had come to a miserable end. Before he departed from the city, Father Ignatius held some services in St Andrew's Hall. They were attended by large congregations who left uplifted and inspired, and the local newspaper reported that

> the evening will long be remembered by the thousands who were present, for the address delivered was certainly of a most powerful and eloquent character ...

So at least, in the end, he was able to depart from the city on a note of triumph. It was unfortunate that his spiritual zeal was not matched by practical abilities, and that he lacked a willing group of supporters to take care of these more mundane aspects of communal life. The monastic dream had been brief. The plaque erected on the entrance door in Elm Hill records that 'after two difficult years it was dispersed'.

As the century progressed, the weaving industry declined due to increasing competition from the northern manufacturing towns. Norwich producers had also failed to invest in machinery and large-scale factory production that would have speeded up the cloth-making processes. Silk weaving continued to survive until the end of the century, although the number of workers was falling all the time. Charles Dickens bought his wife a silk shawl in 1849, and says in his letter, 'I bought you a shawl in Norwich – I don't think much of it. It's Norwich manufacture. That's all I can say. But it's bright and cheery besides – I forgot that ...' He seems to think that Kate could find something of more fashionable style in London.[35]

The city managed to prosper, though, and a broader economic base developed with less reliance on textiles. Boot and shoe

manufacture increased at a great rate, and other important industries included soap and paper production, printing, brewing, and iron founding. Developing British colonies provided a good export market for agricultural machinery and general hardware. Boulton & Paul, with manufacturing works in Rose Lane, could boast in their advertisements:

> Not only are the wonderful contrivances in the form of conservatories, portable buildings &c. to be found on all great estates throughout the kingdom, but we believe it would be difficult to name any single country into which one or other of their varied manufactured articles have not long since found entry.

The portable buildings included bungalows, and 'revolving summer-house tea-rooms'. They were also producing sheds, poultry houses, pumps, and refuse carts, and their 'unsinkable steel motor-boats were becoming immensely popular'.[36]

There was also a boom in farming. The closeness of the Norfolk countryside to the city helped to establish agricultural services such as corn dealing and land agency, and there were weekly livestock markets in the Castle Ditches, attracting all sorts of customers into the city.

This prosperity was reflected in some fine new buildings in and around the centre. Edward Boardman practised as an architect from 1860 to 1900, and rebuilt the Norfolk & Norwich Hospital in partnership with Sir Thomas Wyatt in a fashionable 'mock-Tudor' style. He also designed the Royal Hotel (1897) on Agricultural Hall Plain, now rather unappealing in its pompous domination of the street corner, like a stout red-faced farmer of the type who probably frequented it. Hardly more attractive is the Agricultural Hall opposite, designed by J. B. Pearse in 1882.

The Royal Arcade between Gentlemen's Walk and Castle Meadow remains a major attraction, an Art Nouveau design by George Skipper which opened in 1899. It combines peacock friezes with coloured tiles and stained-glass lamps and screens, and was described when it first opened as 'a fragment of the Arabian Nights dropped into the heart of the old city'.

Skipper also designed the remarkable if somewhat over-the-top Norwich Union office in Surrey Street (1905), described by Pevsner as 'without any doubt one of the country's most convincing Edwardian buildings'. Today it has lofty modern glass extensions looming around it, and unsightly new Aviva logos following the company's name change.

Other fin-de-siècle designs include Burlington Buildings, in Orford Place (1904), designed by J. Owen Bond, with half-clad nymphs supporting the stone balustrades on the first floor. Across the road in Red Lion Street is a fine row of other ornate Edwardian buildings, including Gurney House. These add considerable decoration to an area which during the twentieth century was developed in more minimalist architectural style. They were fortunate to escape the bomb blasts that demolished the Curls store during the Second World War, and created a huge crater in the heart of the city.

One historian of the city bemoaned the fact that so many of the fine medieval buildings had been sealed in white shrouds:

In the church of St. Benedict we read on a tablet that James Wilkins died in 1820 'an eminent Plasterer of this Parish'. Half Norwich is his monument. The evil that men do lives after them. Much of mediaeval Norwich, with her fair exterior of carven oak or stonework and split flint, lies imprisoned by such as he. They splashed plaster in her lovely face; they drowned her in oceans of whitewash. They sought to make her such as they desired; they trusted future generations should think the city was moulded of the material they loved. But in the spring of 1913 there came to Elm Hill, men armed with axes and hammers. They broke down the work of eminent plasterers and were smiled upon by the beauty it had concealed. They laid bare long-imprisoned panels that skilled and loving craftsmen of five centuries ago had carved with cinquefoiled arches and pierced with quatrefoils above. And now a delightful little front of late mediaeval timbering has for ever thrown off its ugly cloak, Much more of this kind, it is to be hoped, will be done before many more years have gone by. Here and there all over the city the mediaeval framework shows through the accretions of later years. Between two shop fronts

in Fye Bridge Street (No. 11 is one), a stone shaft of the fifteenth century may still be seen.[37]

This was written by Ian Hannah in 1915. Since then, more of the rich medieval architectural heritage of the city has been restored and revealed. The work of one generation is unpicked by another. Which new developments today will be reviled and removed by later hands?

# Norwich Since 1900

'... and I must keep on with hosses because after this War there'll be no such thing as having any to paint'

By the twentieth century, new forms of travel were rapidly replacing reliance on horses and carts or carriages. Bicycles, trams and trains were making a speedy difference to daily life. By the early years of the century, most young people who could afford it, and many older ones too, were enjoying the freedom and convenience of travel that a bike could offer and, in the Norwich area, finding it an ideal way to explore the beautiful Norfolk countryside.

Trams were becoming the most comfortable method of city travel for those unwilling or unable to manoeuvre a bike. The first journeys commenced in April 1900, and on the very first day 25,000 passengers used the service. The introduction by James Hooper to the *Jarrolds' Official Guide to Norwich* (1909), after providing a brief sketch of the city attractions for visitors, concludes:

> These rough hints can merely serve for a preliminary survey of the ancient city of Norwich, but will aid the newcomer to reach the chief places of interest with some facility, whence he may begin wanderings into lesser thoroughfares and byways, many of them abounding in nooks and corners such as fascinate artists and other lovers of the picturesque past. Naturally a simple primary survey of the main arteries may be made cheaply and comfortably by traversing the tram routes, either methodically in geographical sections, or by more free and easy systems, according to inclination

or time and weather facilities. A sum of two shillings will cover
the journeys to and fro over all the routes.

Phew! What a lot of verbiage! Tourist guides are more simply
written these days. Two shillings was probably well within the
budget of the middle and upper classes, but too expensive for
poorer folk, who had to remain reliant on 'Shanks's pony'. The
guide also provides information about all the city tramway routes,
and the names of some of the principal places of interest passed.
The ten different routes covered Newmarket Road (including
the Norfolk & Norwich Hospital and the Newmarket Road
Cricket and County Football Grounds), Unthank Road, Earlham
Road, Mousehold Heath (described as including the 'Lollards Pit,
St. Leonard's Priory, Bishop Bridge, Cow Tower, the Britannia
Barracks, H.M. Prison, site of the chapel of St. William in the
Wood, and the breezy hills and dells of the Heath'), Thorpe,
Magdalen Street, Dereham Road, Aylsham Road, Trowse, and
Lakenham.

So a very large and comprehensive area was covered, providing
a useful and enjoyable service for both locals and tourists alike.
By 1935, however, the services were phased out as motor bus
transport, with greater flexibility of routes, was becoming more
popular. The Eastern Omnibus Company reported:

> No longer were people compelled to ride on an exposed top deck
> in bad weather, nor were there any irritating delays through the
> limitations of a single track. Householders also expressed great
> appreciation from the point of view of their wireless sets, free at
> last from irritating interference caused by the overhead electric
> wires.[1]

It is interesting to note that recent attempts to revive tram services
in some cities have run into all sorts of problems with technical
difficulties and exorbitant costs. Also in modern times, it's proving
an uphill battle to ease people out of their cars and into more
environmentally friendly forms of transport.

The city in the twentieth century could also offer not just one,
but three railway stations. The guide reports:

There are three stations in Norwich – City, Thorpe, and Victoria, the former being the terminus of the Midland and Great Northern Joint Line, and the two latter Great Eastern. Norwich is fortunate in its train service with London, the North, and Midlands, as with London an excellent service of fast trains is provided by the Great Eastern Railway from Liverpool Street, on leaving which there is a choice of travelling either by the main line via Cambridge, or via Colchester and Ipswich. A daily service of express trains is also run from and to St. Pancras via Cambridge. Restaurant car accommodation is provided on the principal up and down expresses. The Midland and Great Northern Joint also offer splendid through trains, steam heated in cold weather, to and from the Northern and Midland Counties.

On both Railways the trains are composed of the most up-to-date stock, with corridor and lavatory accommodation.

The way this last sentence is worded implies that if you can't get a seat, then sit or stand in the corridors or lavatories instead. But in the early twentieth century there were probably never such problems with overcrowding as occurs on the main city routes from London to Norwich today and in peak-time holiday periods.

Today the city has a newly designed bus station on the original bus station site in Surrey Street which opened in 1936. There are regular services throughout the city centre and outskirts, as well as coach services to London and other parts of the country. In addition, from 1969, the city has had its own airport built on the RAF Horsham site, offering a good variety of flights.

In March 1898, the Norfolk Hotel in St Giles Street was purchased by a syndicate for £9,500 and the Norwich Opera House and Theatre of Vanities was built on the site. The *Jarrolds' Official Guide to Norwich* (1909) recorded that the 'new Opera House opened on 4 August 1903, and is noted for a good class of variety entertainment'. It was later known as the Hippodrome Theatre.

The proprietors on early posters are listed as E. H. Bostock and F. W. Fitt, and the building is described as the 'Handsomest

Place of Amusement in the Eastern Counties'. Much of the management was organised by Frederick Fitt and his wife Fannie, with assistance from other members of the family. There was a busy programme of entertainment, with shows twice nightly, and a matinee on Saturday afternoons, with extra matinees during holiday periods. Frederick was born in 1871 and served on Norwich City Council from 1901 to 1922, and then became an Alderman. He married Fannie Bostock in 1895, and they had one daughter, Doris, who later also became a Norwich City Councillor.

Fannie's mother, Mrs Bostock, kept a diary which provides some fascinating details about family life during the exciting period when the Hippodrome was newly developing in the early years of the twentieth century.[2] The entries are quite brief, written mainly in small pocket diaries, and in two small notebooks for the period towards the end of 1904, during which year she reached her seventieth birthday.

She mentions that on 31 August the family were celebrating the anniversary of 'the Hippo', as they affectionately called it. She was keeping in touch with the Wombwell family, who had a large menagerie that regularly visited Norwich on its tours around the country. Fred and Fannie are mentioned as being very busy at the theatre dealing with rehearsals, matinees and evening performances. On 9 October they also went to inspect the Opera House and took their daughter Doris with them – she would have been about seven at the time. A camel and a llama arrived from London on 15 October, presumably destined for one of the menagerie shows that the family were involved in. On 18 October, Fred was driving around in his car sorting out uniforms, presumably for the staff, and a new licence for the Opera House, while Fannie was 'up in the warehouse sorting furniture for the Corn Hall sale', and on the following day, Mrs Bostock records:

Dear Teddie's Birthday, a day of usual Confusion and bustle here. Doris to school, Fannie out driving with Fred in morning, her face very bad, decided to have tooth out at dentist's, not at home, home to dinner, out again after, then Hippo at night.

It seems that Mrs Bostock's home was actually at Palatine House in the city but she was living with Fannie and Fred because she could assist with various aspects of the theatre business and help to look after Doris. Also, she may have become infirm because in one entry it is mentioned that she had to be helped to the front door, and, later on, be taken out to see the menagerie in a 'chair'.

> Oct. 20th: Fannie still in great pain. Fred & her to dentist, at 10.30 met Dr. Everitt had to have Gas twice, gum much cut about, dreadful painful & sore, but got more easy towards night. After tea to the Hippo. Doris playing with dollie ... Sent papers for Fred as he was so queer [ill].

> Oct. 21st: Fannie & Fred both better and driving at 10.30 about various things with the Opera House.

> Oct. 22nd: Fannie's face not much better, out driving a bit in morning, shopping, then to Hippo for matinee. Doris also very excitable, both her and Fred over the transfers after tea, again to Hippo for evening performance, Gus arrived at 10 minutes to 9 in hansom, only popped here a few minutes and went in same to Hippo, the last night of the old theatre. Fannie, Fred & Gus to Opera House, seeing goods & c. ... till 4 o'clock in the morning then home to bed.

The family seem to have used a great variety of different vehicles for travelling around. They were living in a period when those who could afford it were changing from horse transport to motor vehicles, and the Fitt and Bostock families were alternating between both. It must have been a very difficult period for traffic congestion and accidents in the city, with horses often frightened by the fast-moving and noisy motors. Various entries in the diary refer to the family motor car, 'the big motor', a pony car, a new little trap, a brougham, a Victoria, and a 'chair', presumably a sedan chair carried by two men. A trap was a small two-wheeled open carriage, a brougham was a one-horse closed carriage for two to four passengers, and a Victoria was a four-wheeled carriage

with a hood for two passengers and a seat in front for the driver. The family also used public transport: cabs, which were horse-drawn carriages; hansom cabs, two-wheeled one-horse chaises with a large hood; and also, for their longer journeys away from Norwich, trains from Thorpe station.

The reference to 'the last night of the old theatre' suggests that the 'Hippo' may have been a different theatre originally from the Opera House, which was perhaps given the name the Hippodrome when the Fitt family took it over, as the following entries in the diary suggest:

Sun. Oct. 23rd: Fan, Fred & Doris to Opera House to help with all, see to cleaners etc. at 9am. Gus not up till ten (they had all had a late night previously), after breakfast he went also.

Mon. Oct 24th: An excitable day – the gents to new building in good time – Fan, Liz & Gus to rehearsal, Teddie & Fred to Goodchilds, then all home for tea and to dress for the great Opening. Mr & Mrs. Cross and Della got to Thorpe [station] at 4 & took apartment at the G. E. [Great Eastern] Hotel, had their tea & dressed & went straight to Hippo. Lizzie went with Cab ... Fannie, Doris & Fred had gone early on acct. of tickets, Teddie walked up, Gus started to, but overtook his mother & party, the Mayor & Mayoress of Ipswich with Mr & Mrs. Parkington went direct in Fred's Brougham from the Royal Hotel to Hippo, a very grand opening, of swells, Band of the Scots [Greys?] and a Full House – all went off splendidly well.

Mrs Bostock continues her diary with entries about other family business matters, the laying of a foundation stone in Ipswich, perhaps for a theatre there, and negotiations concerning the theatre in Colchester. She continues on Wednesday 9 November:

Very wet & windy, quite miserable for new Mayor's Procession. Bells ringing joyously.

Sun. 13th Nov: Fannie & Fred to Cathedral to meet new Mayor ... Porters had a big fire at 9 pm. in the yard, thousands of pounds

property destroyed, machinery, motor engines & c. & c. as well as lots of timber. Mr. Porter away in London.

Wed. Nov. 16th: Fan & Fred out at 11 – driving to meet menagerie, see parade start & c., came home and got me to front door to see them all pass, Band played Auld Lang Syne, all raised their hats, bowed & c. so did the drivers of vans.

It seems that Mrs Bostock knew most of the menagerie people, who were presumably the Wombwell family referred to earlier in the diaries.

Thurs. 17th Nov: Another foggy day, City very full, opening of the War memorial, cattle show, Hippodrome matinee, menagerie & various other places. Frank had a few minutes in morning, to Hippo with baby, Doris & c., afternoon rode back to their show in motor-car – Doris took money a little while at the menagerie before tea, was delighted, Jessie & Dollie to menagerie ...

Friday, Nov. 18th: Doris taking money with the little pony, having rides, a jolly time she said ...

Sunday Nov. 20th: Collins took me in Chair to the menagerie for an hour and a half, all home to dinner ...

Mon. Nov. 21st: It was both raining & snowing, terrible for pulling down [i.e. the menagerie tents, stalls, etc.], seemed such a pity ...

Tues. Nov. 22nd: Very bad snowy morning & slippery, show got an eleven mile journey, but reached safely, a vile day all through, Teddie & Fred saw them off the ground and on the road fairly, then drove back for breakfast at 9.30.

And so an exciting season for the Fitt family came to an end, but even after the menagerie had left the city there was plenty of work to do organising the programme of entertainment for the Christmas season at the 'Hippo'. So many more days of 'confusion & bustle' for the energetic and hard-working family.

The Fitt and Bostock family papers deposited in the Norfolk Record Office also include some school exercises written by Doris Fitt when she was aged about sixteen. They cover domestic science lessons and are neatly handwritten in Jarrold & Sons' stiff-covered notebooks, signed in the frontispieces 'D. W. Fitt'. They were written in the period September 1914 to September 1915, presumably shortly before Doris completed her education.

The notebook titled 'Housewifery' provides fascinating information concerning the various duties of the married woman, the weekly routine for cleaning the house, details about the correct methods of cleaning different sorts of kitchen utensils, and how to choose a good piece of meat, with a drawing illustrating all the edible 'cuts' of a cow.[3]

There is also information about the choice of a house. At that time purchasing a property was unusual, except for wealthier couples, so Miss Fitt was advised by her teacher that 'one eighth of the income is usually considered the proportion to be spent on rent'. With regard to the neighbourhood, the young wife should select

> if possible a house near the railway station or trams, or near the occupant's place of business. The house should not be near an overcrowded churchyard, unwholesome trade premises, marshy land, or stagnant water, also avoid narrow, dark streets facing north, houses closely hemmed in with trees, or a low damp situation.

The role of the husband is not actually mentioned, perhaps because this might be thought 'unseemly' in a girls' school in the early years of the twentieth century. So it is the prospective young wife who is advised, before choosing a house, that:

> All particulars of the water supply should be obtained and cisterns examined.
>
> Make sure that no case of infectious illness has recently occurred in the house. Also, that the house is dry.
>
> All chimneys should be swept and mantelpieces examined for signs of smoky chimneys.

All old wallpapers should be stripped off, because they frequently harbour insects & germs & disease.

All floors should be thoroughly scrubbed & fires lit in the rooms to dry them before linoleum or carpets are put down.

Look for signs of house-pests – mice, rats, ants & beetles.

What a carry-on! The new young bride would suffer a fit of the vapours followed by sleepless nights with all these problems to deal with. And she thought that married life was going to be fun!

Then, she had to deal with the weekly programme of domestic work for her live-in maid. In the early twentieth century until the Second World War, 'middle-class' families, even with low incomes, would have a live-in maid or daily help, but as the poorer classes became more emancipated and less willing to be domestic drudges, the agencies for providing servants gradually declined. Doris's school book makes clear why, in her neatly written instructions for the maid's duties in a seven-room house:

> The mistress should carefully plan the work so that the maids may know exactly what is required of them and lose no time wondering what to do next.
>
> 6 a.m.: Rise, light kitchen fire, fill kettle, clean boots, sweep hall, clean steps and brasses, light breakfast or dining-room fire. Sweep & dust the room.
>
> 8 a.m.: Prepare table for breakfast. Have breakfast in kitchen while dining-room breakfast is going on. Open bedroom windows, strip beds & clean wash-stands.
>
> 9 a.m.: Remove & wash breakfast things
>
> 9.20: Help mistress make beds & dust bedrooms. Prepare vegetables & receive orders for the day
>
> 10–12 noon: Undertake special tasks, depending on the day of the week.

These tasks included hand-washing clothes, cleaning bedrooms, cleaning silver, and cleaning the kitchen, drawing room, hall, kitchen range (which required black leading), storerooms and scullery.

12–1 p.m.: Prepare dinner & lay table

1 p.m.: Dinner for house-owners & servants [in the kitchen of course]

1.30 p.m.: Wash dinner things, make up sitting-room fire, & clean kitchen.

2.30 p.m.: Dress, and do some light work.

In case you thought that the maid might be sluttishly performing all her morning chores in her dressing-gown and curlers, 'dressing' meant changing her morning uniform to a smarter outfit (but both with an apron and cap, of course) to serve afternoon tea and the evening meal. The mistress of the house would also change from her morning clothes into a fancier afternoon frock. And 'light work' was usually the boring occupation of having to mend and darn a huge basketful of the family's clothes, including 'Master Georgie's', which seemed to get stained, ripped, and lose buttons remarkably regularly. There would also be 'alterations' required, as clothes were expected to have a long wardrobe life and be adjusted to changes in the size and shape of the wearer. If she was lucky, the maid might be ordered to do some shopping or exercise the dog, but these occupations were usually performed by the lady of the house.

4.30: Prepare tea [and there might be several afternoon guests to cater for, so she had to remember the silver serviette rings and second-best lace doilies].

5.10: Remove tea-things & wash up.

5.45: Turn down the beds, pull down the blinds, light fires & gas-lights as necessary

7.30 p.m.: Prepare supper.

By this time the master would probably be home, along with perhaps other members of the family, so a lot of extra work was needed.

Note that the maid is not specifically required to cook, which suggests either that a separate cook was employed or the mistress did most of the cooking herself.

9 p.m.: Wash supper things

9.45: Take up hot-water to bedrooms. Retire to bed.

Although whether the exhausted maid actually ever got to bed by 9.45 would depend on whether there were a few 'little extras' to perform that her mistress had forgotten to mention earlier.

So this was the maid's weekly lifestyle. Apart from Sunday, when the 'afternoon off' was usually agreed, she could expect only occasional holidays from the gruelling and monotonous routine. It was typical of the lives of thousands of women living in Norwich in the period, as well as throughout the rest of the country. Doris Fitt was of the class to employ her own maids by the time she had a house of her own, but, as the century developed, and women became more liberated with better employment opportunities, most householders would learn to make do with a 'daily-help' or manage on their own.

Although the city was entering a new era, there was still a great deal of poverty, many households continuing to live at subsistence level. Women continued the craft of weaving in their own homes, because in that way they could keep an eye on the children, and fit in cooking and cleaning, while supplementing their husbands' incomes.

A historian comments, in 1915:

> Though much minished and brought low, the ancient labour of weaving is far from being extinct. Some factories still exist, and from small cottages in slummy streets the click-clack of venerable looms may still quite frequently be heard ... many of the primitive machines are still used to weave hair-cloth ... The reward of the devoted mothers who thus try to assist their families, is unhappily most lamentably low.[4]

Meanwhile, their husbands or sons might also help out by breeding canaries, a cottage industry for which Norwich was particularly famous. Canaries were said to have been introduced by the Flemish weavers when they emigrated to the city in the Tudor period. In the twentieth century, the canaries also provided a name for the local football team. Norwich City FC's familiar yellow and green kit is now seen more regularly on television since City has been promoted to the Premier League, and it was

inspired by the birds' bright colours. In the *Jarrolds' Official Guide to Norwich* of 1909, a more professional canary breeder states: 'All birds on approval, at my sole risk, and if not giving entire satisfaction, readily exchanged or money returned in full.' If only Delia Smith could have the same arrangement with the signed-up football players in her team.

The poverty of many working-class citizens before the Second World War was apparent to visitors:

> The great bane to the industry of the city is the immense amount of labour which is purely casual … The number who live miserably by picking up odd jobs is terribly large, and Norwich does not hide her trouble; it is hard to enter the city without being depressed by the wretched looking specimens of humanity who desire to carry one's bag.[5]

Many of the poor also lived in unhygienic and damp conditions. The site of much of the city is very low and exposed to floods, from which Norwich has suffered very frequently in the course of her long life. In 1343, heavy rain sank a vessel called the *Blitheburghesbot* (obviously connected with the town of Blythburgh near Southwold), on the Wensum at Cantley; she was bringing up a cargo of Baltic timber, onions and herrings to Norwich, and no less than forty people were drowned. More recently a similar, perhaps still greater, storm in August 1912 laid the lower portions of the city under water and left the ancient tenements reeking of damp.

On 26 and 27 August, rain fell so heavily that the streets were flooded, the drains blocked by debris, and the river overflowed. More than 3,500 homes were damaged by the floods and many people had to be provided with temporary accommodation.

Many of the poorest classes lived in houses in the Norwich 'yards', little courts entered through archways from the streets. A writer in the *Daily Citizen* of 30 April 1913 reported:

> The place has literally hundreds of little, narrow, sunless courts, resembling nothing more than a series of rabbit-runs, and the dampness which the waters left as legacy has never disappeared!

The writer also quotes one of the councillors as saying that a third of the Norwich houses are below the standard laid down by the Local Government Board, and that a fifth are positively unfit for human habitation:

> A good deal has been done to pave and light the yards; some of the worst are swept away or stand untidily, broken windows and disused; but many still occupied houses are mildewy and damp ... one result of the floods has been greatly to stir public feeling in the matter of housing reform.[6]

The outbreak of the First World War in 1914 did not result in much damage to the city itself, but a huge number of Norwich men were killed overseas, a total of 3,544, fighting to defend their homeland. Wounded troops were brought home to receive medical treatment and nearly 45,000 were dealt with at the county asylum, transformed into a hospital, in addition to those accommodated at the Norfolk & Norwich Hospital. There was a constant fear of air raids, and one in September 1915 did result in four people being injured at East Dereham and requiring hospital treatment. A Volunteer Corps was formed in the early months of the war to defend the city, and its members – formed from those men who were too old to enlist – were engaged in patrolling railway lines, bridges and other vulnerable areas, and assisting with the construction of an airship base at Pulham Market.

Some Norwich businesses were engaged in manufacturing equipment connected with the war, and Boulton & Paul built over 2,000 military aeroplanes, and also provided large quantities of wire for use in the trenches.

The artist Alfred Munnings (1878–1959) was born and grew up in Mendham in Suffolk, and studied at the Norwich School of Art. He was particularly keen on painting horses and scenes of gypsy life, and there is an amusing anecdote describing his attendance at a horse fair held near the Bell Hotel in the early 1900s. The sale was attended by gypsies, and Munnings, seeking the advice of one he knew, known as 'Drake', ended up by buying 'a wicked little dark brown Dartmoor mare who kicked any cart to bits', a bay yearling colt, a little dun-coloured horse, a placid

donkey, another pony, and finally a blue caravan. He was quite flush with money, having already had paintings exhibited at the Royal Academy, and with dealers keen to purchase his work. At the end of the sale, there was seen, trotting out of the city,

> the future President of the Royal Academy, riding the dun horse, leading the brown mare, with the villainous Shrimp, sharp as a newt, riding another and leading the rest with the uncomplaining donkey.

'Shrimp' was an illiterate gypsy lad and a friend of 'Drake', 'an undersized, tough, artful young brigand', as Munnings described him; but they became constant companions, because Munnings loved all types of horsey people.[7]

By the time war broke out, Munnings was living in Penzance but was still keeping in touch with friends in Norfolk, including local picture dealers. One of these was John James Nurse, an antique dealer at 12–16 Elm Hill and 14A St Andrew's Street, Norwich. Munnings wrote to him from Lamorna, Penzance, on 17 November 1915:

Dear Nurse,

Gerald Bullard is still wanting a picture from me for the money he has for a wedding present & this time I am going to send him a fair knock-out.

I have written to Huddersfield Gallery (where it is borrowed for a time) and they are going to send it out to you – will you be good enough to unpack same with case & advise him of its arrival so that he can come and see it. You will think it a good one – a bit of the touch of poor old Cotman about it.

Mr. Bullard wants a caravan ... I tell him he'll have a fire, a tent, a pony, nice girls, & everything to do with gypsies when he gets it.

For god's sake don't you crab it – I shall know if you do as I'm going to his place to paint his horse later. If you crab it I'll cut your throat.

& now, about those pictures – I can see you aren't having them at the price I quoted so please don't hold them any longer or

hawk them round. My dealer in Cardiff is writing me bloody
letters crazing for some water colours and I can get them done
like [butter?] so buck up & send them back again – You missed a
stupidly cheap deal – Your heart is dead Nurse. You would have
been all over them at that price a year ago. Let me know when
you send 'em on & oblige.

Yours,

A. J. Munnings

Remember me to your wife & thank me for sending Major Bullard
round.[8]

Munnings wrote in the following year:

January 4th, 1916

Dear Nurse,

This War is a hopeless business. I thought I'd got you a small
order & your quotation was alright. Now the fellow is up in the
next group for the army & it's all off. Perhaps in a year or two,
I'll introduce him to you in a mine in Flanders or India or Egypt
or somewhere. What the hell is going to come of it all I don't
know. What I do know is this, that I got one or two bloody bills
in today which I had forgotten although the blighters who send
them hadn't. A cheque from either you or Major Bullard would
have [been] a dam'd sight better.

Look here – seriously are you going to take those drawings at
£25 the lot – now, or let me have them to send on to a certain
sale – They've been away now for months – please write on return
about it. I actually sold 3 drawings the other day through a friend
in Manchester. The first good sale I've ever made there. But it
only helped to pay my horse corn for the last 6 months. Shit – &
I must keep on with hosses because after this War there'll be no
such thing as having any to paint I'm afraid, besides no money to
keep 'em.

What has happened to Major Bullard is he too flooded with
bills? My God: – I could do with a sight of a cheque from him.
I sent that good thing along on purpose to please his particular

mind. Has his wife seen it yet? In a weekly paper from Norwich the other day I read of poor old S. F. Howitt's death. Dear old chap – I'm sorry he's gone – & on Xmas eve too –

Do you ever see Adcock? Surely he'd take one of those good drawings or is he suffering from the war as well.

Hazell from the Hospital was here before Xmas having a rest before going North & he bought 3 things from me …

How is your wife & how is the business? Remember me to her & also remember to let me know what you can do about the drawings. It's a good offer I'm making you.

Best wishes for the coming year,

Yours,

A. J. Munnings

How is Charles?

Jan. 13th, 1916.

Dear Nurse,

Thanks for letter & cheque although I must say that you are a wily devil. Don't you tell me about any 20 quid stock. I want my price £25. I can remember each picture of that lot. The two larger ones are dam'd good & you couldn't get anything to touch them anywhere & you know it. It isn't the fault of the pictures that you can't sell them it's your moustache or some old coat you're wearing or your ways which haven't improved during this depression. You ask your Missus to take a good look at you with a fresh eye & see if you couldn't be brushed up a bit …

Rot it – my dear chap – you look at the work & quality in the one with the huntsman going along on the grey 'oss with hounds with the round hill behind. The big one. I damn well know that if you had let me have them back when I wrote for them that I would have sold the pair for £25. You spoilt a sale. The Cardiff dealer came over & bought [three?] of ones here & took what I could spare & if only I'd had them they would have gone.

You say Adcock says two of my watercolours fetch £2 10s each – well how much more do you reckon you're giving me for these? You get him down & show them to him, & let him & what were the watercolours he saw sold?

The letter is unsigned, so Munnings probably finished the letter in a huff. The correspondence illustrates how both artists and dealers were suffering from the effects of the war. But Munnings needn't have worried about his future career specialising in painting horses – he became an increasingly successful artist, received a knighthood, and was elected president of the Royal Academy in 1944. Nurse must have looked back on their early association with nostalgia, and maybe regretted that he hadn't paid Munnings the prices he demanded – he could have stored the paintings and sold them for thousands of pounds later on.

After the war, a city war memorial, designed by Lutyens, was erected in the Market area near the Guildhall, but later moved higher up the hill to a more prominent position opposite the City Hall, surrounded by a garden facing towards the market stalls.

A public subscription was raised to build a war memorial chapel at the east end of the Cathedral, and another significant memorial is the statue near the Cathedral entrance in Tombland, depicting Edith Cavell. She worked for the Red Cross, nursing wounded soldiers in Brussels, and also assisted some to escape across the border to Holland, a neutral territory. She was arrested in August 1915 and executed by firing squad two months later. She was a native of Swardeston, a small village to the south of the city, but her family wished her to be commemorated in Norwich. The statue features a soldier carved in shallow relief, raising a laurel wreath to honour her.

One woman who survived the war, Miss Harriet Copeman, celebrated her hundredth birthday on 30 August 1919. She was a member of the Copeman family, who managed a prosperous grocery business in the city. John Copeman, born in 1811, was also a founder of the Norfolk News Company, became an Alderman of the city, and died in 1899. His son Henry was elected Mayor in 1911. The family papers, which are held in the Norfolk Record Office, include a letter expressing Miss Copeman's delight on receiving a telegram from King George V congratulating her upon her centenary. She was perhaps one of the first people in the city to receive the honour. The telegram states:

The King understands that today you celebrate your hundredth birthday & His Majesty desires me to congratulate you upon your attaining this great age and trusts that you may enjoy peaceful and happy days for the remainder of your life,

[signed] Stamfordham.[9]

Miss Copeman replied on the following day. The letter is on headed notepaper with her address: Rose Cottage, Surrey Grove, Norwich.

Dear Sir,

I am very much obliged to His Majesty the king for his kind and gracious words in the telegram which he sent me yesterday.

It was quite a surprise to me as I had no idea any communication had been made to him, nor did I imagine that so humble an individual as myself could possibly receive so great an honour.

The telegram was a source of great gratification to myself & to my relatives & it will be suitably framed to be kept as an heirloom for the future generations of my family.

I have to thank God for all the care & blessing with which He has guided me throughout my long life.

With my dutiful respects to His Majesty, who, I pray, may be spared for many years to reign over a prosperous Empire,

I beg to remain,

Etc. etc.

The letter bears no signature and is obviously a draft of that which she sent to the king. It is beautifully written, suggesting that Miss Copeman remained very sprightly at the grand old age of 100. A note mentions that she was the only surviving sister of the late John Copeman, JP.

Nugent Monck was the creator of the Maddermarket Theatre, which in 2011 is celebrating the centenary of the year when the Guild of Norwich Players was first established.

Monck lived for nearly fifty years from 1909 to 1958 in the narrow alley of Ninham's Court, off Chapelfield North, in a house called the 'Crypt'. Some of his earliest theatrical productions were staged there. In 1910, he produced a revival of the Norwich 'Paradise Play', which had originally been performed by the

Grocers' Company in the late medieval period. The revival was in the Blackfriars' Hall, a suitably atmospheric medieval venue, and in the following year Monck created a dramatised version of the Old Testament Book of Job. The poet William Butler Yeats, who was staying with Monck at the time, was given the task of tying the ticket numbers on the seats. This seems an odd task for one of the greatest poets of the twentieth century. No doubt he performed it in a suitably poetic style, but unfortunately no verse survives to commemorate the occasion. Monck was a devotee of Yeats's early plays, such as *The Land of Heart's Desire*, and later revived some of them when he created his own theatre.

He formed a company called the Norwich Players, and in 1914 took over the ancient Music House in King Street, converting it to a theatre that could seat an audience of a hundred. The outbreak of war caused productions to cease, but after the war, in September 1921, Monck established the more central and convenient Maddermarket Theatre in a building previously used as a Roman Catholic chapel. The site, near St John's church, was originally the medieval market where the red vegetable dye 'madder' was sold for use in the cloth-making trade. It was officially opened by W. B. Yeats on 26 September, having been promoted from his role of tying ticket numbers on seats.

The interior of the new building was fitted out with an Elizabethan apron stage, much in the style of theatres in Shakespeare's lifetime, and here all the great Bard's plays were performed, as well as many other period and modern productions. It became one of the most celebrated repertory theatres in Britain, despite all the performers being unpaid amateurs. Monck produced 280 plays there, before he eventually retired in 1952.

He was also involved with the Norwich Pageant. On 23 February 1926, the following letter concerning the event was sent to the editor of the local journal:

Dear Sir,

We should be glad if you would allow us to inform the public that the City of Norwich Pageant, which will be produced under the directorship of Mr. Nugent Monck, will take place in Earlham Park during the week commencing July 19th 1926.

The Pageant will be produced on a large scale requiring a thousand performers for the following episodes:

1. British-Roman
2. Emma delivering up the keys
3. The building of the Cathedral
4. Queen Philippa and the Weavers
5. Tombland Fair
6. Kett's Rebellion
7. Queen Elizabeth with Kemp's Morris Dance
8. Cromwellian period
9. King Charles II and knighting of Sir Thomas Browne
10. Snap and the Georgians
11. Earlham between 1798 and 1800
12. Personages of importance connected with the city (Finale).

The services of fifty ladies will also be required to assist in making the costumes.

As this effort is chiefly for the benefit of the city and county, we trust there will be a ready response to this appeal. Names and addresses should be sent to the General Secretary, the Pageant Office, Picture House, Haymarket, Norwich, as early as possible.

[signed] Thos. Glover (Lord Mayor of Norwich)

D.O. Holmes (Chairman of the Pageant Committee)

To commemorate the centenary of the Maddermarket in the autumn of 2011, apart from some special celebrations, the Trust members are publishing a book telling the story of the Norwich Players, its illustrious founder Nugent Monck, and the men and women who have come after him and contributed so much to maintaining the theatre's dominant place in the cultural life of the city. George Bernard Shaw, writing to Monck in the 1940s, affirmed:

> There is nothing in British theatrical history more extraordinary than your creation of the Maddermarket theatre.

Whereas the First World War had caused few casualties and little damage in the city, the Second World War had considerably more

tragic impact. The first air raid was on 9 July 1940, when bombs were dropped on Carrow Hill, and on the Boulton & Paul factory on Riverside. Twenty-seven people were killed.

Because the outbreak of war had been delayed, there had been time to build air-raid shelters before hostilities commenced, and by 1942 there were deemed to be sufficient numbers for the entire populace, including the underground chalk tunnels in Gas Hill, and Earlham Road, which had been fitted out with bunks. This provision helped to reduce the numbers of fatalities and injuries, but the slaughter was still high, especially during the worst bombing period in April 1942, which resulted in Norwich becoming one of the worst-damaged cities in the country. The raids were German retaliation attacks for the British bombing of the civilian populations of Rostock and Lubeck, and resulted in 162 people killed and 600 wounded on the first night, and sixty-nine killed and eighty-nine injured on the following night, the heaviest loss throughout the entire war.

A second raid occurred in June 1942, when about 1,000 incendiaries fell in the area of the Close, causing damage to the Cathedral, and destroying some adjacent houses. The Bonds family department store on All Saints Green was destroyed, and about 3,000 houses were damaged in both raids, most of them beyond repair. The bombing also destroyed four churches in the city centre, St Benedict, St Julian, St Paul and St Michael at Thorn, as well as the synagogue in King Street and, further away, the St Mary's Baptist chapel in Duke Street, and the St Bartholmew church in Heigham.

St Benedict's parish was particularly badly affected, and what had been a crowded community area of shops and terraced houses was virtually annihilated. Another ancient building that perished was the Dolphin Inn in Heigham Street, the fine Jacobean building with panelled rooms to which Bishop Hall had retired after the Cathedral was pillaged and desecrated by the Puritan mob and musketeers. The inn has since been rebuilt. Many shops and business premises were damaged or destroyed, including Boots and Curls, and about a hundred factories to the north and west of the city. The last of the air raids was in November 1943, when some bombs were dropped in the city outskirts in

the Unthank Road and Bluebell Road areas, but fortunately there were no casualties.

In total it is estimated that between 1940 and 1943 there were forty-five raids on the city, causing approximately 400 deaths, about 1,000 injuries (many requiring hospital treatment), and damage to around 30,000 houses.

The Hippodrome Theatre had been hit during the June 1942 raids, and both the manager and his wife were killed. By that time, Fred and Fannie Fitt had retired, Fred dying in 1957, aged eighty-five. The 'Hippo' had featured some major stars between the wars, including Charlie Chaplin, Marie Lloyd, and Gracie Fields. After the Second World War it was rebuilt and reopened and was described in the *Official Guide to Norwich* (*c.* 1960) as specialising in 'live variety shows' – Max Miller, the Goons, and Morecambe & Wise all appeared there, and it also functioned as a cinema. The last variety show was in 1958, and the building was demolished in 1964. The site is now occupied by the St Giles car park.

When the war ended in 1945, there were ambitious plans for a major reconstruction of the city. As the centre of the city in the Orford Place area had been badly affected, with a massive bomb crater where the Curls department store had been, it was decided to boost public morale by rebuilding it in modern style as swiftly as possible. By the early 1950s, a Marks & Spencer's and Woolworths had been erected nearby in Rampant Horse Street, and the centre began to radiate with hustle and bustle and the tinkling of tills again.

However, the building programme was generally sluggish, due to a shortage of funding, as well as a lack of manpower and materials in the post-war era. Gradually, the heart and spirit of the city has been restored with many fine new buildings and leisure areas, and when walking around today it is difficult to imagine how bleak the atmosphere must have seemed in the early 1950s.

One national event organised to foster community optimism and business initiatives, and celebrate the country's survival and recovery from the Second World War, was the Festival of Britain. Norwich was selected as one of the principal centres for the

celebrations of 18–30 June 1951. The city officials decided to organise three grand street processions on the theme of 'Norwich Through the Ages'. This theme linked up with the traditional medieval guild pageants such as the Woolcombers' events, and the historical personages portrayed included Viking warriors, bishops, and Queen Elizabeth I with her train of courtiers.

There was a concert performance at the old Odeon cinema in Botolph Street, with the Royal Philharmonic Orchestra conducted by Sir Thomas Beecham, and a recital by the pianist Dame Myra Hess. The Theatre Royal provided a performance of two Gilbert & Sullivan operas, and Nugent Monck at the Maddermarket provided performances of Shakespeare's *Pericles*, and *The Taming of the Shrew*. Brass bands played in the evenings in the Eaton and Waterloo parks, and there was dancing in Chapelfield Gardens.

The events and activities created a 'feel good' factor in the city again, and attracted many tourists, who stayed in local hotels, ate in pubs and restaurants, and bought gifts and souvenirs – all helping to stimulate the local economy.

Much of the festivity occurred around bomb-scarred streets and patches of wasteland, so the rebuilding of the city remained a firm imperative. Apart from new shops and businesses, one of the major new buildings was the Central Library, designed by David Percival in 1962, with a large entrance courtyard and a light-filled interior created by the extensive use of glass. Unfortunately it survived little more than thirty years, destroyed by fire in 1994, and the new millennium building, the Forum, replaced it in 2001.

Another significant development was the establishing of the city's University of East Anglia, at Earlham, partly on the site of Earlham Hall, former home of the Gurneys. Student life added a new sparkle to the city, and there are regular buses running from St Stephen's to transport them back and forth to the University Plain or their student accommodation. What would the Quaker family say if they could see the Ziggurat-style buildings and students in jeans on the campus today? The Gurney girls would surely applaud the new fashions, having been frowned upon for their own choice of dress two centuries earlier. And, after all, Elizabeth had created her own large group of students there,

'Betsy's Imps', long before the university campus was ever thought of.

August 2011, and bumble bees are buzzing around the flowering plants on sale from a stall near the Haymarket. It's a reminder of how close the city centre is to open spaces such as Chapelfield Gardens and the Cathedral Close, and the fields of the Norfolk countryside.

Bill Holman was a keen naturalist, and in his diaries, written between 1929 and 1987, he recorded various aspects of the weather, and sightings of birds, animals and wild flowers, mainly in his walks in Earlham Park and the fields around the city, but also in the city itself.[10] He was employed as a night worker in the print room of the *Eastern Daily Press* for his entire working life, so was free to enjoy his own interests during the daytime.

On 7 April 1943, during the Second World War, he wrote:

Terrific gale blowing today; wind north-west. Struggled down to Earlham. On the way saw two barrage balloons break away. Bet there wasn't a balloon left by nightfall. Went through Blackdale Plantation, counted five large pine trees down. From the plantation to park dare not open my eyes as the wind was blowing dust off the fields like huge smoke clouds, everywhere was obliterated. 15 trees down on the park, some huge elms among them, and boughs and branches scattered everywhere. Near the entrance to Earlham Park a large elm lay right across the road and every house which stood a bit high had tiles off. About 30 off Charlie's. Must be a tremendous amount of damage done.

Thurs. April 8th: Gale blew itself out this morning. Went down to Earlham and found more trees down – 21 on Blackdale alone, all firs. All the top surface of the fields had silted up in the loke and it was like walking over Yarmouth beach. I counted 63 trees down just on Earlham Park estate. Never seen so much devastation.

After the war, he noted in his diary on 28 January 1947:

Waxwings were seen in Castle Gardens yesterday, so I was in the Gardens this morning on the off chance of seeing them and I was

in luck, about eight were feeding off berries in one of the thorn trees at the top of the bank. I stood with two other men within a few yards of them, and had a nice view. It was snowing hard and a keen east wind was blowing and after a few minutes the birds flew away over the Cattle Market. They were not quite so bright in colour as I expected but it might be because it was so very dull at the time. Never seen waxwings before.

And during the Christmas period in 1947 he wrote this wonderfully evocative description of the Norwich landscape at night:

Mon. Dec. 22nd: While E. went to hear Carol singers round a huge Christmas tree on the Town Hall steps I took a walk down round Cow Drive, over fence to sweet chestnut trees, down to the firs along the fairways, down to the hurdle, across marshes, along the river, over the park, and home. The moon was half-full so it was bright out, not cold. The reeds on the marshes in the moonlight looked as if they were covered in frost. Could hear some Carol singers away over the marshes in Coney Lane. First time I've been down marshes in the dark for about twenty years.

In the following month, he recorded on 11 January 1948:

Wild day, rain and wind, mild. Going past bottom of Grapes Hill on a bush by the blitzed lavatory saw several goldfinches. I thought this very unusual. Much waste land round here.

The wasteland, overgrown with weeds, would be an ideal spot for goldfinches to find seeds to peck at during the cold winter months. Bill Holman's diaries illustrate how much of nature can be observed even around the city centre if you keep your eyes and ears alert.

The 'Norwich Trails' scheme has recently been created encouraging visitors to explore the city's heritage by foot. Norwich has the largest surviving medieval street pattern in Europe. The 'Norwich Lanes' aspect of the project covers the narrow alleys and thoroughfares radiating from the Market, the trail commencing from the Guildhall. It is organised by HEART

(Norwich Heritage Economic and Regeneration Trust), which has published a booklet illustrating the trail with historical notes, and blue plaques, street name plates, pavement markers and creative bollards have been provided along the lanes and other routes with more information about the areas.

One of the best routes starts along St Giles Street, which lies within the powerful shadow of the soaring City Hall tower. Its presence strides behind you like a giant, and you don't need to consult your watch or your mobile, for the clock face will keep bobbing up to remind you of the time.

St Giles Street was previously known as Nether Newport, meaning a street lined with tradesmen's stalls, perhaps an overflow from the crowded Market area. As soon as you turn into St Giles from the hubbub of Guildhall Hill, the atmosphere changes. There are broad pavements lined with trees on either side, and, further along, rows of handsome Georgian and Victorian buildings, with decorated and pillared doorways. The street has some gentle motor traffic but otherwise a sense of peace prevails, and you can relax and stroll along without any fear of being jostled by busy shoppers or struck by teenage skateboarders.

The buildings are elegant because they were built for prosperous citizens. Gladstone House was the home of John Harvey, Sheriff in 1784, and Mayor in 1792, whose main claim to fame is that he revived horseracing on Mousehold Heath, and introduced shawl weaving in 1791, which became a fashionable industry for the city. Opposite Gladstone House was the Hippodrome Theatre, which was demolished in 1964. A plaque marks the site, now occupied by a car park and the excellent classical music shop Prelude Records.

Further along is the imposing Salvation Army citadel, with rusticated façade and elaborate window frames, and the red-brick YMCA, which always seems to have youths peering or hanging out of the windows. The street is a little shabby and down-at-heel, like an old gentleman in a frayed jacket and odd socks who has known better days. But the variety of specialist shops provides an uplift – antiques, high-quality picture-frames, and at the end, as you draw closer to St Giles church, Ellis's bookshop stuffed with tantalising goodies, at moderate prices.

This is next to Willow Lane, which got its name from a willow tree that grew on the south side in the seventeenth century. Further down the lane – it runs steeply downhill – is the splendid former Catholic Holy Apostles Jesuit chapel, designed by John Patience, which opened in 1829. The façade features chunky Ionic pillars at the entrance, and pilasters with Corinthian capitals on the first-floor level. It became a Catholic school in 1894 when the chapel closed. There is no information about its previous use – it deserves a blue plaque – and it is now occupied by Rogers & Norton, who must be the smartest-housed solicitors in the city.

Further along on the same side, a plaque commemorates the local historian Francis Blomefield, who lived at No. 15, and then the road drops into Cow Lane, where you can see the plaque commemorating George Borrow that was mentioned in the previous chapter. The Cow Lane/Willow Lane/Pottergate junction is a picturesque huddle of buildings with an air of secrecy, as if it wished you hadn't discovered its hiding place. Cow Hill climbs uphill to Upper St Giles Street, and was the last city street to remain cobbled – the cobbles were not removed until 1925. How steep and painful it must have been for old people with tired legs in worn boots.

St Giles is one of the most splendid of the city churches, with its lofty tower shooting into the firmament. It has a paternal aspect as if eager to spread a comforting and sheltering wing over its parishioners. This parish comprised part of the original medieval French Borough so is an early occupied part of the city. The church displays some delightfully grotesque gargoyles at the clerestory level near the south entrance porch, including a neurotic wild-eyed pig and a sad-eyed monster who has just had a tooth pulled and is pointing towards his mouth in agony. Well, there were no anaesthetics in medieval times.

Above the fifteenth-century porch is an alcove containing a small stone image of Saint Giles, with his hind, and holding a crozier. He was an abbot of a monastery on the Rhone, in the eighth century, and became one of the most popular saints of the Middle Ages, the patron of cripples, beggars and blacksmiths. The rear churchyard daydreams in serene solitude, an oasis of peace amid the pounding heart of the city.

In the fifteenth century, John Colton was returning to the city after a journey one night when he lost his way. He was saved from slipping into the river and being drowned by hearing the bells of St Giles. By following their sound, he gradually discovered his homeward path again. As a thanksgiving, when he died in 1497, he bequeathed a meadow, known as Colton's Acre, near Earlham Road, to the parish. In accordance with his will, the curfew bell is still rung every night for the benefit of other travellers who may have lost their way.

Opposite St Giles in Bethel Street is Churchman House, one of Norwich's finest Georgian houses. Thomas Churchman was an Alderman, and his son Sir Thomas Churchman was Mayor in 1761, and there is a handsome memorial in the church. The house is now a registry office.

Radiating from the other end of St Giles Street are Lower and Upper Goat Lane. On the corner of Upper Goat Lane is a terracotta-coloured building designed in 1900 by George Skipper for the *Norfolk Daily Standard* news office. Sadly, Upper Goat Lane has become Graffiti Lane, with daubings of sprayed paint all along it. It's not the most graffitied part of Norwich; but because it's narrow and quite short, the impact is greater. It is also loomed over by the ugly multi-storey car park. At the other end is the Friends Meeting House, built to a design by John Patience in 1826, and replacing the earlier building that the Gurney sisters attended with such distaste. Still a Quaker meeting house, it seems to be suffering from the same malaise as the rest of the street, with weeds growing through the wonky paving stones, posters tied to the entrance pillars, and some strange objects along the entrance path. On closer inspection, they prove to be seats, comprising square wire baskets filled with objects such as logs, mugs, bottles and bits of stone, and capped by stone slabs. It's an original idea but they seem out of keeping with the serene and elegant façade of the meeting house. The stone plaque by the entrance gates proclaims, 'Consider the Lemmings how they doth grow'.

Lower Goat Lane has a very different personality, bright, bustling and thronged with a fascinating range of shops. Several are aimed at young people, including bizarre fashion styles at The Rock Collection, and daintier frocks and accessories at Daisy & Lola's.

Sadly the current economic downturn is affecting many businesses throughout the city, and The Blue Jean Company is pasted with closing-down posters declaring 'EVERYTHING MUST GO'. So it's stuffed with art and college students scooping up bargains, when they should be buying books for the new autumn term. There are also charity shops, the Salvation Army Community Store, and Arthritis Research UK, selling some good second-hand stuff. Let's hope the recession doesn't hit this cute street too hard.

Emerging into Guildhall Hill, you are now in the dynamic market area again, with its brightly coloured stalls and the magnificent City Hall tower, the secular equivalent of the Cathedral, and just as commanding in its own twentieth-century way.

The newly designed War Memorial gardens are thronged with holidaymakers enjoying a picnic lunch in the sun, so why not go and join them before exploring another section of the fascinating Norwich Trails?

One of the latest city centre developments is the Chapelfield Shopping Mall. It has a large variety of shops and eating places, and is as busily humming as a beehive. Perhaps not the best analogy, as bees are currently under threat and in decline. But, at the same time, we are in the midst of an economic recession that will affect all the stores in the city. Anyhow, the new mall always seems to be buzzing. Whereas London has the 'Gherkin', Chapelfield has the 'Peanut', a sort of beacon beckoning shoppers to empty their handbags and wallets into its tills.

An unusual feature is that the entrance route from Theatre Street is along the churchyard path of St Stephen's, lined with gravestones, and in the summer with wild flowers growing in the grass. To see the crowds of smartly dressed shoppers thronging the walkway loaded with colourful plastic bags from Next, Thornton's and Fifi's, to name but a few, surrounded by images of death and the vanity of human life, brings an ironic smile to the lips. Yet it's also an engaging spectacle of human vitality contrasted with the crumbling gravestones and rotting bones of mortality.

When this you see,
Remember me,

What I am now
So shall you be.

Thus declares Ebenezer Jones, dressed in his Sunday best moleskin suit for burial in 1792. The suit was long ago eaten by worms, and only his bones now remain.

It is estimated that around 50,000 people a day walk through the churchyard, but the priest in charge of St Stephen's, the Reverend Madeline Light, reports that the congregations in the church doubled during the 2008–09 period, so the popularity of the shopping mall has provided a refreshing new participation in church worship.

Another grim reminder of mortality was discovered beneath the floors of the shopping mall itself. When the foundations for the new building were being dug in 2004, the local archaeology team uncovered a deep well shaft, and, at the bottom, a mangled mass of bones. Charles Emery and his colleagues excavated the skeletons, and later examination revealed they comprised seventeen humans, of which six were male and female adults. The other eleven were children but it was not possible to distinguish sexual characteristics. In addition, some cat bones were found among the human remains.

The archaeology team were used to digging up skeletons, but found this particular discovery disturbing and confusing. Why were the bodies in the well? Were they alive when they fell, or were they dropped in? What was the cause of death? Could it be a plague burial, a quick way of disposing of bodies that could cause infection? Whatever the causes of death, the circumstances appeared sinister.

A forensic team from the University of Dundee arrived in Norwich to examine the find. Professor Sue Black and Dr Xanthe Mallett organised carbon dating of the bones, which revealed that the skeletons were of the twelfth or thirteenth century. This immediately discounted the possibility of a plague connection, as the Black Death did not arrive until 1348. There were no apparent injuries to the bones from weapons, but there was evidence of trauma impact, and fractures to the legs indicated a hard and sudden impact, suggesting the bodies had been thrown

into the well. The well must have been dry or the bodies would have been cushioned when they hit the water. The injuries to the skulls suggested they had fallen head first, and as the bones of the children were less injured it seems that they were thrown in last, so the bodies of the adults had softened their fall.

The forensic tests suggested the children were aged between two and fifteen years old. There were some signs of anaemia and malnutrition, but no clear patterns suggesting that illness contributed to their deaths, although an infectious disease such as dysentery, malaria, or typhus could not be ruled out. So had these people been removed from the community because they were infected with a disease other than the plague? This seemed unlikely. Most people who died naturally were given a Christian burial by members of their community, not discarded in a well.

The team carried out a reconstruction of the skulls of two of the best-preserved sets of bones, those of an adult male and a child. The man proved to be aged about forty, with prominent ears, and the child, sex unknown, was aged about five to seven years old, with similar facial and ear characteristics, although not fully developed at such a young age. This suggested a family relationship, possibly father and child, and further forensic evidence suggested that some of the other bodies could be of the same kin. The DNA revealed that they were local residents, but of foreign extraction. It was concluded that they could be members of a Jewish family, and the area, close to St Stephen's church, was known to have had Jewish occupants in that period.

A thirteenth-century document in the Norfolk Record Office was examined with the assistance of Senior Archivist Susan Maddock. It recorded that the area was primarily inhabited by tradesmen, their occupations including butchery, skinning, and leather-working. It was therefore suggested that the cat bones in the well were the remains of bodies thrown in there after the skins had been removed to make fur gloves and trimmings. But then why were there no remains of other skinned animals? Did the presence of the cats have a supernatural significance? Cats were believed to possess magical qualities by superstitious people in the medieval and later periods and were sometimes walled up in chimney breasts and cavities to help ward off evil spirits.

Although there was no conclusive evidence, the work of the research team tended to suggest that the seventeen bodies were family members from the Jewish community who had died a violent death as a result of persecution. It will be remembered that in the first chapter of this book the Jews were held responsible for the death of the child William, and that they were then attacked by the local mob. As the city and Church officials did little to punish those believed to have been responsible for the boy's death, antagonism towards the Jews increased. Towards the end of the twelfth century they were accused of poisoning wells, and later spreading diseases. There were increasing demands for the whole community to be expelled, not just from Norwich but from other towns in Britain, and it was argued they should be sent back to their former homeland in Northern France. Mob violence increased at the beginning of the thirteenth century, and Jews' houses were set on fire. City officials could do little to control the increasing level of violence.

The forensic team could not be sure whether the victims were alive or dead when they were dropped in the well, but it is thought that they were probably dead. Death by attack with weapons was ruled out, but they could have died in a house fire, from smoke inhalation. This would explain why the bodies seemed to be of the same kin, and whoever caused the fire then quickly disposed of the bodies in the well as a convenient hiding place. Alternatively, they could have been murdered in a house attack by being smothered, or possibly by having their throats slit. It was also suggested that, in view of the increasing persecution of their community, a Jewish family decided to organise mass suicide – this had happened in York in the same period. But it seems less likely, for why would they end up in a well, and who would have thrown them there?

Although there has been speculation by historians about the antagonism directed against the Norwich Jews, there had previously been little evidence. The discovery of the bodies in the well is a shocking revelation suggesting the degree of victimisation that may have occurred.

1 September 2011: a sunny and serene morning after one of the coldest summers for twenty years. The school holidays are

coming to an end, and crowds of tourists on the streets will be replaced by jostling and jabbering schoolchildren, dressed in their smart new 'beginning of term' uniforms. In the shop windows, woollies and jackets are replacing summer frocks and shorts, and Christmas cards twinkle from the racks in the stationery departments. The swifts have ceased circling high above the rooftops, and are winging their long journey back to warmer climes. In the Cathedral Close, yellow leaves spin slowly down, scattering the neatly mown lawns.

Despite the current economic recession, the city appears as bonny and blithe as ever. There are a few empty shops appearing in the streets like black gaps in an otherwise healthy set of teeth. But the number of shoppers thronging the streets seems not to have diminished; although, when questioned, some may say, 'Yes, we're planning to spend a bit less on Christmas this year.' There is a shiny new Marks & Spencer's food store near St Stephen's church, creating a vivid contrast of architectural styles, and the Market is graced with the revamped War Memorial gardens. Norwich FC are now in the Premier League, so there will be even greater numbers of yellow and green strips strutting about on match days.

And so a new season commences in the fascinating chronicles of Norwich. What may the next chapters reveal?

The city winks.

# Notes

## Introduction & Chapter One

1. Green, B. and Young, R., *Norwich: The Growth of a City*, City of Norwich Museums, 1968, p. 9.
2. Goulburn E. and Symonds, R., *The Life and Letters of Bishop Herbert de Losinga*, 1878. Two other useful sources are: Yaxley, S., *Herbert de Losinga, 1050–1119*, The Larks Press, 1995; and the chapter on Losinga in McCutcheon, E., *Norwich Through the Ages*, Alastair Press, 1989.
3. McCutcheon, *Norwich Through the Ages*, p. 27.
4. Anderson, M. D., *A Saint at Stake: The Strange Death of William of Norwich, 1144*, Faber & Faber, 1964, Introduction, p. 19.
5. *The Book of Saints: A Dictionary of Servants of God, canonised by the Catholic Church*, compiled by the Benedictine monks of St Augustine's Abbey in Ramsgate, A. & C. Black, 1989.

## Chapter Two

1. Hudson, W. and Tingey, J. C., *The Records of the City of Norwich*, vol. 2, Jarrold & Sons, 1910, p. 8. In the extracts quoted throughout this book, some of the spelling has been adjusted to make it easier to read.
2. Ibid., p. 9.

3. Ibid., p. 14.
4. Ibid., p. 15.
5. Ibid., p. 360.
6. Fowler, E., *Official Guide to the City of Norwich*, Norwich Publicity Association, *c.* 1960, p. 32.
7. Hudson and Tingey, *Records of the City of Norwich*, p. 269.
8. McCutcheon, *Norwich Through the Ages*, p. 42.
9. Ibid., pp. 36–7. The opinion about who was to blame is my own.

## Chapter Three

1. Hudson and Tingey, *Records of the City of Norwich*, p. 7.
2. Ibid., p. 23.
3. Ibid., p. 81.
4. Ibid.
5. Ibid., p. 87.
6. Ibid., p. 100.
7. Ibid., p. 101.
8. Ibid., p. 360.
9. Ibid., p. 153.
10. Ibid., p. 154.
11. One of the best local accounts can be found in: Cornford, B., *Studies towards a History of the Rising of 1381 in Norfolk*, Norfolk Research Committee, published with financial assistance from the University of Cambridge Extra-Mural Board, 1984.
12. Haymon, Sylvia, *Norwich*, Longman Young Books, 1973, p. 75 ff.
13. Quoted in Simpson, R., *Literary Walks in Norwich*, privately published, 1983.
14. Information about the Lollards can be found in: Blomefield, F., *The History of the City of Norwich*, 1806.
15. Hudson and Tingey, *Records of the City of Norwich*, p. 66.
16. Davis, N., *The Paston Letters: A Selection in Modern Spelling*, Oxford University Press, 1963.
17. Ibid.

# Chapter Four

1. Hudson and Tingey, *Records of the City of Norwich*, p. 124.
2. Ibid., p. 163.
3. Ibid., p. 126.
4. Ibid., p. 127.
5. Ibid., p. 132.
6. Ibid.
7. Ibid.
8. Haymon, *Norwich*, p. 102.
9. Hudson and Tingey, *Records of the City of Norwich*, p. 180.
10. Ibid., p. 180.
11. Ibid., p. 172.
12. Ibid., p. 168.
13. Ibid., p. 175.
14. Ibid., p. 177.
15. Ibid., p. 179.
16. Ibid.
17. Ibid.
18. Ibid.
19. Ibid., p. 177.
20. Ibid., p. 84.
21. Ibid., p. 205.
22. Ibid., p. 97.
23. Ibid., p.110.
24. Ibid., p. 115.
25. Ibid., pp. 127–8.
26. Ibid., p. 133.
27. Ibid., p. 172.
28. Sotherton, N., *The Commoyson in Norfolk, 1549*, ed. Susan Yaxley, The Larks Press, 1987.
29. Ibid., p. 29.
30. Ibid., p. 30.
31. Ibid., p. 31.
32. Haymon, *Norwich*, p. 109 ff; McCutcheon, *Norwich Through the Ages*, p. 55 ff.

33. Hudson and Tingey, *Records of the City of Norwich*, p. 187.
34. Ibid., pp. 186–7.
35. Ibid., p. 336.
36. Yaxley, S. (ed.), *Kemp's Nine Daies Wonder. Performed in a daunce from London to Norwich. Containing the pleasures, paines and kinde entertainment of William Kemp betweene London and that Citty in his layte Morrice in the year 1600*, The Larks Press, 1997.

## Chapter Five

1. Prideaux, Dean, *Letters*, Camden Society, N.S. 15, 1875, quoted in Meeres, F., *A History of Norwich*, Phillimore, 1998, p. 91.
2. Meeres, *History of Norwich*, p. 90.
3. Hudson and Tingey, *Records of the City of Norwich*, p. 154.
4. Meeres, *History of Norwich*, p. 90.
5. Goodwyn, E. A., *Selections from Norwich Newspapers, 1760–1790*, *c.* 1970, p. 144.
6. Meeres, *History of Norwich*, p. 127.
7. Seymour, J., *The Companion Guide to East Anglia*, Collins, 1970, p. 89.
8. Aubrey, J., *Brief Lives*, ed. R. Barber, Book Club Associates, 1983, p. 79 ff.
9. Quoted in Simpson, *Literary Walks in Norwich*, p. 14.
10. Quoted in *The Official Guide to the City of Norwich*, Norwich Publicity Association, *c.* 1960, p. 25.
11. Meeres, *History of Norwich*, p. 70.
12. Haymon, *Norwich*, p. 127 ff; Meeres, *History of Norwich*, pp. 70–1.
13. Blomefield, *The History of the City of Norwich*, vol. 1, p. 364.
14. McCutcheon, *Norwich Through the Ages*, pp. 65–70.
15. Meeres, *History of Norwich*, p. 79.
16. McCutcheon, *Norwich Through the Ages*, pp. 79–87.

17. Ibid., p. 86.
18. Browne, T. (Sir), *The Religio Medici and Other Writings*, Everyman's Library, J. M. Dent, 1906, pp. 65–6.
19. Woolf, V., *Orlando: A Biography*, The Hogarth Press, 1928 (first edition), p. 76.
20. Simpson, R., *Literary Walks in Norwich*, p. 38.
21. Evelyn, J., *The Diary of John Evelyn*, J. M. Dent, 1907, p. 68 ff.
22. Ibid., p. 69 ff.
23. Meeres, *History of Norwich*, p. 119.
24. Evelyn, *Diary of John Evelyn*, p. 70.
25. Schellinks, W., *The Journal of William Schellinks: Travels in England, 1661–1663*, ed. M. Exwood, and H. L. Lehmann, Camden Fifth Series, vol. 1, Offices of the Royal Historical Society, University College, London, 1993.

## Chapter Six

1. Norfolk Record Office (NRO), MC 79/1, 'Norwich Scrapbook, Newscuttings, 1610–1883'. The newspapers from which the cuttings in the Scrapbook are taken are not named, and dates sometimes omitted.
2. NRO, MC 79/1, 'Norwich Scrapbook'.
3. Meeres, *History of Norwich*, p. 103.
4. NRO, MC 79/1, 'Norwich Scrapbook'.
5. Woodforde, J., *The Diary of a Country Parson, 1758–1802*, ed. John Beresford, Oxford University Press, 1978, pp. 198–200.
6. McCutcheon, *Norwich Through the Ages*, p. 89.
7. Ibid.
8. *Calendar of State Papers, Domestic Series of the Reign of Anne: Preserved in the Public Record Office. Vol. 1. 1702–1703*, HMSO London, 1916, p. 237.
9. Hannah, I. C., *The Heart of East Anglia: The Story of Norwich from the Earliest to Latest Times*, Heath, Cranton & Ousely Ltd, 1915, pp. 345–6.
10. McCutcheon, *Norwich Through the Ages*, p. 94.
11. NRO, MC 79/1, 'Norwich Scrapbook'.

12. Ibid.
13. Ibid.
14. Goodwyn, *Selections from Norwich Newspapers*, p. 25.
15. Ibid., p. 83.
16. Surry, N., *'Your Affectionate and Loving Sister'*: The Correspondence of Barbara Kerrich and Elizabeth Postlethwaite, 1733–1751, The Larks Press, 2000, p. 56 ff.

## Chapter Seven

1. NRO, MC 79/1, 'Norwich Scrapbook'.
2. Ibid.
3. Goodwyn, *Selections from Norwich Newspapers*, p. 74.
4. Ibid., p. 75.
5. Meeres, *History of Norwich*, p. 121.
6. NRO, MC 79/1, 'Norwich Scrapbook'.
7. Simpson, *Literary Walks in Norwich*, pp. 35–6
8. Meeres, *History of Norwich*, p. 101.
9. Goodwyn, *Selections from Norwich Newspapers*, p. 67.
10. Simpson, *Literary Walks in Norwich*, p. 77.
11. Woodforde, J., op. cit. pp. 250–1.
12. Goodwyn, *Selections from Norwich Newspapers*, p. 65.
13. Ibid., p. 66.
14. NRO, MC 79/1, 'Norwich Scrapbook'.
15. Ibid.
16. Goodwyn, *Selections from Norwich Newspapers*, p. 17.
17. Ibid., p. 28.
18. Ibid., p. 39.
19. Ibid., pp. 17–18.
20. NRO, MC 79/1, 'Norwich Scrapbook'.
21. Ibid.
22. Hudson and Tingey, *Records of the City of Norwich*, pp. 207–9.
23. Hannah, *The Heart of East Anglia*, pp. 26–7.
24. Goodwyn, *Selections from Norwich Newspapers*, p. 122.
25. Williams, N., *The Blue Plaques of Norwich*, Norwich HEART, 2010.

26. Eshleman, D. H., *The Committee Books of the Theatre Royal, Norwich, 1768–1825*, The Society for Theatre Research, 1970.

27. Goodwyn, *Selections from Norwich Newspapers*, p. 66.

28. Ibid., p. 105.

29. Ibid., pp. 105–6.

## Chapter Eight

1. NRO, MC 26/1, 'Journal of an Excursion to Yarmouth, Norwich and Cromer etc. by Mr. Marten in 1825'.

2. Hare, J. C., *The Gurney's of Earlham* (2 vols), 1895.

3. Simpson, *Literary Walks in Norwich*, p. 58.

4. Bardens, D., *Elizabeth Fry: Britain's Second Lady on the Five Pound Note*, Chanadon Publications, 2004.

5. Hare, *The Gurney's of Earlham*.

6. Hannah, *The Heart of East Anglia*, pp. 341–2.

7. Simpson, *Literary Walks in Norwich*, p. 30.

8. Ibid., pp. 31–2.

9. *Dictionary of National Biography*, Oxford University Press.

10. Ibid.

11. Ibid.

12. Simpson, *Literary Walks in Norwich*, p. 58.

13. NRO, MC 1118/1, 'Letter From Amelia Opie to Mr. Dyer, June 29th, 1821'.

14. Jessopp, A., 'Lights on Borrow', *Daily Chronicle*, 30 April 1900.

15. Ibid.

16. Harries, R., Cattermole., P., Mackintosh, P., *A History of Norwich School: King Edward VI's Grammar School at Norwich*, Friends of Norwich School, 1991, p. 70.

17. Ibid., pp. 69–70.

18. Ketton-Cremer, R. W., *Three Generations: Based on Letters of the Astley Family during the Civil War*, The Larks Press, 1992.

19. Shorter, C. K., *George Borrow and his Circle*, Hodder & Stoughton, 1913.

20. Ibid.
21. Haymon, *Norwich*, p. 159.
22. NRO, MC 27/2, 'Autobiography of John Bilby'.
23. Simpson, *Literary Walks in Norwich*, p. 53.
24. McCutcheon, *Norwich Through the Ages*, pp. 153–4.
25. NRO, MC 79/1, 'Norwich Scrapbook'.
26. Honeywood, F., Reeve, C., Reeve, T., *The Town Recorder: Five Centuries of Bungay at Play*, Morrow & Co., 2008, pp. 201–2.
27. Paton, C., *The King of the Norfolk Poachers: His Life and Times. A Biography of the Author of 'I Walked by Night'*, Old Pond Publishing, 2009.
28. Rolfe, F., *I Walked by Night: being the Life & History of the King of the Norfolk Poachers, written by HIMSELF*, ed. Lilias Rider Haggard, Nicholson & Watson, 1935, pp. 38–41. Quoted by kind permission of the executors of the Lilias Rider Haggard literary estate.
29. NRO, MC 160/23, 626X9. 'Letter written by W. F. Mitchell from Mousehold Prison, Norwich'.
30. Kitson, S. D., *The Life of John Sell Cotman*, Faber & Faber, 1937, p. 355.
31. Ibid., p. 357.
32. Ibid., p. 361.
33. Ibid., p. 11.
34. McCutcheon, *Norwich Through the Ages*, pp. 140–5.
35. Meeres, *History of Norwich*, p. 141
36. Hooper, J., *Jarrolds' Official Guide to Norwich*, Jarrold & Sons, 1909.
37. Hannah, *The Heart of East Anglia*, pp. 363–4.

## Chapter Nine

1. *Jarrolds' Official Guide to Norwich*, 1939.
2. NRO, MC 198/16, 665X4, 'Family Diaries and Correspondence of Fitt & Bostock Families'.
3. NRO, MC198/74, 665X5, 'School Exercise Book, "Housewifery", D. W. Fitt, September 1914 to September 1915'.

4. Hannah, *The Heart of East Anglia*, p. 361.
5. Ibid., p. 362.
6. Ibid., pp. 367–8.
7. Walpole, J., *Suffolk Lives*, Images Publication, 1993, p. 91.
8. NRO, MC 2719/2, 958X8; MC 2719/3, 958X8; MC 2719/4, 958X8.
9. NRO, MC 81/26/396, 525X9. 'Centenary of Miss Harriet Copeman'.
10. NRO, MC 535/8, 763X5, 'Diaries of Bill Holman'.

# Select Bibliography

Green, B. and Young, M. R., *Norwich: The Growth of a City*, City of Norwich Museums, 1968.

Groves, N., *The Medieval Churches of the City of Norwich*, HEART (Norwich Heritage Economic and Regeneration Trust), 2010.

Hudson, W. and Tingey, J. C., *The Records of the City of Norwich* (2 vols), Jarrold & Sons, 1906–10.

McCutcheon, E., *Norwich Through the Ages,* Alastair Press, 1989.

Meeres, F., *A History of Norwich*, Phillimore, 1998.

*Official Guide to the City of Norwich*, Norwich Publicity Association, *c.* 1960.

*Pitkin City Guides: Norwich*, 2007.

Priestley, U., *The Great Market: A Survey of Nine Hundred Years of Norwich Provision Market*, Centre of East Anglian Studies, University of East Anglia, 1987.

Rawcliffe, C., *Medicine for the Soul: The Life, Death, and Resurrection of an English Medieval Hospital: St. Giles's, Norwich, c. 1249–1550*, Sutton Publishing, 1999.

Sheehan, B. and Watson, C., *Norwich 12: A Journey Through the English City*, HEART, 2008. This focuses on twelve iconic Norwich buildings, dating from the Norman period to the present day.

Simpson, R., *Literary Walks in Norwich*, 1983. This privately printed book contains a fascinating amount of information about authors associated with various buildings and sites in the city. It deserves to be reprinted.

Williams, N., *The Blue Plaques of Norwich*, HEART, 2010.

Also available from Amberley Publishing

# NORWICH
## in the 1960s
### Ten Years that Altered a City

PETE GOODRUM